Young

gners

Young Fashion Designers

evergreen

© 2007 EVERGREEN GmbH, Köln

Editor & texts:
Marta R. Hidalgo

Special collaboration:
Marta Dominguez Riezu

Editorial coordination:
Anja Llorella Oriol

English translation:
Veronica Fajardo

Proofreading:
Julia Hendler

Art direction:
Mireia Casanovas Soley

Graphic design:
Emma Termes Parera

Printed in China

ISBN 978-3-8228-4423-6

As almost all means of expression, the phenomenon of fashion goes through constant changes. Nonetheless, what remains intact is the idea that clothes are a sign of the body that wears them, a barometer of the person's illusions, frustrations or dreams... They are the letter of introduction to a *modus vivendi*, to a personality... Be that as it may, the passing of time and the new ways of the world also bring with them new fashions. And although one can pretend to be outside of them, it is difficult to remain excluded from an expression or aesthetic proposal.

Fashion talks. It lives. And it grows. Every new year, the list of international fashion calendars grows with new names of designers who are eager to transmit their particular view of the moment. The contests that award the creative abilities of the promising needles are growing, as are the new schools that add their names to already prestigious ones, all of them responsible for training professionals in an area that is constantly growing.

These are our protagonists. Promising designers on whose hands lay the responsibility of capturing and giving expression to what we will decide to acquire and wear. The fashion created by these young people redefines the changing, accelerated pace of the reality that surrounds us, which is as uncertain as the common thread that links the social with the aesthetic.

We have a lot of information about clothes readily available. But only on very rare occasions have we the chance to see from up close the birth of what our body strolls around wearing, the origin and the sense of the sketch that one day was what later became a sign of our personality. Only they are capable of capturing the present moment and making predictions two years ahead. Their drawings are the indisputable proof of visual impressions that demonstrate how open the eyes of these visionaries are; they are capable of foreseeing what may sometimes serve to satisfy a recently attained success, and other times the identification with our restlessness or our specific mood.

Marta R. Hidalgo

Bilbao, Spain, 1968

"Ailanto's universe is mainly visual."

INTERVIEW

How would you define your style?
Ailanto's universe is mainly visual, characterized by the combination of colors, geometrical shapes and their reference to avant-garde artistic movements.

Which is the most difficult piece to design?
No piece is difficult to design. What is really complicated is finding the solution to the problem of making the piece work: choosing the right fabric, the volume, the pattern, the details and the finish.

Who or what is your main source of inspiration?
There is a different source of inspiration for each collection. None of them is the same. For example, for the 2006 summer collection, we were inspired by the film *The Blue Lagoon* and for the 2006-07 fall-winter collection, we found inspiration in Peggy Guggenheim.

What area of your work do you enjoy the most?
We really enjoy the projects that involve cooperation with different firms. Among these, we can mention the rugs we designed for DAC, the Garbo lamp for Santa & Cole, the NafNaf collections by Alianto. In September 2006, an exhibition called "Textil y Arquitectura del Siglo XX", of which we are curators, was inaugurated at the Colegio de Arquitectos.

Who is your icon of style and good taste?
The French actress Catherine Deneuve.

What are your plans for the future?
We want to open a shop in Madrid and another in Barcelona.

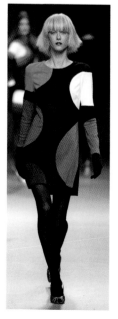
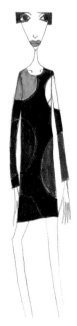

professional CAREER

Ailanto is the name of a fashion firm created by the twin brothers Iñaki and Aitor Muñoz, established in Barcelona in 1992. Born in Bilbao in 1968, the twins moved to the Catalan capital, where they both obtained a degree in Fine Arts at the Universidad de Barcelona; at the same time, Iñaki also studied Fashion Design at IADE. Ailanto's universe is evoked through geometric patchworks and the combination of carefully selected colors reminiscent of the most characteristic aspects of Russian constructivism. In 1995, Ailanto participated in the Gaudí salons in Barcelona and the Semana Internacional de la Moda in Madrid, distributing their collections at the main points of sale in Spain. In 1999, they participated in the Prêt-à-Porter salon in Paris (Atmosphères) and in the creators' week at Workshop Paris and Tranoï. The main international markets for Ailanto are Japan, the United Kingdom, Hong Kong, the United States, Belgium and Italy. Since 2002, Ailanto collections have been presented at Pasarela Cibeles in Madrid. In June 2004, Ailanto became part of the Asociación de Creadores de Moda de España, under the presidency of Modesto Lomba. In November of that same year, it won the prize for Best Designer, given by *Glamour* magazine, as well as the Llongueras prize for Fashion and Image under the category of Best Designer; the jury for this award is made up of the directors of the major fashion magazines. Alianto has also taken part in various exhibitions.

Iñaki Muñoz,
Aitor Muñoz

C/ Diputació 248, 3º 2ª
08007 Barcelona, Spain
T: +34 93 487 06 96
F: +34 93 317 53 00
ailanto@ailanto.com
www.ailanto.com

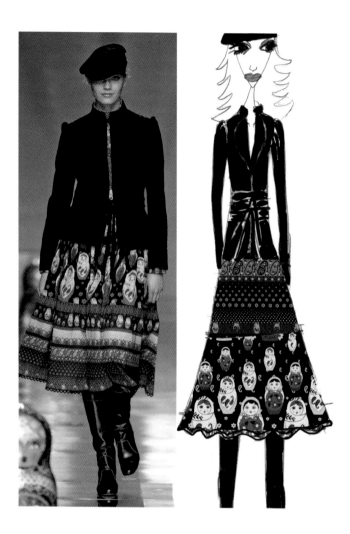

Sketch that accompanies
the proposal for the 2006-
07 fall-winter collection,
presented at Pasarela
Cibeles in Madrid.

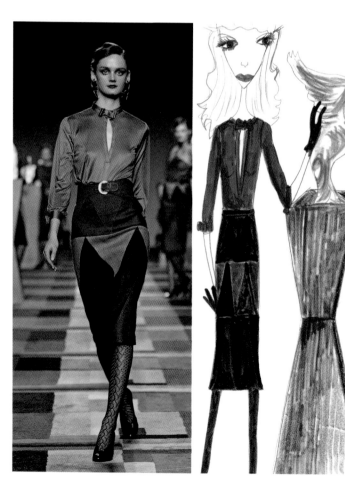

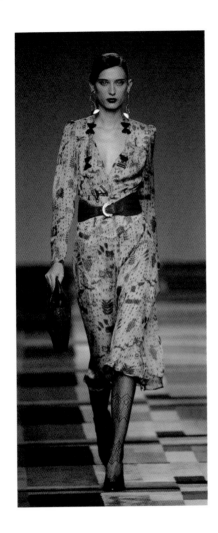

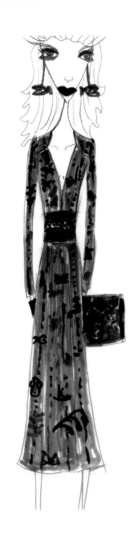

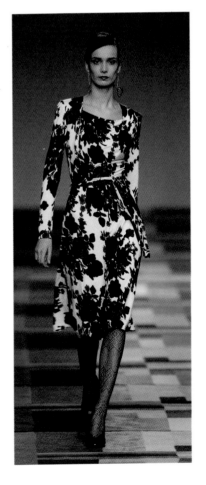

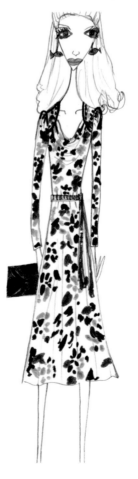

Peggy Guggenheim was the muse for the Muñoz brothers, for their entire collection.

"I'm focused on the architecture of a garment."

INTERVIEW

How would you define your style?
I would like to give to my collections a sophisticated allure, with a balance between strict understatement and a little bit of glamour.

Which is the most difficult piece to design?
Dresses in general, because I always start from haute couture constructions and try to make them lighter, wearable and contemporary.

Who or what is your main source of inspiration?
The couture pieces themselves; I'm focused on the architecture of a garment. And always cinema as well, in particular the American movies from the 60s and 70s. They are a constant in my collections.

What area of your work do you enjoy the most?
I love working with fabrics and studying the patterns of my garments; I also love to create the atmosphere for the fashion shows as a film maker. There are many important elements like music that also help to give the look you really want.

Who is your icon of style and good taste?
Actresses and models like Julie Christie, Jane Birkin, Donna Jordan and Twiggy.

What are your plans for the future?
I'd love to start a menswear collection. From the beginning of history, fashion has been a women's affair but fortunately times have changed and currently, men are also interested in fashion and dressing well. That is why I would like to focus my efforts on developing a new men's collection. Anyway, I still do not know when I will do it exactly.

professional CAREER

Of Roman origin, with a Neapolitan father and Franco-Italian mother, Albino D'Amato studied architecture in Rome and industrial design for a year in Turin, where he worked for the car company Fiat.

At the age of 20, he moved to Paris, where he started studying fashion at the well-known École de la Chambre Syndicale de la Couture. His professional trajectory started as a designer at Emanuel Ungaro, and continued by collaborating with Guy Laroche, Lolita Lempicka and Emilio Pucci. Later, he returned to Milan and became part of the creative team of Dolce & Gabbana until he received an offer from Giorgio Armani, a firm he abandoned soon after to create his own personal collection.

After a certain time of business readjustment, and thanks to the help and the cooperation of his current partner, interior designer Gianfranco Fenizia, he finally presented his collection during the Milan Fashion Week in 2004, receiving unanimous support from fashion critics.

His clothes can be purchased at various recognized international points of sale, such as Penelope in Brescia, Biffi in Milan, Maria Luisa in Paris, Shine and Harvey Nichols in Hong Kong, Princess in Antwerp, Midwest in Tokyo, Lide in Moscow or Belinda in Sydney.

Albino D'Amato

Via Federico Confalonieri 36
20124 Milan, Italy
T. +39 02 688 74 00
viviana.coppola@studionext.it
www.studionext.it

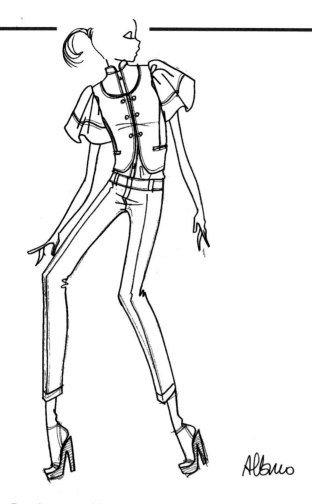

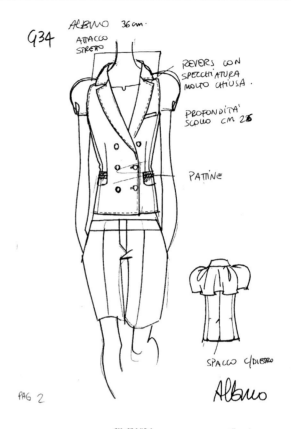

Two-piece ensembles
with fitted or bermuda
pants. Tailor-cut jackets
tightly fit to the waist
with short sleeves. Day
dress, sleeveless, with
box neckline and bell
skirt.

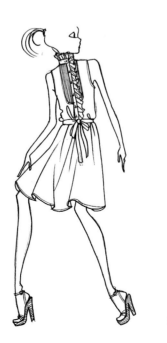

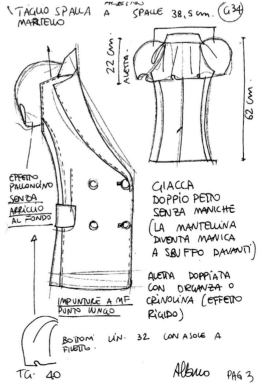

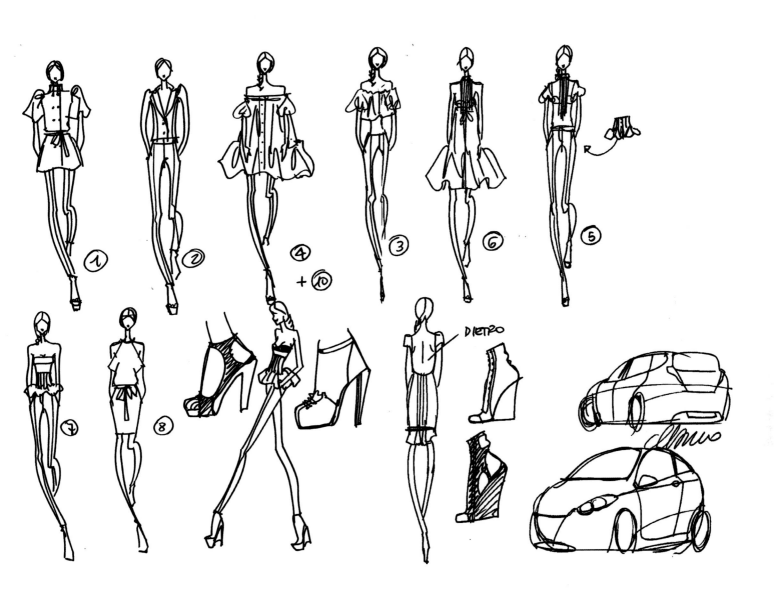

Different sketches of the
items selected for the
last Albino fashion show
in Milan.

Madrid, Spain, 1976

"You should never be 100% conscious of your sources of inspiration, or they could stop being so."

INTERVIEW

How would you define your style?
It is hard to define in words: romantic and feminine, reinterpreting the old from the perspective of the "non-commercial". I try to make timeless pieces.

Which is the most difficult piece to design?
Transparencies and the superposition of several pieces...

Who or what is your main source of inspiration?
Everything in general and nothing in particular: from there, it could be people on the street, a film from the 40s, Madame Butterfly and/or a Picasso exhibit... I think you are never, and should never be, 100% conscious of your sources of inspiration, or they could stop being so. I also like to evolve from my own work and mix it all with that previously done.

What area of your work do you enjoy the most?
At first it was the design and creation phase. Nowadays, it is not so clear. The change from paper to fabric, when it is first tried on and becomes three-dimensional, is captivating. I am also more and more fascinated by the workshop and all that is handmade. I think I am very lucky to enjoy the whole process.

Who is your icon of style and good taste?
For his trajectory and work in anything he sets his mind to, Karl Lagerfeld. For her magic, turning anything she wore into something elegant and special, Audrey Hepburn. I could choose many others, but these would be the first... for today.

What are your plans for the future?
All of them! These are some: Allegra, my second collection; Alma Aguilar MINI, for girls of ages 2 and up; accessories, bags for now, in numbered and limited series; brides' prêt-à-porter atelier, because now I only work in tailor-made dresses; and opening a couple of stores outside Spain... But mostly, to continue enjoying my work as I have done so far.

professional CAREER

Alma Aguilar was born in Madrid in 1976, to a family connected with the world of art; her father was a jazz musician and her mother a painter and poet, and they both inspired in her a deep interest in art. She combined her academic education with drawing, and started studying design, illustration and pattern making in 1993 at the Escuela Superior de Técnicas Industriales de la Confección in Madrid.

In March 1995, she won the Primer Concurso de Diseño Alternativo in Madrid and in June that same year she received the second prize in the contest of La Galería del Prado for young European designers. After finishing her studies, she became a professional while working at the workshops of designers like Paco Casado or Devota & Lomba, and for companies like El Corte Inglés, combining this with other things like jewelry design for Ansorena and book illustrations.

In 1998, she started her own firm, and in September her first Prêt-à-Porter 1999 spring-summer collection was born in her small workshop in Madrid. A year later she opened her first shop, which soon after became a showroom and later a wedding dress atelier.

In 2001, she took part in Pasarela Cibeles for the first time and started appearing frequently in fashion pages of the international press like *Collezioni*, Italy; *Wallpaper/Spruce*, London; *Handelsblatt*, Germany; *FashionShows*, New York; *Textil Zeitung*, Austria; and *Senken Shimbun* or *Soup*, Japan.

Only two years later she was chosen by the Plan Global de la Moda Española, together with ICEX (Instituto de Comercio Exterior), to promote Spanish Fashion in London through the Yellow Door agency, thus appearing in *Vogue UK*, "How to Spend It" (*The Financial Times*), *Elle UK* and *Marie Claire UK*.

Currently, Alma Aguilar has showrooms in Spain and New York, and her clothing items can be found in over twenty points of sale in the United States, Australia, Japan, China, Italy, Spain or England, some as prestigious as Harvey Nichols, Tsum, Dover St. Market or Bergdorf & Goodman.

Alma Aguilar

Callejón de Jorge Juan 12
28001 Madrid, Spain
T: +34 91 577 66 98
almaaguilar@almaaguilar.com
www.almaaguilar.com

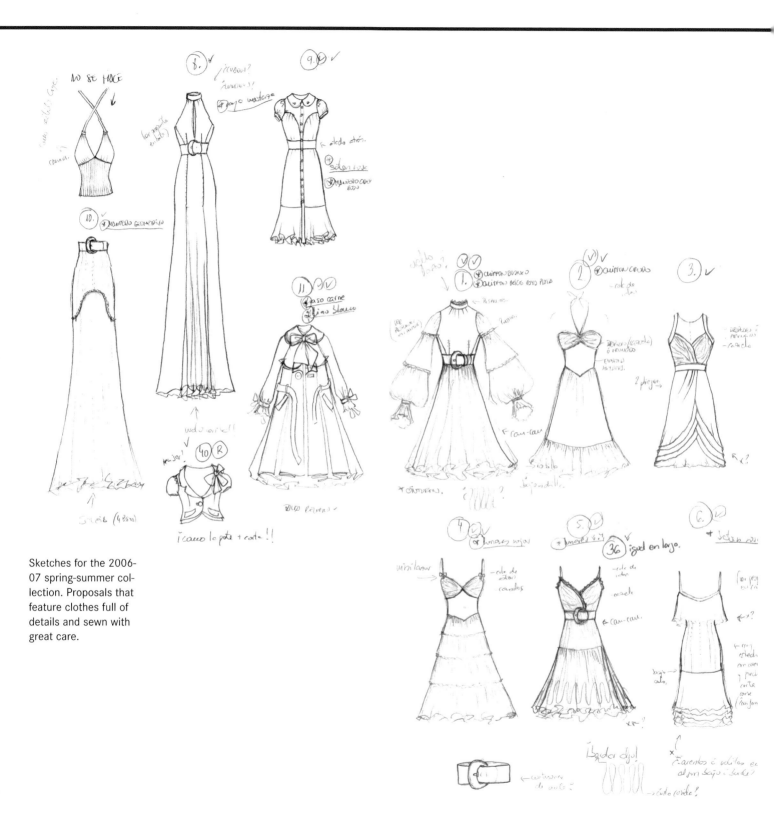

Sketches for the 2006-07 spring-summer collection. Proposals that feature clothes full of details and sewn with great care.

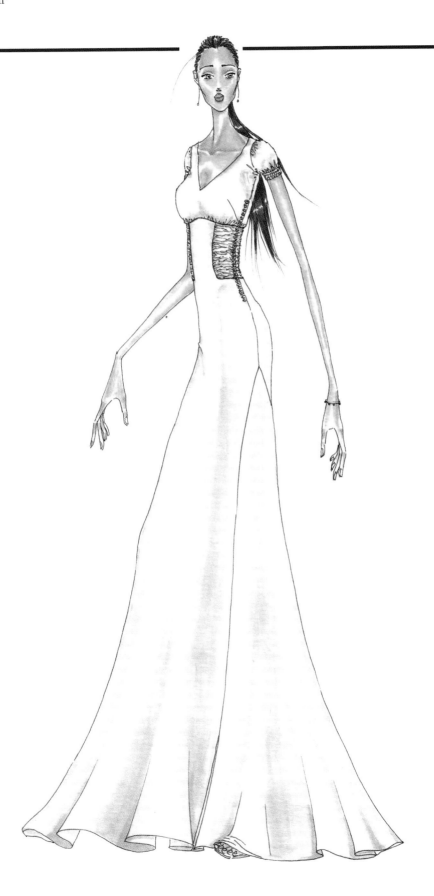

Vaporous dress of a very
feminine style that calls
for the use of delicate
fabrics such as chiffon.

ANNHAGEN 4

Copenhagen, Denmark, 1974

"I design for the twilight hour."

INTERVIEW

How would you define your style?
I have my own particular vision that I would call Metamorphic. This would be a kind of concept that could be defined as a mix of draped underground, exclusive "couture" and high-quality garments and finishing.
We could say it's design for the "twilight hour" – the time between day and night, between a busy daily routine and the temptations of the night. Each part of the day has its own styling demands.

Which is the most difficult piece to design?
Each piece has its own particularity. Though I would say definitely wrapped outerwear and fur coats.

Who or what is your main source of inspiration?
My heritage combined with historical issues that I think are relevant for the world that we live in today.

What area of your work do you enjoy the most?
When I am draping a dress while dancing to incredible and loud music at 3 o'clock in the morning all by myself.

Who is your icon of style and good taste?
Japanese people – so stylish and with no compromises. They are a very advanced society. Modern and with good taste. No celebrity or top model. They represent very well the current way of living. Quick but with style.

What are your plans for the future?
To have more time to be creative in different medias. I hope it is not a dream and that some day it can come true. Time is something more difficult to get every day. We live in a hurry and time is precious!!

professional CAREER

annhagen is a fast-growing Danish designer brand aimed at the international market. Designed by Dianna Opsund Bay, the company started in 2004 and has already exceeded all preliminary expectations with customers all around the world.

Dianna was educated at the renowned fashion school, Magrethe Skolen, in Copenhagen, and at the Central Saint Martin's School of Fashion in London. She has worked at SAND in Copenhagen, and Roland Mouret and Vivienne Westwood in London. She lives and finds inspiration in Copenhagen and in her husband, the famous art director, Kenneth Opsund Bay.

Whilst still a relatively young fashion label, the company has already gained a loyal following around the world. annhagen currently have two showrooms, one in Copenhagen and a second in Tokyo, with distribution in Austria, Germany, Sweden, Switzerland and the UK.

annhagen's collections are built around experimental designs and dark nuances. The individual designs consist of a detailed look, with finely cut, sharp silhouettes. The style is an avant-garde design for everyday use.

A combination of the exclusive and the dark sensual underground gives people a better opportunity to dress experimentally and creatively, and that way create a look as daring and raw as they feel. annhagen provides customers with these interesting and daring designs. It is not dictated by the industry's conventional idea of who and what fashion is.

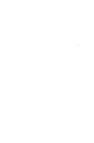

Dianna Opsund Bay

Nørre Søgade 9a 1th
1370 Copenhagen k, Denmark
T: +45 3332 3023
info@annhagen.com
www.annhagen.com

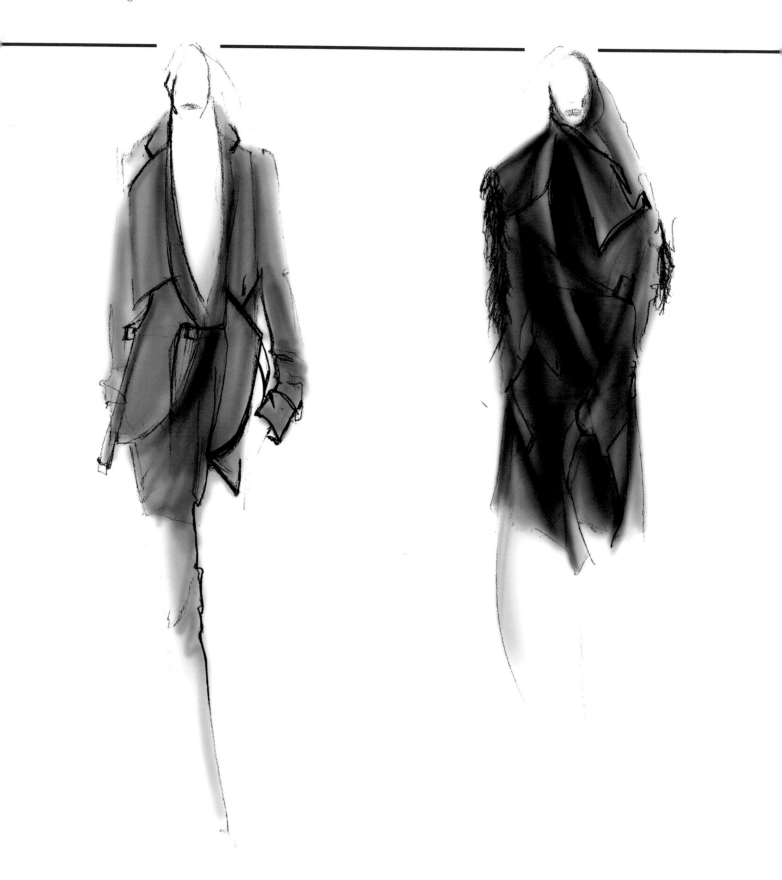

Sketches for the 2006-
07 fall-winter collection.
Coats and two-piece
ensembles cut in straight
lines and silhouettes that
give shape to the body.
Vanguard style.

BAMBIBYLAURA 5

Barcelona, Spain, 1980

"My source of inspiration comes from what is not perfect and looking for perfection."

INTERVIEW

How would you define your style?
My collections are very feminine and at the same time have a futuristic air, and I think this is where the essence lies. Bambi is sophisticated, yet always young; optimistic with a dark point.

Which is the most difficult piece to design?
One with many seams, pleats, creases, pieces, and so on.

Who or what is your main source of inspiration?
My source of inspiration comes from what is not perfect and looking for perfection. I watch people, cities, specific places, photographs, vintage clothes and whatever filters into my head, I express it in my collections.

What area of your work do you enjoy the most?
I love designing although it is a small part of the whole process. But what I like the most is the moment when I finish a collection, do the fashion show and wake up the next morning thinking of the shapes and colors that the next one will have.
The good part about my job is that you meet many people, many designers who are just like you, struggling to find their place in the fashion world, and others who have already found their position and who can tell you a bit about how it works. Then again, you also get to know the other elements that move it and that are part of the circle, like agents or showrooms, buyers, people who work for the press... A bunch of people are part of that circle and somehow they are all indispensable and need each other.

Who is your icon of style and good taste?
There is no one who is not wrong sometimes.

What are your plans for the future?
To continue working and growing. I hope to sell more in Europe and Japan.

professional CAREER

Bambi by Laura is the brand by the 26 year-old designer Laura Figueras, born in Barcelona.

Laura started designing for Preen in London, right after graduating from ESDI school in her hometown. Her first professional experience was for Women'Secret, before creating and consolidating her own brand.

Since she started Bambi, at the age of 23, Laura has presented six collections at different catwalks such as Circuit Barcelona, Circuit Lisbon and the last at Pasarela Barcelona. She soon awoke interest both in national and international press with articles and editorials for magazines of known prestige such as *i-D*, *Nylon*, *Purple*, *Spoon*, *Vogue*, and *Elle* among others; she was also chosen for international projects like Absolut Label 2006 or the Motorola Fashion calendar. She also designs exclusive collections for Red Bull.

Bambi by Laura is sold at many points, such as Olga in Le Marais, Paris; Pineal Eye in London; Dernier Cri at the Meat Pack district, New York; and Faline in Tokyo, among others.

Laura Figueras

C/ Joan Miró 33
08970 Sant Joan Despí
(Barcelona), Spain
T: +34 93 373 49 35
bambibylaura@hotmail.com
www.bambibylaura.com

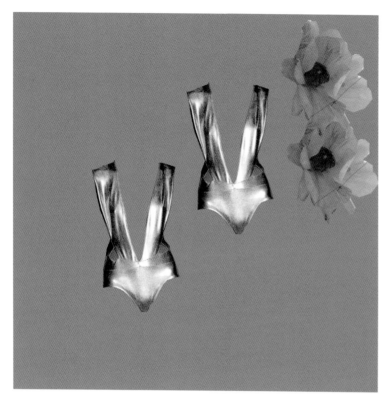

Sketches for the
collection presented at
Pasarela Gaudí in
Barcelona for spring-
summer 2007.

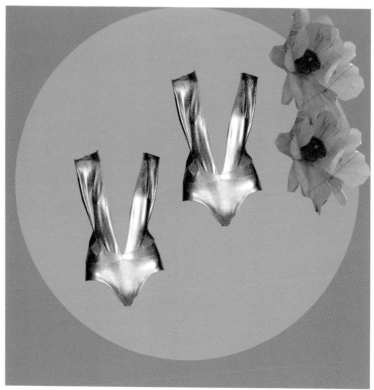

Models of a firm that trusts white and gold to be the basic colors of its entire collection.

"We are storytellers."

Ciudad Santos, Brazil, 1978;
Notts, United Kingdom, 1974

INTERVIEW

How would you define your style?
We are storytellers, crossing over between fashion and graphic design. Our style is instantly recognizable - which is always a bonus in such a competitive world.
Our work involves the macro and the micro, we invite you to look and then to look closer. They are print-based which gives us the scope to play a lot with colour and imagery; this would not be possible without the use of digital print, another important element in our work, as it is a new and exciting way of working.

Which is the most difficult piece to design?
Anything boring or monotonous.

Who or what is your main source of inspiration?
Understanding what people recognize as beautiful (or the non-beautiful), and observing and discussing about society and its vanities, anxieties, fears, seduction and desires. We are both from different media and we have our own values/ideas; we also have our own studies and knowledge in our chosen media, we can often become too involved in our own work, so we push each other a lot.

What area of your work do you enjoy the most?
The process itself, the challenge of creating something new. Seeing the garments from the initial idea to how we present them on the runway; it's interesting how things evolve, get new meanings and transform a lot along the way.

Who is your icon of style and good taste?
CB: Grace Jones.
BB: Liberace?

What are your plans for the future?
To develop our label in all areas. We are currently developing the interiors line on a bespoke basis - offering the customer unique pieces especially for them. We are doing wallpaper, ceramic tiles, rugs, lamps and furniture, as well as other printed things...

professional CAREER

English illustrator & graphic designer Christopher Brooke and Brazilian fashion designer Bruno Basso joined forces to concoct Basso & Brooke, an explosive cocktail of British style and Carioca exuberance which won them the prestigious London's Fashion Fringe 2004 Award. Their diverse backgrounds may account for their appeal. They won the competition with a collection that was sexually exuberating, using prints that were almost classical and Libertyesque, which, on closer inspection, were an orgiastic carnival of sexual liberation and allegories of power. With a judges panel that included members such as Rosemary Bravo (Burberry's CEO), Alexandra Shulman (Editor in Chief, *Vogue UK*) and Hamish Bowles from *Vogue America*, this award was instituted and directed by Colin McDowell for the first time to discover and launch particularly promising up-and-coming designers.

Basso & Brooke have since entered a production and distribution agreement with the Aeffe Group, that also represents the Alberta Ferretti, Moschino, Narciso Rodriguez, Jean Paul Gaultier and Pollini brands.

After winning the award in 2004, Basso & Brooke presented their first on-schedule show at London Fashion Week entitled "The Succubus and Other Tales". If the Fashion Fringe collection represented sexual freedom, AW 05 was its counterpoint. Using mediaeval imagery and regal graphics against soft drapery and streamlined tailoring, Succubus evoked repressed eroticism. The collection also marked Basso & Brooke's debut collaboration with Swarovski. Their showroom is located at Percy Street in London.

Bruno Basso,
Christopher Brooke

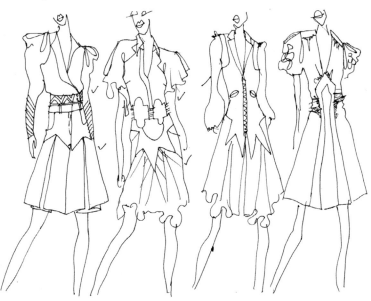

15 Percy Street, 1st Floor
London W1T 1DS
United Kingdom
T: +44 207 436 9449
info@blow.co.uk
www.bassoandbrooke.com

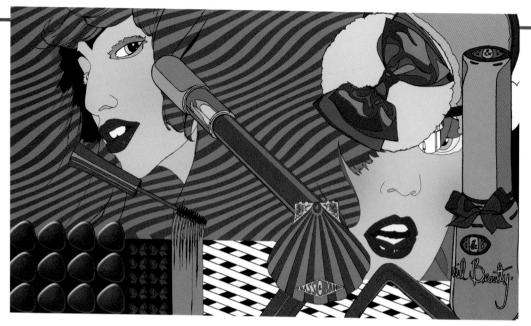

Different samples of prints and human figures from their womenswear collection. Perfect fusion between fashion and graphic design. A nearly theatrical esthetic concept.

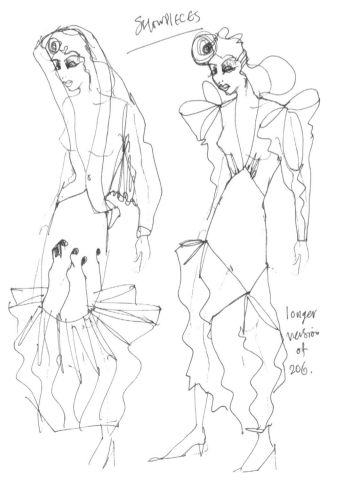

SHOWPIECES

longer version of 206.

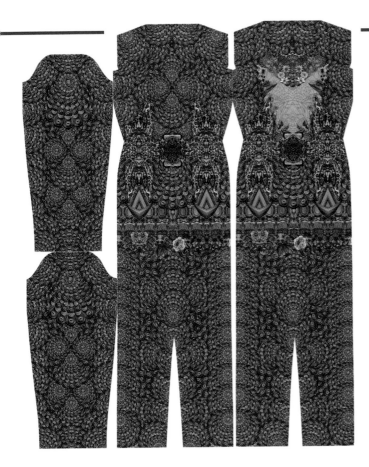

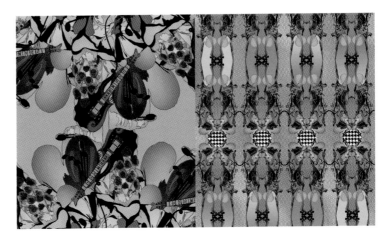

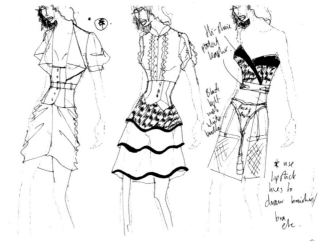

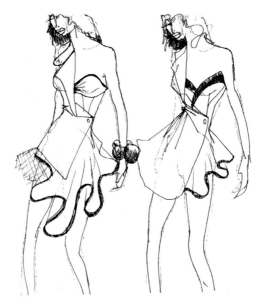

"I design for active women."

Tehran, Iran, 1970

INTERVIEW

How would you define your style?
It is difficult to summarize in one word, but I think it could be named modern feminine. I design for active women whose lives are completely full with work, family, friends and hobbies.

Which is the most difficult piece to design?
The perfect fitting pant. It is more difficult than it looks. A simple piece like this needs more attention than others.

Who or what is your main source of inspiration?
Textiles and crafts from other countries and cultures.

What area of your work do you enjoy the most?
Working with different and original fabrics.

Who is your icon of style and good taste?
Audrey Hepburn. She is my favorite.

What are your plans for the future?
To design more products for women, in the area of accessories and beauty.

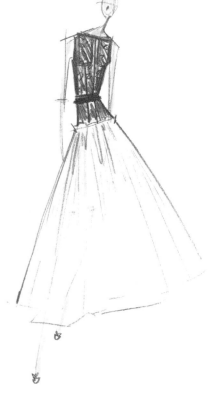

professional CAREER

Behnaz Sarafpour began her career as a designer at Parsons School of Design. After her graduation, she was awarded the prestigious Golden Thimble Award. While attending Parsons, Sarafpour worked at Anne Klein & Co., where she was given the opportunity to intern for Senior Designer Narciso Rodriguez and work as an assistant designer to Richard Tyler. In 1994, Sarafpour was named Senior Designer at Isaac Mizrahi & Co. In 1998, she was appointed Designer of the Barneys New York Collection. In February 2002, she produced her first runway show, sponsored by Style.com. The following season, Sarafpour was sponsored by Moët & Chandon and was chosen to be the first solo designer to re-launch the Moët & Chandon Presents series. In 2004, Tiffany & Co. sponsored her 2005 spring show. Sarafpour's close relationship with the CFDA began in 2002 when she was nominated for the Swarovski's Perry Ellis award for ready-to-wear. Nominations followed in 2003 and 2005. In 2004, she was selected as a finalist of the first VOGUE/CFDA Fashion Fund. The Behnaz Sarafpour collection can be found at such luxury retailers as Barneys New York, Neiman Marcus, Saks Fifth Avenue, Jeffrey, Stanley Korshak, Nordstrom and Fred Segal Flair. The collection is also sold internationally in France, Germany, Greece, Hong Kong, Japan, Taiwan, and Russia.

Behnaz Sarafpour

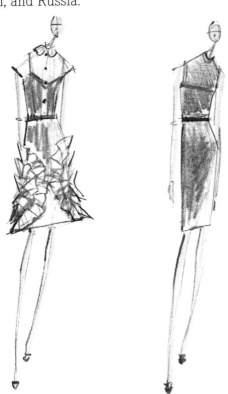

136 W 21st Street, 6th floor
New York, NY 10011
United States
T: +1 212 242 2343
fiona@behnazsarafpour.com
www.behnazsarafpour.com

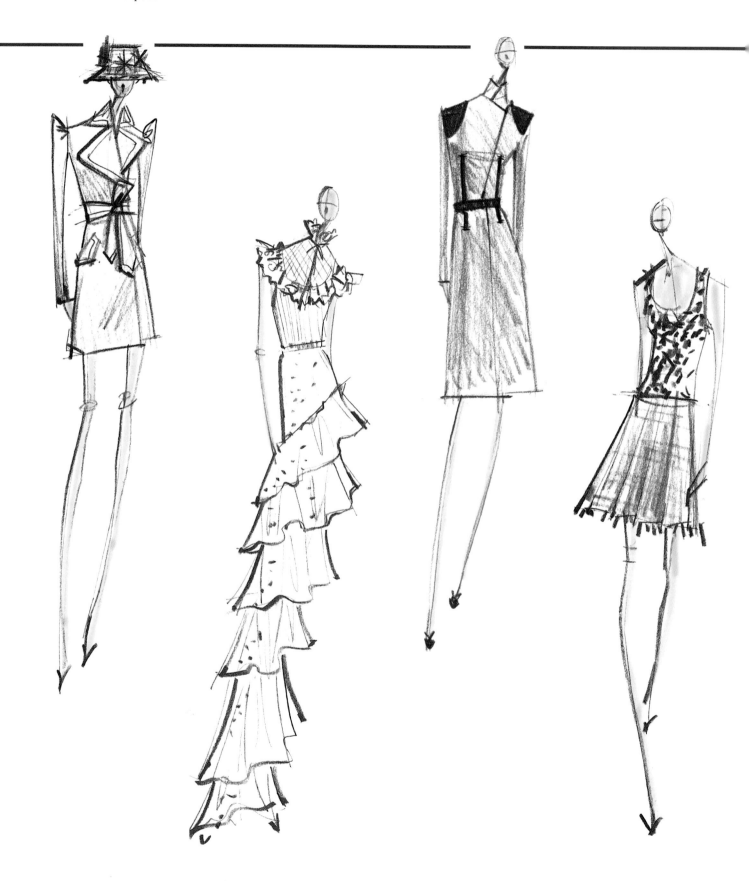

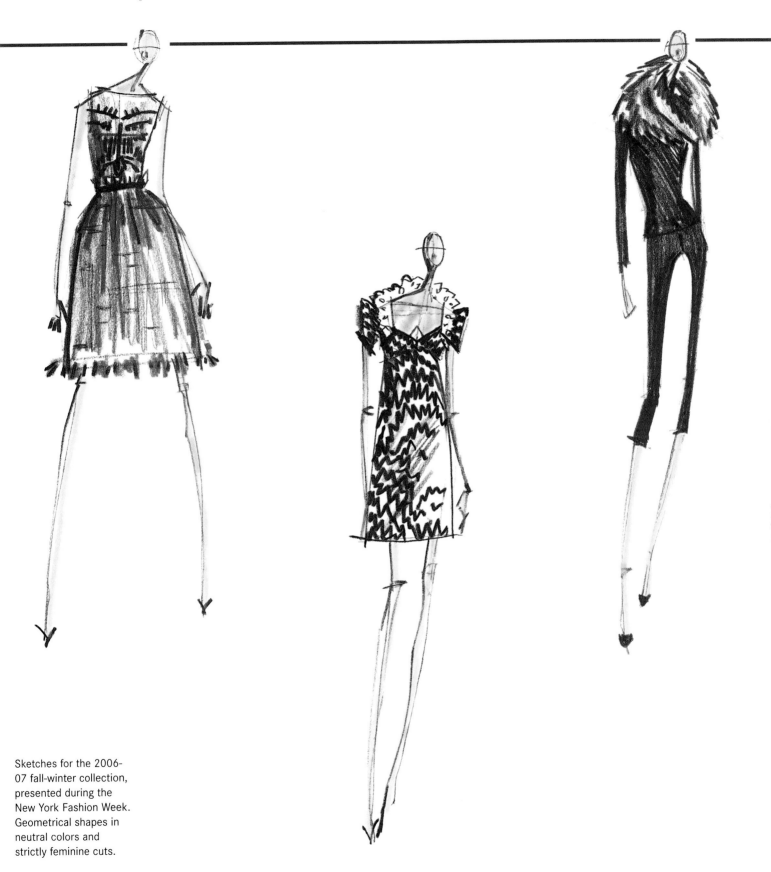

Sketches for the 2006-
07 fall-winter collection,
presented during the
New York Fashion Week.
Geometrical shapes in
neutral colors and
strictly feminine cuts.

"Chaos inspires me."

INTERVIEW

How would you define your style?
Everything we love: birds flying towards us and then flying away again. The moments between moments when you're happy. Cafés with two guests and a dog. Streets made of golden sunlight. Meat and dumplings at home. The high of sex. A lot of money when we earn it, not later when we spend it. Art at the moment it's created. Something too expensive that we can afford. A certain smile. Elephant showers. Death, as long as we are not dying. And you, because you read this to the bitter end.

Which is the most difficult piece to design?
Most things are difficult to make.

Who or what is your main source of inspiration?
Nature; in general: chaos.

What area of your work do you enjoy the most?
To discover people wearing our creations.

Who is your icon of style and good taste?
My business partner, Mme. Jutta Kraus.

What are your plans for the future?
None, do you have any?

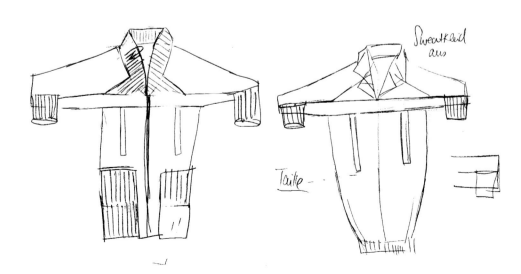

professional CAREER

Bernhard Willhelm was born in Ulm, in the south of Germany, in November 1972. During his studies he assisted Walter van Beirendonck, Alexander McQueen, Vivienne Westwood and Dirk Bikkembergs. He received his diploma in fashion design with honors in July 1998 at the Royal Academy of Fine Arts in Antwerp.

Bernhard Willhelm founded a company, together with Jutta Kraus, to launch his first women's collection in a show at the Paris Fashion Week, in March 1999; after an immediate success he presented his women's collection regularly in Paris.

His first menswear outfits date from October 2000, leading to a complete men's line which was shown at the Men's Fashion Week in Paris. After such success, he received the Moët & Chandon Fashion Award in September 2001.

After that, Willhelm moved his creative atelier from Antwerp to Paris and started as art director for the house of Roberto Capucci with the creation of a first ready-to-wear collection under the name Capucci. At that time, he published his first creative book called *Bernhard Willhelm 1999-2004*, published by Lukas & Sternberg on the occasion of the exhibition at the Ursula Blickle Art Foundation.

In February 2005, Six Showroom showed his first shoe collection produced by a Portuguese manufacturer and he was also awarded the first prize and accessory prize by the ANDAM. Last year, Willhelm opened his first boutique in Shibuya, Tokyo.

Bernhard Willhelm

69 rue de Charonne
75011 Paris, France
T: +33 1 47 00 08 68
bernhard.willhelm@wanadoo.fr

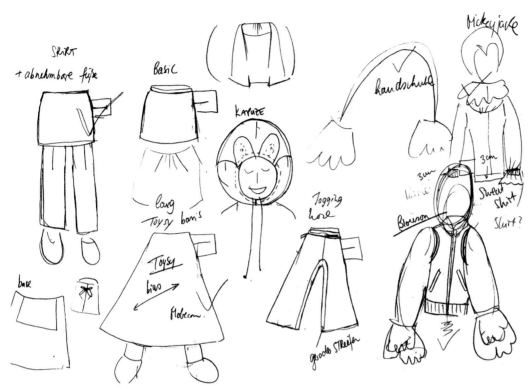

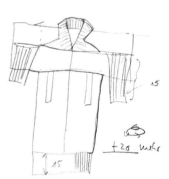

Different sketches of clothes forming Willhelm's collection. Pants, waist-length jackets, hats, shirts and T-shirts. All of them in easy-going style.

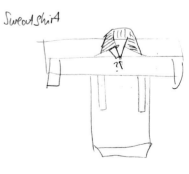

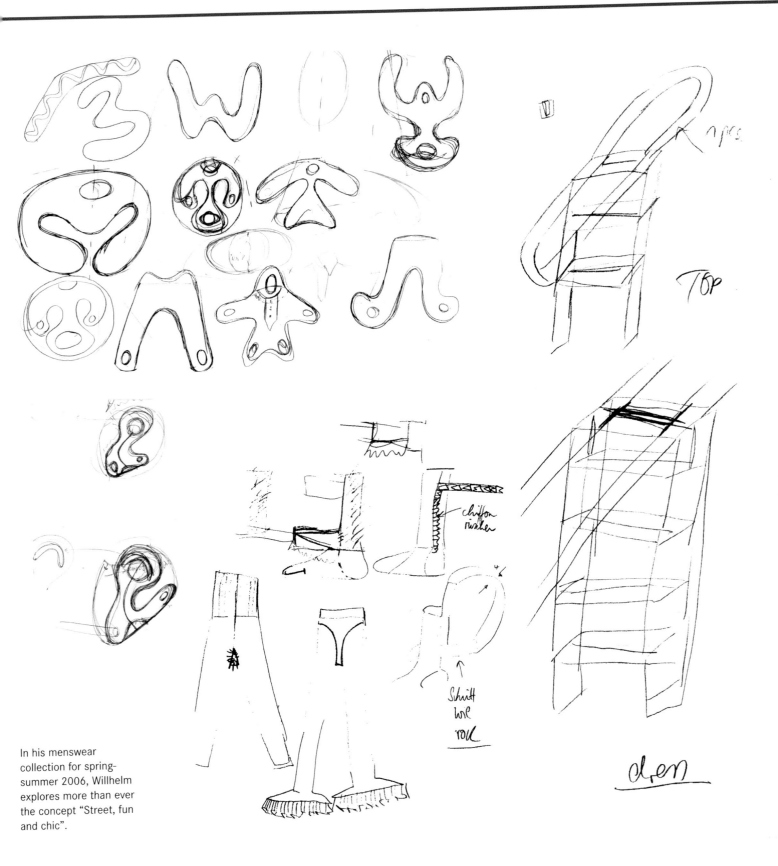

In his menswear collection for spring-summer 2006, Willhelm explores more than ever the concept "Street, fun and chic".

BLESS 9

Fürth, Germany, 1970;
Freiburg, Switzerland, 1971

"Icon of style and good taste: any happy person."

INTERVIEW

How would you define your style?
Style free. With no label. Our products must follow certain principles, though they have to be new for us, they have to cover a need we both have, they have to continue to make sense in one, five or ten years. They need a name. They must be produced.

Which is the most difficult piece to design?
Commercial pieces. At first, we also had problems explaining to people that we do not mix disciplines because we want to confuse them, but because it seems natural to extend interests and combine activities and utilities.

Who or what is your main source of inspiration?
Our own needs.

What area of your work do you enjoy the most?
We love working in our producer's garden, in Italy. We do not like to be visible, to be famous, to have people recognize our faces.

Who is your icon of style and good taste?
Any happy person. Our friends and collaborators inspire us. We feel that we work outside the pressure of the fashion industry, but absolute freedom does not exist. We started regular collections because we have a responsibility towards the people who are implicated in our work and who believe in what we do. It is perfect freedom to work in order to make those friends that are expecting our products happy.

What are your plans for the future?
To grow old.

professional CAREER

BLESS is a project that was born in 1996 and is comprised by Desirée Heiss and Ines Kaag. The purpose of the creators is to make the near future something worth living, through their design proposals. Born at the Paris and Berlin headquarters, the clothing items of this creative pair are always hard to describe, but easy to understand: they want to be useful, esthetic and to make an unexpected twist on what is traditional.

Between fashion, art and design, BLESS collections are organized into numbered products. Their first creation, BLESS Product #0, was a wig made of recycled leather that Martin Margiela used for his emblematic collection "Demi Couture". Right away, the Boijmans Van Beuningen Museum in Rotterdam acquired a piece. That same museum celebrated BLESS's tenth anniversary with an exhibition in 2006.

Some of the most representative pieces of Heiss and Kaag are their collection of wool and knitting called "Uncool"; the sheets with an image of a couple sleeping; hanging furniture from "Perpetual Home Motion Machines"; the "Materialmix" which are bracelets and necklaces made from a sum of non-jewels of different textures; cable jewelry; wallscapes which are part wallpaper, part photograph-landscape, or the collection of glasses that serve to comb the hair. All these are objects with a poetic and simple air, that question the established.

Desirée Heiss,
Ines Kaag

14 rue Portefoin
75003 Paris, France
T: +33 1 48 01 67 43
blessparis@wanadoo.fr
www.bless-service.de

Between fashion, art and design, BLESS's collections are organized in numbered products.

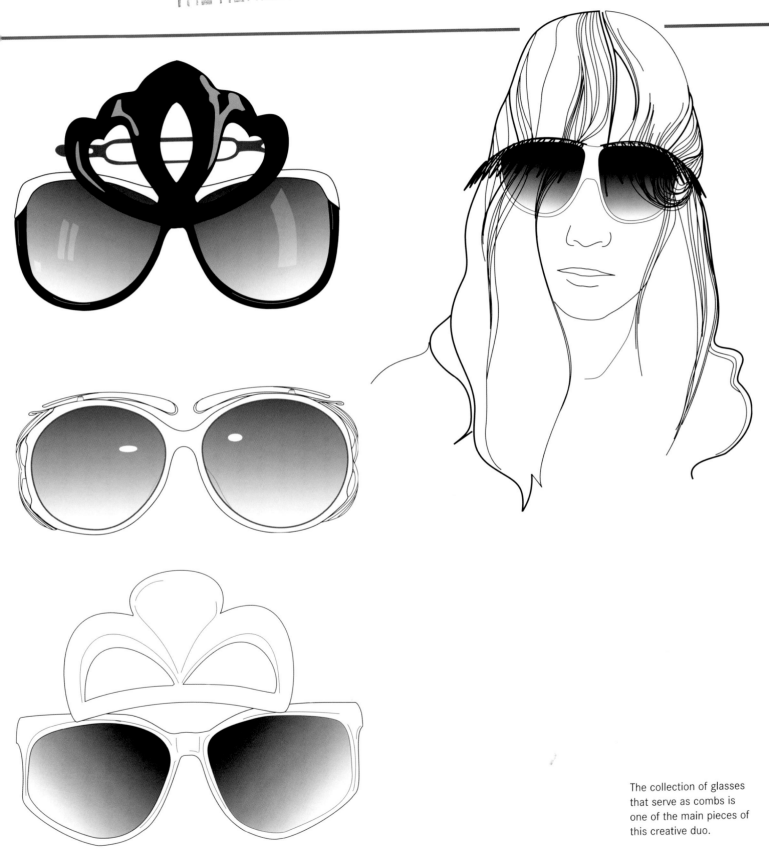

The collection of glasses
that serve as combs is
one of the main pieces of
this creative duo.

Izmir, Turkey, 1969

"I believe in keeping the amateur spirit."

INTERVIEW

How would you define your style?

To me creativity is a very sensitive and personal way of expressing yourself. It's almost your unique language to communicate with the world without using actual words.

My design language is based on seeking the right balancing point between different weights of fabrics. Through cutting, knitting, hand stitching, wood carving or leather ornaments, finding the balance of the garment and making it work is the key challenge.

Which is the most difficult piece to design?

Classic jackets. But then it challenges me and I always make jackets as part of the collection each season. As life challenges us constantly, my design process needs to be challenged as well.

Who or what is your main source of inspiration?

It's mainly my friends who surround me. I love the way they add their personalities to a garment and make it alive. To start a collection I always start out with something very personal like childhood reminiscences. I always mix completely unrelated things to create a collection. I believe in contrasts as well, because in real life you always have contrasts. It's very rare in life that everything goes well together.

What area of your work do you enjoy the most?

Researching and experimenting has to be my favorite. In the creative process, too much planning does not bring freedom. Therefore you always need to leave space to be free.

Who is your icon of style and good taste?

Madeleine Vionnet was a woman of great taste. Her dresses remain timeless.

What are your plans for the future?

When you are a student, you work in such a spirit that nothing really discourages you regarding creativity. I always believe in keeping the amateur spirit within my work. I guess that's my aim: to be able to carry on my work keeping the spirit of amateurism.

professional CAREER

Turkish-born, London-based designer Bora Aksu completed a BA Honours Degree and an MA degree in fashion design at Central Saint Martins College of Art and Design, where he graduated in 2002 with distinction. The MA Fashion show marked a major turning point for Aksu, as his stand out collection received a huge response from the press. Pieces from his collection were bought by Dolce & Gabbana and his collection also provided him a sponsorship award to start his own label. Aksu's debut off schedule autumn-winter show 2003 took place during the London Fashion Week in February of that year. CNN introduced Aksu as the rising new name, and *The Guardian* quoted his show as "One of the top five shows in London".

After his first off schedule show, Bora was immediately awarded by the British Fashion Council as the New Generation Designer.

Since his first appearance, Aksu has been awarded with the Top Shop New Generation sponsorship four times. His collections can be followed in the London Fashion Week, where he is always one of the most visited.

Bora Aksu

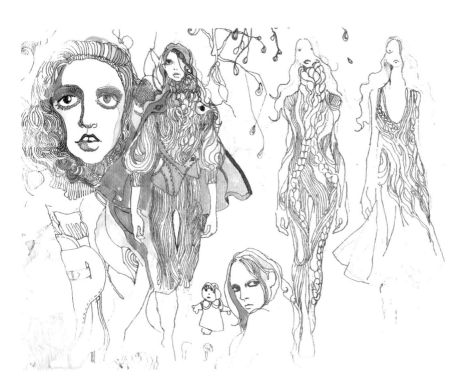

130 Milligan Street
West Ferry, London E14 8A5
United Kingdom
T: +44 20 7515 0535
studio@boraaksu.com
www.boraaksu.com

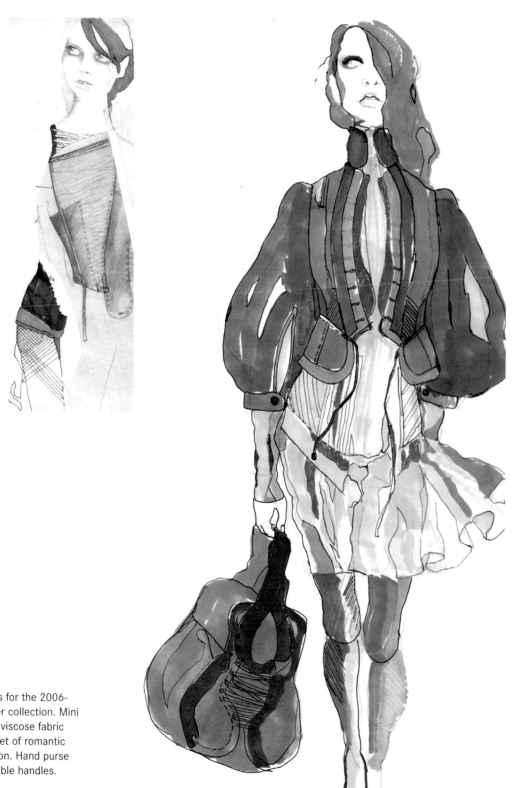

Sketches for the 2006-
07 winter collection. Mini
dress in viscose fabric
and jacket of romantic
inspiration. Hand purse
with double handles.

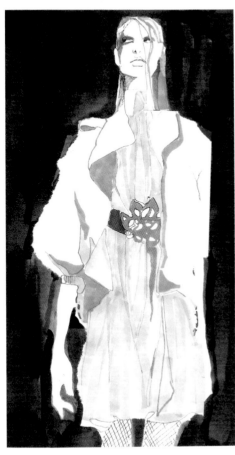

Sketches for the 2006-07 winter collection presented at the London Fashion Week.

Grenoble, France, 1963

"I love to experiment."

INTERVIEW

How would you define your style?
Using the tradition of dressmaking and handcrafted details to create an ultrafeminine silhouette with an urban edge.

Which is the most difficult piece to design?
Every piece is a challenge because I love to experiment!

Who or what is your main source of inspiration?
Contrasts: From Peter Fonda's attitude in *Easy Rider* to *Death in Venice*, an embroidered handkerchief, a wood carving sculpture, Maria Callas, Tina Turner, a piece of metal, the powder color of makeup...
Inspiration is found everywhere and in everything. It's Paris and New York!

What area of your work do you enjoy the most?
The fitting is the first moment when my sketches become a reality and I also like "giving birth" to my designs by draping, cutting, shearing. Without all this, the sketch is just an abstract idea.

Who is your icon of style and good taste?
It's not about good taste or bad taste. It's about individuality and risks. Independent free spirited women like Colette and Peggy Guggenheim.

What are your plans for the future?
Redefining the home through a maison hotel that would propose a different approach to life for the women that I am dressing.

oversized "cheminée" collar

cotton satin quilted coat

hand stitch embroidery

fitted silhouette

professional CAREER

Born in Grenoble, France, Malandrino began her career in Paris after graduating from Esmod. She worked in the houses of Dorothée Bis and Emanuel Ungaro.

She made her entrance in America doing the relaunch of the Diane Von Furstenberg collection in New York. "I want to bring poetry and softness to the urban woman, to help them live happier in a better world." Catherine Malandrino's creations blur the line between dreams and waking life, enhancing a woman's femininity while cultivating an edge. This contrast is what Malandrino calls "soft elegance", and it is at the core of everything she creates. It also explains her metaphoric rise to success.

Since starting her own label, Malandrino has woven together the two souls of her being: the energy of Manhattan and the romance of Paris. Currently Catherine Malandrino designs two lines: the designer Malandrino Collection and the contemporary Catherine Malandrino Collection. In spring 2006, she launched a collection of shoes and hand bags under her Malandrino label, her first full line of accessories. Catherine's latest project was a collaboration with Repetto, a well known French ballet shoe company.

In addition to the opening of the Paris Boutique and the enlargement of the Soho boutique in New York City, four other boutiques have opened in the United States since 2006 with locations in Manhasset, Long Island, California's Melrose Place, New York's Meatpacking District and East Hampton, New York. Today, the Catherine Malandrino collection is available in over 250 points of sale worldwide.

Catherine Malandrino

275 West 39th Street
New York, NY 10018
United States
T: +1 212 840 0106
vchevray@catherinemalandrino.com
www.catherinemalandrino.com

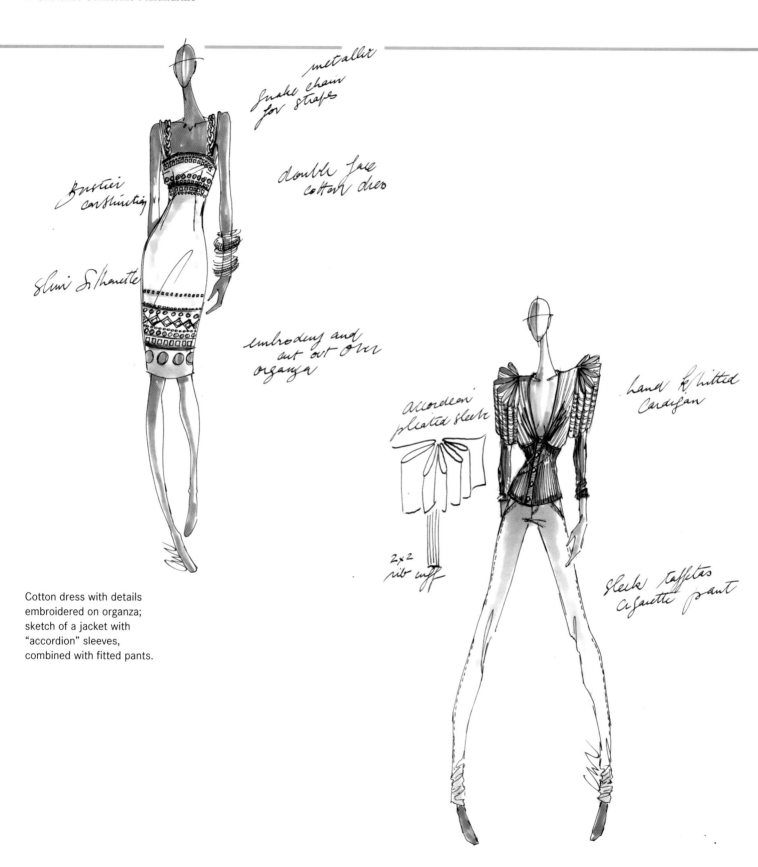

metallic
Snake chain
for straps

double face
cotton dress

bustier
construction

slim silhouette

embrodery and
cut out over
organza

accordeon
pleated sleeve

hand knitted
cardigan

2x2
rib cuff

sleek taffetas
cigarette pant

Cotton dress with details
embroidered on organza;
sketch of a jacket with
"accordion" sleeves,
combined with fitted pants.

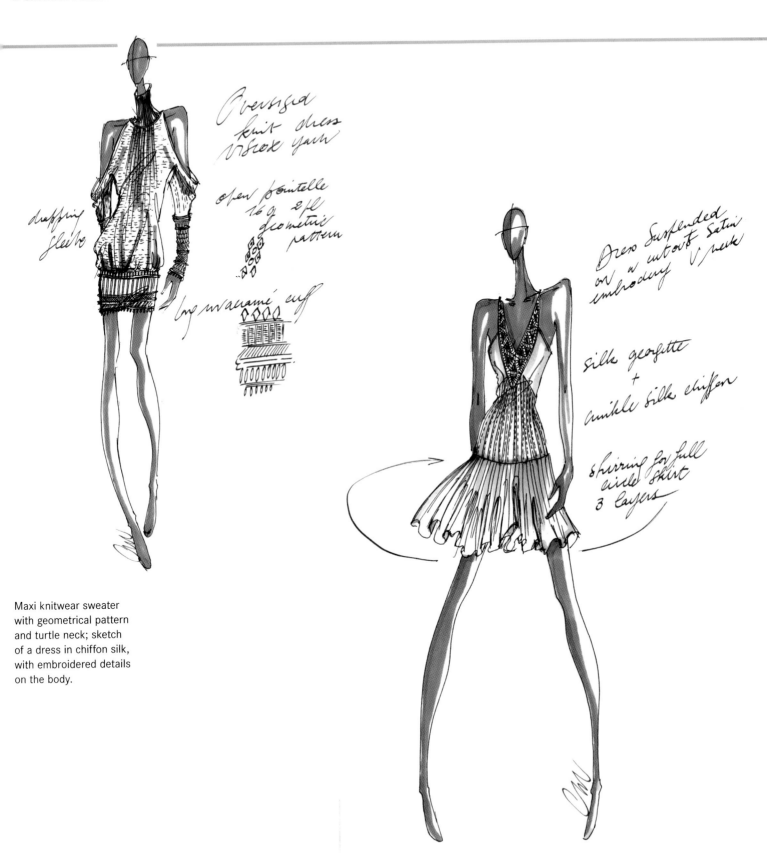

Maxi knitwear sweater
with geometrical pattern
and turtle neck; sketch
of a dress in chiffon silk,
with embroidered details
on the body.

Helsinki, Finland, 1976

"To move my projects towards the art world."

INTERVIEW

How would you define your style?
Clean, sensitive, romantic and pure. Contrasts between feminine and masculine. Scandinavian functionalism and the Barcelona lifestyle. Pequeños Héroes (Small Heroes) is made of old pieces like dresses, pillows, embroideries, which we cut and dye by hand.

Which is the most difficult piece to design?
None in particular; I think that production in general is the most difficult.

Who or what is your main source of inspiration?
My family, my partner, my friends, my dog, all the rooms in which I have lived, my books, dreams, memories. Documentary photography from the beginning of the 20th century like that of August Sander.

What area of your work do you enjoy the most?
The process of designing: researching about the collection's topic, fabrics, colors and designs… Seeing the collection finished for the first time, when the samples arrive. It is very interesting to have your own shop, because you see the customer's reaction.

Who is your icon of style and good taste?
No specific person; imaginary figures. For example, my collection spring–summer 2007 is based on the symbols of dreams and what surrounds them: nightgowns from the 19th century, oversized T-shirts with small buttons, long-legged boxers, always made using natural materials like cotton, silk, viscose…

What are your plans for the future?
To continue developing my collections and selling all over the world. To move my projects towards the art world.

professional CAREER

Born in Helsinki, Cecilia graduated in 2001 from her Fashion Design studies in Barcelona, a career she had started studying in England. She had also studied some pattern design in Helsinki and worked for designer Antonio Miró.

Cecilia attained the prize for Best Young Designer granted by ModaFAD in Barcelona in 2002. From that moment, she started to be part of the group of designers that formed Comité, a very particular space in the Catalan capital, in which they all believe in domesticity, detail, quality and subtlety. The young creator is also co-proprietor of Bingo Shop located in the same city.

One of Sörensen's premises is based on the fact that "unique pieces and collections, produced locally and ethically, are the only way to offer luxury to the purchaser in the near future. These are the type of clients that I want: those that look for the quality of what is special." Cecilia has often shown her collections at fashion shows like Circuit, ModaFAD or Pasarela Gaudí, and she has also appeared at trade shows like Bread & Butter or Rendez-Vous.

She currently offers two different fashion lines: one for women, Cecilia Sörensen and one made of recycled materials, Pequeños Héroes (Small Heroes). Her collections are sold in Spain, Finland, Sweden, France, Italy, Germany and Japan.

Cecilia Sörensen

C/ Roger de Llúria 45
08009 Barcelona, Spain
T. +34 93 467 62 86
contact@ceciliasorensen.com
www.ceciliasorensen.com

53

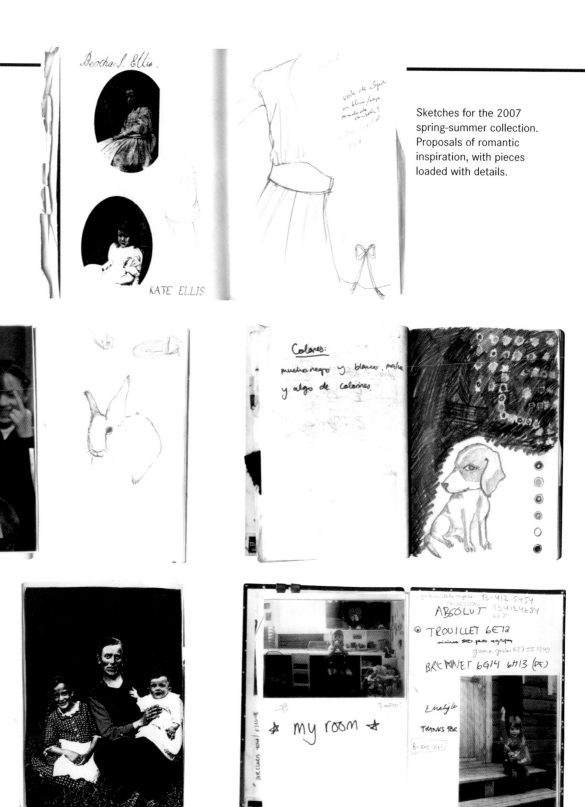

Sketches for the 2007 spring-summer collection. Proposals of romantic inspiration, with pieces loaded with details.

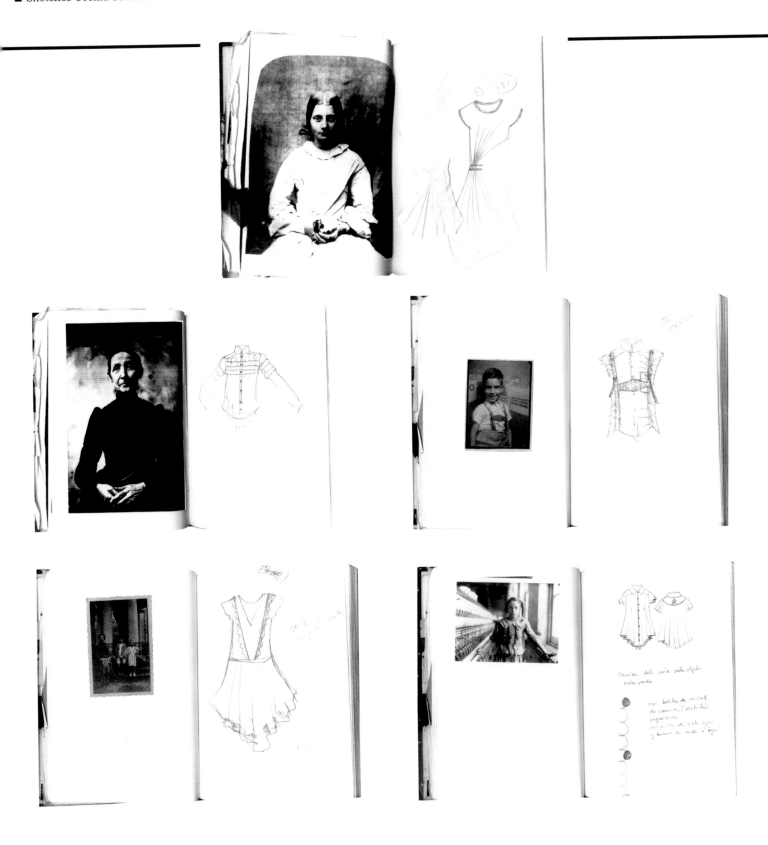

CIRCOJEWELLERY 13

Madrid, Spain, 1976

"Icon of style and good taste: the jewelry by Miriam Haskell, Chanel, Gripoix..."

INTERVIEW

How would you define your style?
Chaotic and a bit naif. In one same piece you can find animal silhouettes made out of metal, stars or colored fruits that seem to have been taken from a fable, with skulls and bones that make it a bit riffraff. A lot of color. I like to be careful with the finish and presentation of the pieces.

Which is the most difficult piece to design?
Pieces with volume or empty pieces are the most difficult to make. I do the prototypes directly in metal, so when I want to make one of these pieces I need a lot of time and effort. To shape metal by exposing the piece to fire and banging it is very laborious.

Who or what is your main source of inspiration?
I am a very good observer and I have a good memory, so I walk around the street checking everything out and then I write it in my notebook. Flea markets and antique shops are fantastic to find interesting things that can be transformed. Of course, I also follow carefully the work of artists, illustrators, fashion designers...

What area of your work do you enjoy the most?
I love collecting photographs, ribbons, colored beads, old necklaces...

Who is your icon of style and good taste?
The esthetics of the 50's: the jewelry by Miriam Haskell, Chanel, Gripoix...

What are your plans for the future?
To expand my collection to handbags and headdresses. To bring out a line for guys in old-looking silver. To find a nice studio with a lot of light. To start selling outside of Spain.

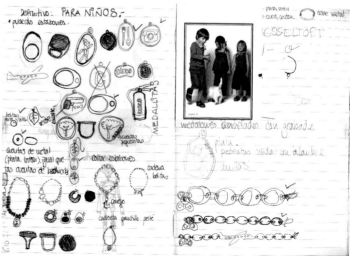

professional CAREER

Almudena Gil was born in Madrid where she studied Interior Design. Even though she did not finish her studies, some of the acquired knowledge became useful for her later on. After dropping out of school she moved to London for a year and discovered her fascination for fashion. "It was always clear to me that I wanted to be present during the process of creation, as I am very much drawn towards artisan production."

After her London experience, she returned to Madrid with many ideas and visual references. She decided to learn traditional jewelry craft, "although my designs are not precisely classical, nor have I ever used typical materials like gold or precious stones. On the contrary, I work with silver and brass; I like the color of brass when it becomes rusty because of use and the passing of time".

While studying jewelry she learned everything related to handling tools and the artisan process of jewelry production. She became a specialist in fabricating things with metal and designed her first twelve piece collection known as Circo Jewellery. "Circo is a name that is easy to remember. A friend came up with it". This was in 2002.

Almudena designs two collections every year, of thirty pieces each. She also works in collaboration with other fashion designers and her creations can be found at different stores around Spain.

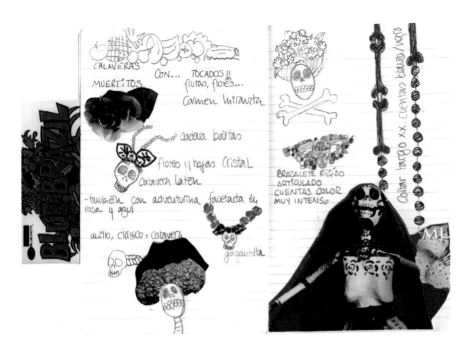

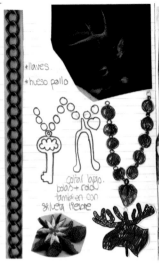

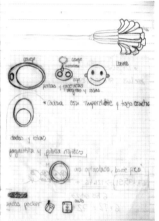

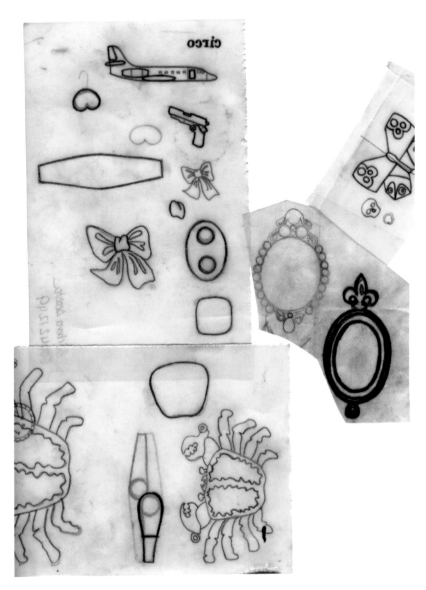

Sketches and notebook
with notes revealing
inspirations for the latest
jewelry collection.

Preview of the 2007-08 fall-winter collection, and notes on the development of collections designed in collaboration with other creators such as La casita de Wendy.

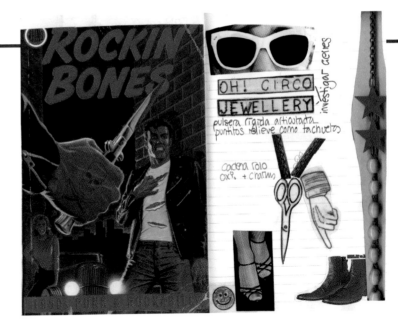

OH! CIRCO JEWELLERY

pulsera rígida articulada
puntitos relieve como tachuelas

investigar aceres

cadena rolo
oxi. + charms

ESQUETOS DINOSAURIOS O ANIMALES.

Perlas grises / logo fuxia

PULSERA Y ANILLO GRUESO HUECO.
AVIONETA CON HELICE

trayectón-collage

invierno 7·8

reverso →

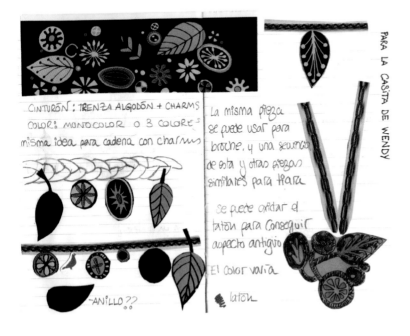

CINTURÓN: TRENZA ALGODÓN + CHARMS
COLOR: MONOCOLOR O 3 COLORES
misma idea para cadena con charms

-ANILLO??

La misma pieza se puede usar para broche, y una secuencia de esta y otras piezas similares para tiara

se puede oxidar el latón para conseguir aspecto antiguo

El color varía

latón

PARA LA CASITA DE WENDY

PARA:

CASITA DE WENDY
* Piezas ropa
4 estampados → estrellas
escamas
geométrico
hojas
1 brocha x estampado
* tocado
* cinturón (cuerda + charms)
* piezas sueltas
- collar.
- pulsera....

PAJARITOS → PRESOPUESTO

* bolita azul brillante
- medallón + cadena.

DESFILE 15 ENERO (ABROX

REINA DE LAS NIEVES
broche estrellas
2 muestras + desfile.

DIADEMAS
* estampado escamas.
tiara para el desfile
escama alta 7 cm

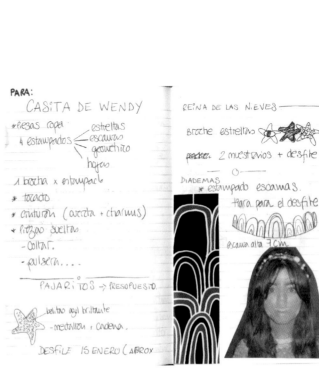

Barcelona, Spain, 1983 and 1984

"We are not too fond of icons."

INTERVIEW

How would you define your style?
Comentrigo is the conjunction of the two personalities of its designers, a constant play between dualities such as male-female, simplicity-complexity... Each one contributes with her peculiar vision of fashion, creating an original whole.

Which is the most difficult piece to design?
There is no specific clothing item. We sketch something very basic, a first instinct, the initial idea, and afterwards it takes definitive shape, the skin mutates, it is transformed and acquires a personality of its own on the cloth.

Who or what is your main source of inspiration?
We are constantly watching what surrounds us. Any stimulus can be a valid inspiration. Inspiration number one comes basically from our surroundings, from the flashes that reach us from near or far.

What area of your work do you enjoy the most?
All areas are enriching.

Who is your icon of style and good taste?
We are not too fond of icons; richness is the shades, the variety, the personality that each person gives to each clothing item. There is not one icon but many and diverse inspirations that change with us and throughout the collections.

What are your plans for the future?
To consolidate Comentrigo in the panorama of new Spanish design, with possibilities of further projection.

professional CAREER

Comentrigo is tailored out of the association of creative spirits Aura Chavarría and Elena Maggi. The combination of the young designers's creative influences offers a rich gamut of contrasts and matches, modern-retro, feminine-masculine, stemming from their two distinct styles and identities. After winning the ModaFAD competition in February 2005, Comentrigo presented their third collection, this time within the frame of Pasarela Barcelona. The first collection, "Storytellers", was their letter of introduction which introduced to the world their fresh, dreamy style and their predilection for embroideries, laces, quilts and all sorts of old-fashioned fabrics. Their work won a prize at ModaFAD, and also a special mention from the jury at the second edition of Modorra, which guaranteed their presence at El Ego of Pasarela Cibeles with thier 2007 autumn-winter collection, "Thunderstorms & Atrocities." In their latest collection, they have the marine world, the jellyfish, the volumes that are transformed under water as main sources of inspiration. From the fluidity of silk gauzes, cottons and leather, to raincoats or multicolor pailleté, everything finds a shape in light colors such as bone or beige, not dismissing immaculate white, coral and blue. Their latest collection came out in spring 2007 and consists of four models of t-shirts that were created in collaboration with Freshfromthelab.

Aura Chavarría,
Elena Maggi

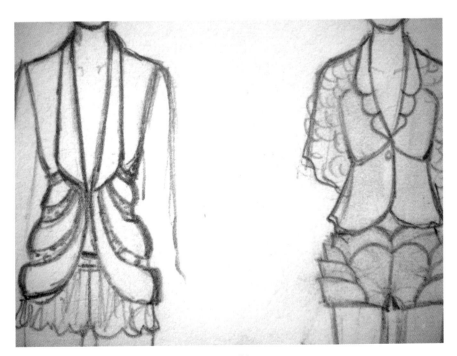

C/ Bertran 120, ático 4ª
08023 Barcelona, Spain
T: +34 659 551 055
 +34 607 421 658
info@comentrigo.com
www.comentrigo.com

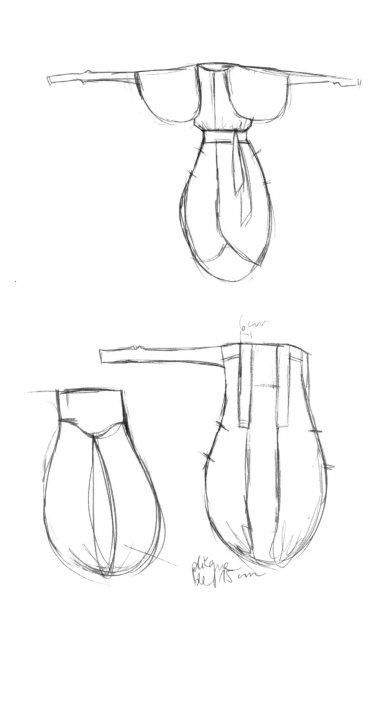

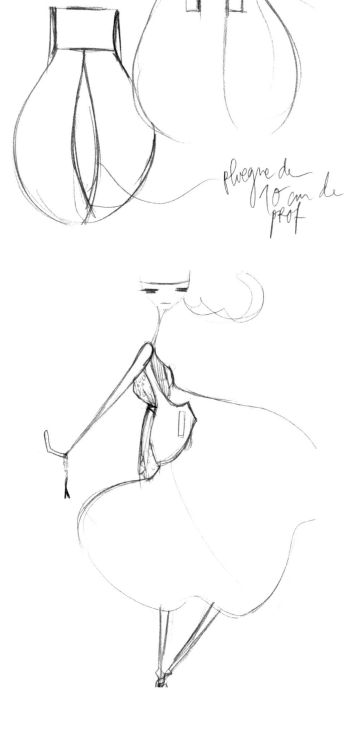

plvegne de
10 cm de
prof

plique
ble 15 cm

Sketches of Flor dress in
gauze with front opening,
small cape and creased
waist, and a belt of the
same fabric.

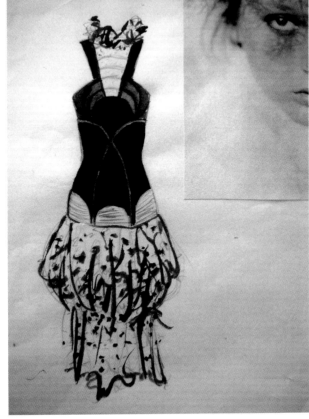

Detailed view of the print on the black velvet cocktail dress. Summer collection dress in balloon cut made of vaporous silk.

Ronda (Malaga), Spain, 1975

"We prefer criteria."

INTERVIEW

How would you define your style?
Classics of the tailor's trade, unfolded and presented in a renovated way.

Which is the most difficult piece to design?
Living is what is difficult!

Who or what is your main source of inspiration?
Ideas and emotions.

What area of your work do you enjoy the most?
The creative process of coming up with ideas and preparing fashion shows in group.

Who is your icon of style and good taste?
We are not interested in taste; we prefer criteria.

What are your plans for the future?
To not stop working.

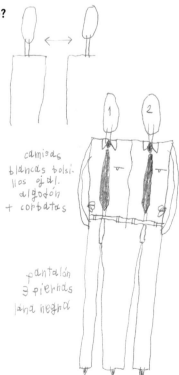

professional CAREER

Davidelfin is a fashion firm, born in Madrid in the year 2000. It made its debut at the Circuit Festival in Barcelona and is already a classic at the Madrid Fashion Week, as well as a regular at Bread & Butter in Barcelona.

Restless, irreverent and eager to renovate the classical pattern of the male suit, Davidelfin has a conception of fashion as a means and way of expression, a platform where different creative disciplines are combined.

The firm is comprised of David, designer; Bimba, model and singer; Diego, musician and producer; Deborah, journalist; and Gorka, architect and photographer. It currently has a place in the fashion sector that works as a referent for new creators, with a recognizable brand identity that has motivated the recent opening of the Davidelfin space on the well-known Madrid street of Jorge Juan.

The wide versatility of the Davidelfin brand, together with a group work ideology, has motivated very diverse companies—cinema, music, art, automobiles, electronics, editorials, and food and beverage—to commission very different projects: art directions, audiovisuals, marketing campaigns, wardrobes...

Among the most important the prizes that the firm has obtained are the L'Oréal prize for the Best Collection of Young Designers for their work entitled "In loving memory" presented at Pasarela Cibeles, Madrid 2003; the Marie Claire fashion prize for the Best Novel Designer and the Shanghay prize for the Best Spanish Designer, both received in 2003.

Davidelfin
"los mortales"
s/s 2006

Davidelfin

C/ Jorge Juan, 31
28001 Madrid, Spain
T: +34 91 700 04 53
davidelfin@davidelfin.com
www.davidelfin.com

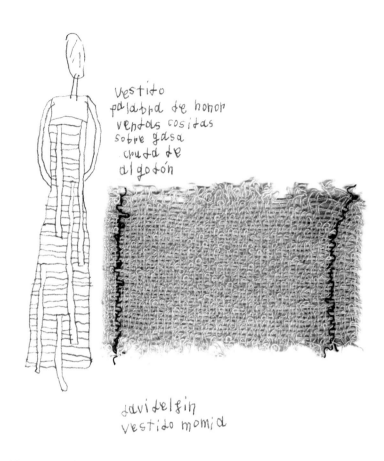

vestido
palabra de honor
vendas cositas
sobre gasa
cruda de
algodón

davidelfin
vestido momia

Mummy strapless dress,
covered with bandages
sewn on cotton gauze.

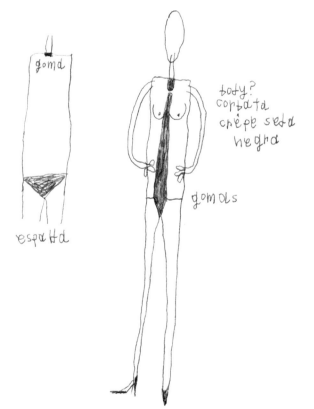

goma

espalda

body?
corbata
crépe seda
negra

gomas

davidelfin
corbata bimba

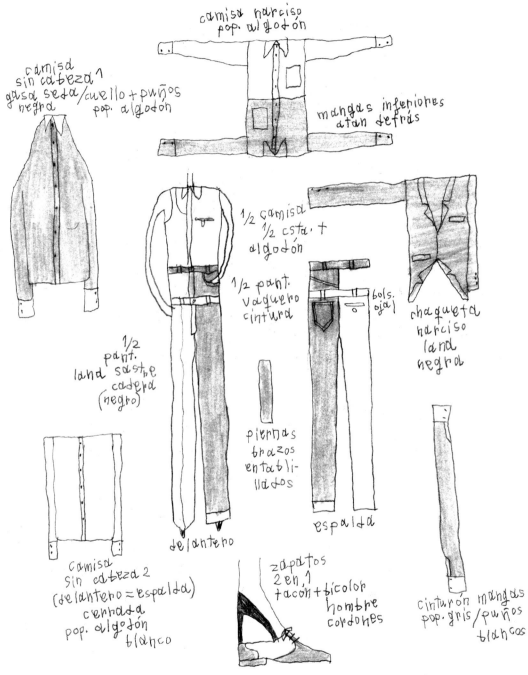

camisa narciso
pop. algodón

camisa
sin cabeza 1
gasa seda/cuello + puños
negra pop. algodón

mangas inferiores
atan detrás

1/2 camisa
1/2 esta. +
algodón

1/2 pant.
vaquero
cintura

bols.
ojal

chaqueta
narciso
lana
negro

1/2
pant.
lana sastre
cadera
(negro)

piernas
brazos
entabli-
llados

espalda

cinturón mangas
pop. gris/puños
blancos

delantero

camisa
sin cabeza 2
(delantero = espalda)
cerrada
pop. algodón
blanco

zapatos
2 en 1
tacón + bicolor
hombre
cordones

davidelfin
"cuerpo extraño"
otoño-invierno 2004/05

Different sketches from the collection "Cuerpo Extraño" by Davidelfin for spring-summer 2004-05, presented at Pasarela Cibeles, Madrid.

Moscow, Russia, 1974

"We look at things from an extraordinary point of view."

INTERVIEW

How would you define your style?
My style is the style of my team. We look at things from an extraordinary point of view, doubt common values, and bring out hidden facts. This position is underlined by the inverted logo of the trademark.
In the collections, we always carry out specific attributes of the Russian personality in which everything is mixed: traditions and high technology, elitist and mass culture, official and underground spirit.

Which is the most difficult piece to design?
Shoes, because they are the most miscounted elements in clothing.

Who or what is your main source of inspiration?
My daughter.

What area of your work do you enjoy the most?
My yurta for meditation and work at the Moscow studio.

Who is your icon of style and good taste?
My dad and mom.

What are your plans for the future?
Opening mono-brand boutiques in Moscow, Europe, and the United Kingdom.

professional CAREER

Born in Moscow, Russia, in 1974, Denis Simachev graduated from Moscow Kosygin State Academy of Textile with a degree in Clothes and Footwear Design. In June 2005, he made his entrance with his men's collection presentation during the Milan Fashion Week, in the Teatro Franco Parenti, and later on in the Manege Hall in Moscow. It is the philosophy of his trademark to see things from an unusual point of view, to be intentionally provocative, and to question commonly-held values —this is the key to making Russian products of European quality. By combining ancient traditions with modern engineering, creative and recognized styles, the firm presents two men's and women's collections in Milan and Moscow twice a year. Denis Simachev trademark collections combine artifacts found in the Far North, the Volga region, Central Asia, and the Caucasus, at different times in history: Imperial, Revolutionary, Soviet, and modern-day Russia. The mixture of colors and decorations, fussiness, multiple layers, disproportional and rollicking spirit, and the combination of incongruous elements, characterize his collections.

The Denis Simachev brand produces men's and women's collections and intentionally avoids unisex style. The feminine characters are always poetic heroines. The male characters always have complex and bright personalities. Even doubtful facts and names are not judged as "good" or "bad." The aim of this brand is to find the true Russian spirit in them.

Denis Simachev

1 Beim Antonskraiz
8116 Bridel, Luxembourg
T. +352 263 312 07
F. +352 263 312 08
info@denissimachev.com
www.denissimachev.com

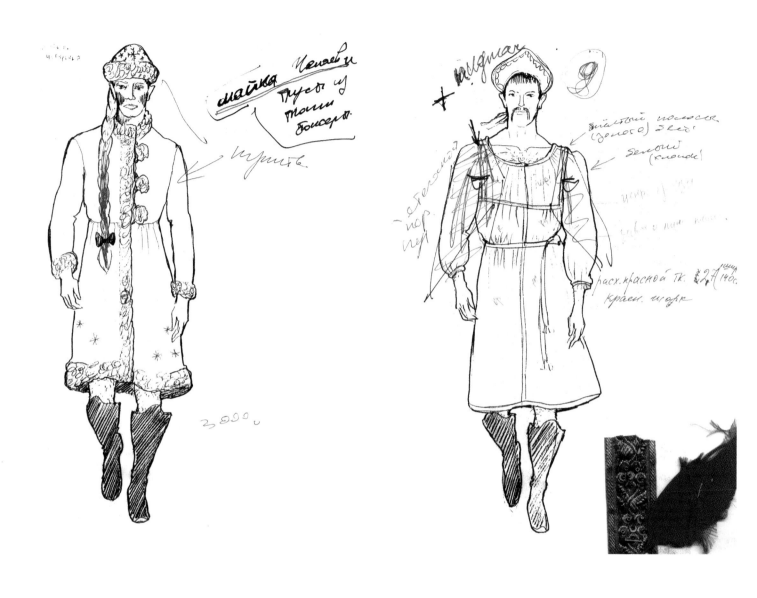

Sketch for the winter collection. Coat with leather details in the buttoning, hem and cuffs. Dress of courtesan inspiration with creases.

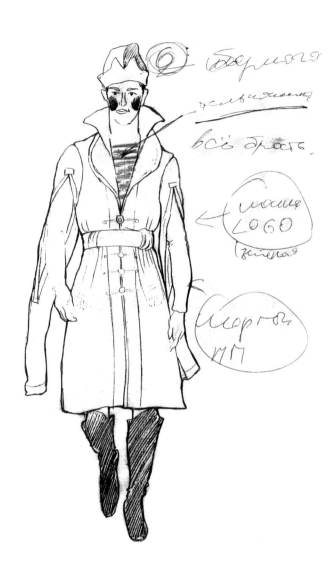

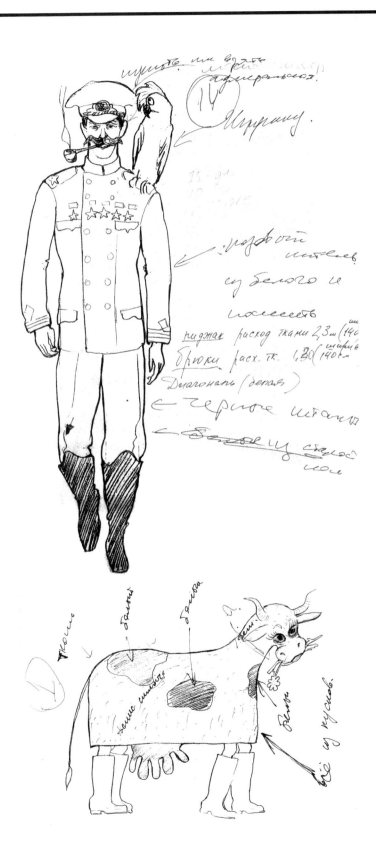

Sketch for the winter collection. Military inspiration. Coat with an open sleeve and double collar. Pant suit with double buttoning.

DOROTEA 17

Barcelona, Spain, 1964

"I am always thinking about the person who will wear my shoes."

INTERVIEW

How would you define your style?
Colorful, fun, elegant, comfortable... Always thinking about the person who will wear my shoes.

Which is the most difficult piece to design?
Sandals because all the parts of a sandal must adapt perfectly to the foot.

Who or what is your main source of inspiration?
The street and the different life-styles of the people.

What area of your work do you enjoy the most?
I enjoy designing heels and looking for leather, materials and colors for my collections.

Who is your icon of style and good taste?
Roger Vivier, Salvatore Ferragamo and Balenciaga.

What are your plans for the future?
Continue to expand our points of sale outside Spain and create two new lines: one of glasses and the other one related to house wear.

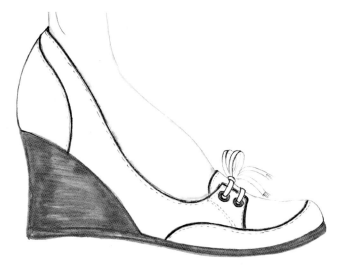

professional CAREER

Born in Barcelona in 1964, Dorotea studied Liberal Arts at the Universidad Autonoma de Barcelona, graduating in 1987. At the same time, she studied Fashion Design at Instituto Artistico dell'Abigliamento Marangoni in Milan, during the summer of 1987, and at IDEP school in Barcelona, in the same year; in 1988, she studied industrial pattern design at Escuela Guerrero, Barcelona, and she did a course on the human figure at Escuela Eina, in the same city.

In 1988, she was granted a scholarship by the Centro de Promoción de Diseño y Moda of the Ministry of Industry and Energy to take a Fashion Stylist course at Instituto Artistico dell'Abbigliamento Marangoni in Milan, between 1988 and 1989.

That same year she became part of the design team for Jesús del Pozo. In 1991, she entered the Camper design team and from 1993 until 2000 she was part of the team working for Antonio Miró, where she was in charge exclusively of the women's shoes line and the brand Dorotea for Antonio Miró.

In July 1999, she founded Sushi Siglo XXI, S. L., her company, and devoted herself to the design, production and commercialization of her own brand. Her collections are sold at shops like Otto Tootsie in New York, On Ward in Paris, La Vetrina de Beril in Milan and others in Great Britain, Ireland, Austria, Japan, Belgium, Holland, Switzerland, the United States and Australia, plus another 90 points of sale in Spain. In September 2005, Dorotea opened her first shop in Madrid and in 2006 she was nominated as a finalist in the VIII edition of the Premios Principe Felipe a la Excelencia Empresarial in the category of design.

Dorotea Valls

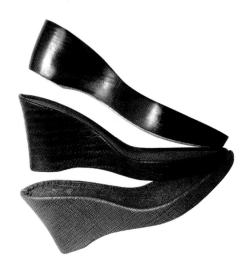

C/ Sant Pere Més Alt 18, 1º 2ª
08003 Barcelona, Spain
T: +34 93 310 54 52
info@dorotea.es
www.dorotea.es

73

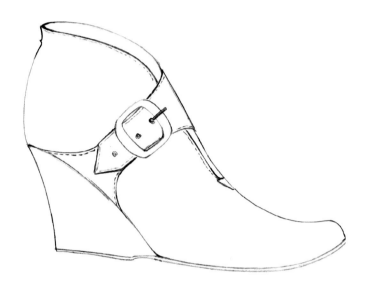

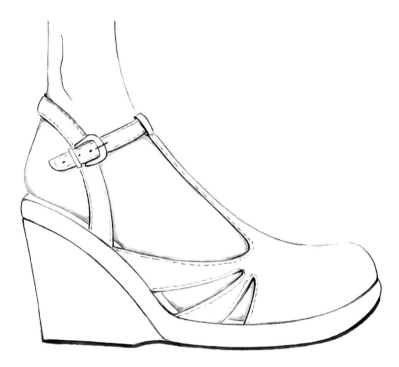

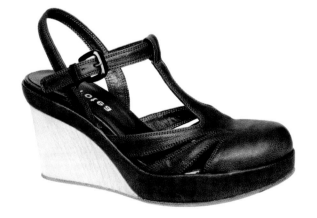

Sketches of shoes in retro style, with cot heel and buckle. Mid-leg boots with details that include backstitches, buttons, and straps with buckles.

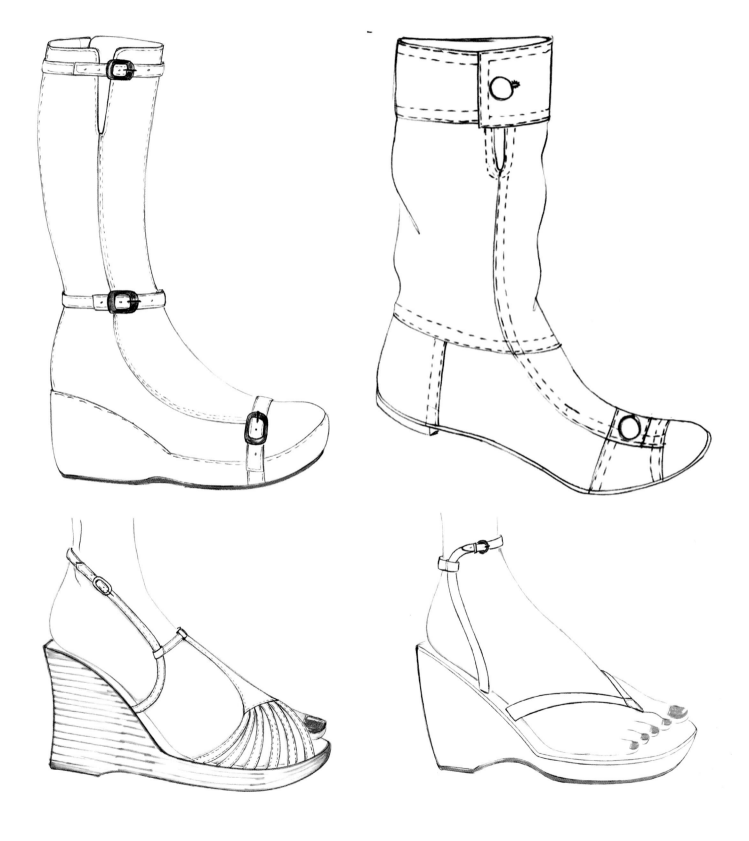

Barcelona, Spain, 1981

"Icons of style and good taste: our friends."

INTERVIEW

How would you define your style?
Young, fresh but without forgetting the classics.

Which is the most difficult piece to design?
The jacket is always particularly complicated for us. Although, really, any piece has certain complications if you want it to be perfect.

Who or what is your main source of inspiration?
We always take reference from the decades of the 50s, 60s, 70s.

What area of your work do you enjoy the most?
The search for information and the development of the subject.

Who is your icon of style and good taste?
Our friends.

What are your plans for the future?
To grow in all areas, creative, professional, commercial, and to strengthen our brand.

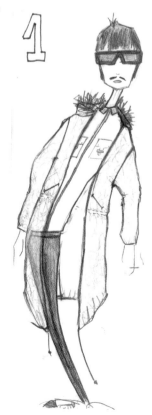

professional CAREER

The joint career of designers Anna and Macarena started when they met while studying fashion design at ESDI. El Delgado Buil, their brand, basically makes a male sportswear line; these are versatile and unisex items of clothing.

They use materials such as knitting, corduroy and leather. They also have a small line of accessories which go accordingly with the clothes they design. Their activity started at the end of July 2004. In February, 2005 they presented their first collection under the name "Crazy Kids" at Circuit Barcelona.

They received excellent reviews after this fashion show which motivated them to prepare the next collection, shown that same year at Circuit 12, Zero. This time, the inspiration came from the city of Las Vegas. Once again, the reviews were so good that they were encouraged to produce more and open up to market.

In February 2006, they opened a shop in Barcelona for the special sale of their creations, and in April 2006, their collection "Black Friday" was well received and appreciated during the first edition of Circuit Lisbon.

Anna Figuera Delgado,
Macarena Ramos Buil

C/ Casp 92 – 94, principal 1ª
08010 Barcelona, Spain
T: +34 657 554 848
 +34 660 991 629
info@eldelgadobuil.com
www.eldelgadobuil.com

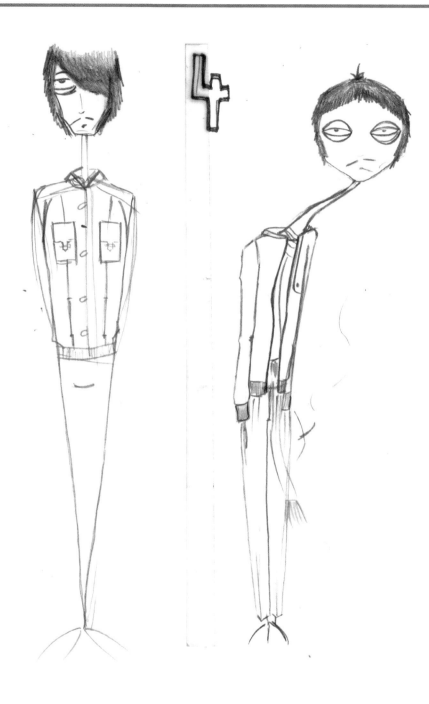

Sketches for the 2006-07
menswear fall-winter
collection. Two-piece
ensembles, in retro cut.

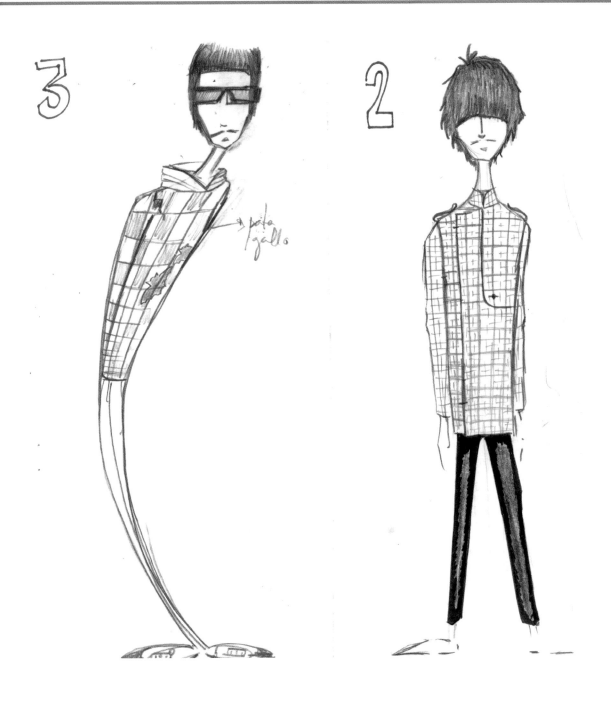

Samples of jacket and
short coat in hound's-
tooth. High collars and
zippers on the side.

Long Island (New York),
United States, 1978

"Minimalist but without forgetting the small details."

INTERVIEW

How would you define your style?
A sober style, minimalist but without forgetting the small details that make a clothing item special.

Which is the most difficult piece to design?
I do not think there is anything difficult to design, but there sure are things difficult to make such as a classical men's jacket.

Who or what is your main source of inspiration?
Music, people who surround me and the social conditions of the moment.

What area of your work do you enjoy the most?
The first part of every collection and the final part, when you see that the work you did on paper has become a reality.

Who is your icon of style and good taste?
Characters as well known as Gandhi or as little known as my best friend.

What are your plans for the future?
To start my own menswear line.

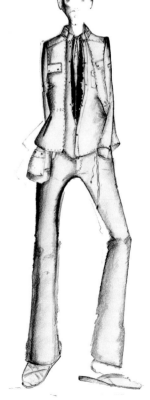

professional CAREER

Emiliano Altamirano started studying fashion at the Fashion Institute of Technology of New York, and after having spent some years in the Big Apple, he decided to continue his studies in Italy where he specialized in menswear design at Polimoda School in Florence. He finished his studies in Polimoda in June 2003 and in September of that same year he started an internship with fashion designer Antonio Miró. As the most important designer of menswear, there was no better place for Altamirano to start his professional experience. Under the direction of Richard Capstick, who was the designer of menswear at the moment, he exercised his know-how in the 2005-06 autumn-winter collection. Antonio Miró was quite satisfied with Altamirano's work during the internship, and after Capstick decided to take a job abroad, he contacted him to design his menswear. Altamirano is still the designer of the first menswear collection of Antonio Miró.

The last collection, 2007 spring-summer was presented at a penitentiary center in Barcelona. Other than being a huge media event, the collection was said to be the best of Antonio Miró at all levels, a professional and personal triumph.

Emiliano Altamirano

Antonio Miró
C/ Consell de Cent 349
08007 Barcelona, Spain
T. +34 934 870 670
emilianoaa@yahoo.com
www.antoniomiro.es

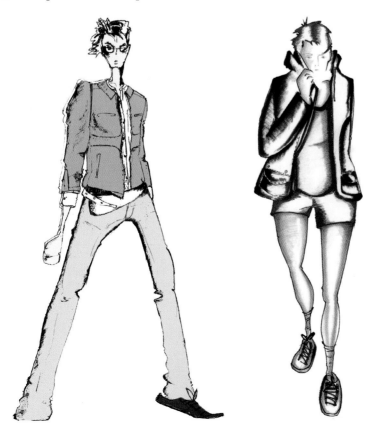

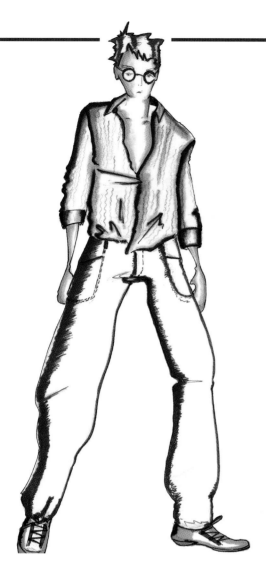

Winter garments sketches.
Simple lines, typical of
casual wear, for a an outfit
composed of a jacket,
trouser & pullover topped
with a borsalino hat.

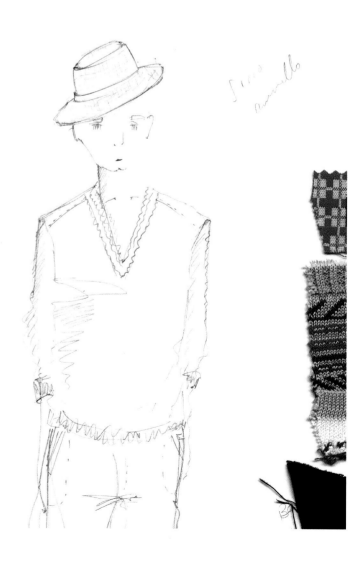

■ Sketches Emiliano Altamirano

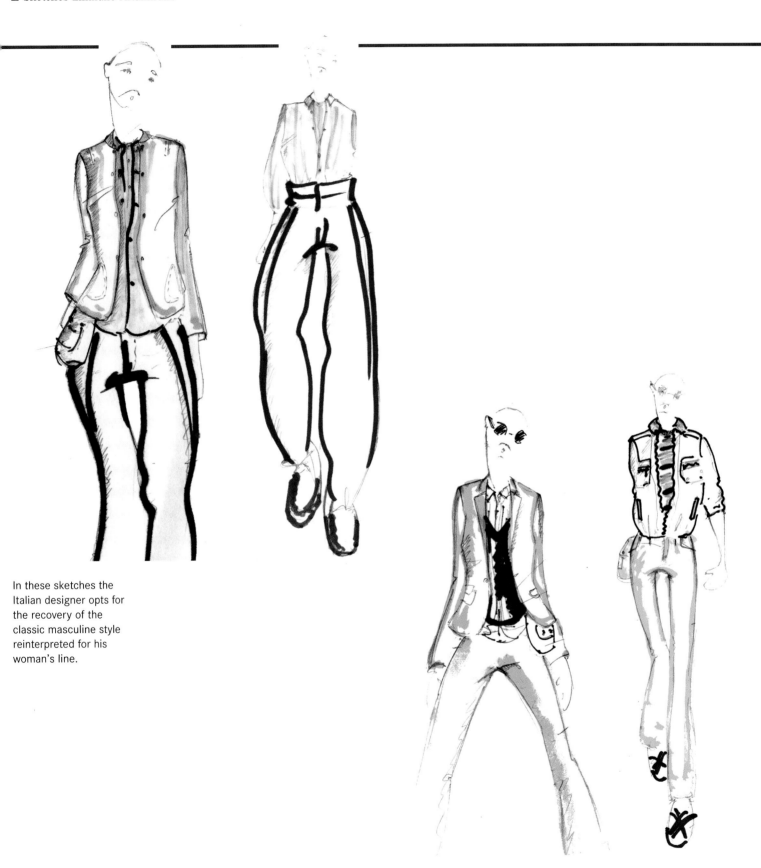

In these sketches the Italian designer opts for the recovery of the classic masculine style reinterpreted for his woman's line.

Funchal, Portugal, 1965

"New collections are my passion."

INTERVIEW

How would you define your style?
My style pays homage to the women's body. Glamour, sophistication, sensuality, femininity and chic.

Which is the most difficult piece to design?
The most difficult piece I have ever done was my gold and diamond's bikini that cost one million dollars.

Who or what is your main source of inspiration?
My main source of inspiration is life. Everything around me, especially all my voyages, films, old books, music...

What area of your work do you enjoy the most?
What I enjoy the most in my work, my real passion, is the creation and the adrenalin of a new collection, from the first sketch to the Fashion Show in Paris.

Who is your icon of style and good taste?
I choose two different women: Jane Birkin for her simple and chic style and Sharon Stone for the glamour, sophistication and sensuality.

What are your plans for the future?
A perfume is the next challenge.

professional CAREER

A self-taught designer, Fátima Lopes started her career after moving from the island of Madeira to Lisbon, the city where she opened a well-known shop called Versos. A while later, she started what has possibly been her most creative personal adventure, traveling for over two years in search of inspirations, with the intention of expressing them in her creations. The result was a series of original creations such as her famous and recognized line of bags and accessories inspired in Morocco, with a particular esthetics. In 1999, she presented her first fashion show during the Paris Fashion Week. Inexhaustible entrepreneur and tirelessly creative, she started her own franchise network in 2000, but it was not until 2005 that she started her adventure as a creator of fine jewelry with her collection "Fátima Lopes Diamond", together with the famous jeweler Pedro Rosas. This collection includes a series of pieces with fine lines, with the diamond as raw material. In February 2006, she received the title of Comendadora da Ordem do Infante D. Henrique from the hands of the Portuguese president, Sampaio. Her latest creative adventures are in the area of decoration with the design of silver cutlery as well as with the creation of the official garments of the Portuguese national soccer team.

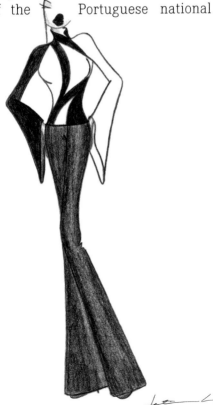

Fátima Lopes

250 rue de Rivoli
75001 Paris, France
T: +33 1 44 55 04 70
info@fatima-lopes.com
www.fatima-lopes.com

85

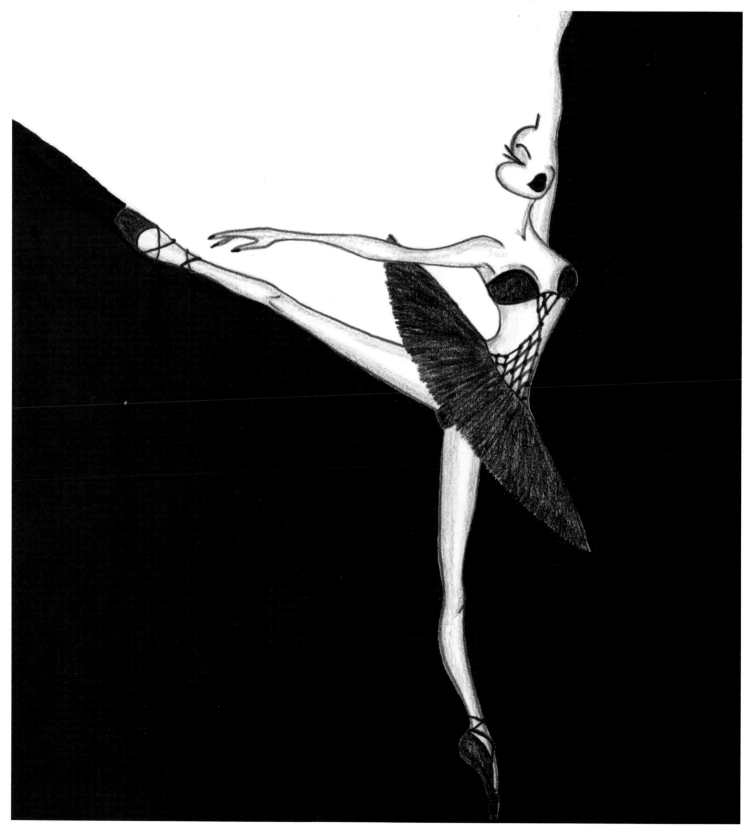

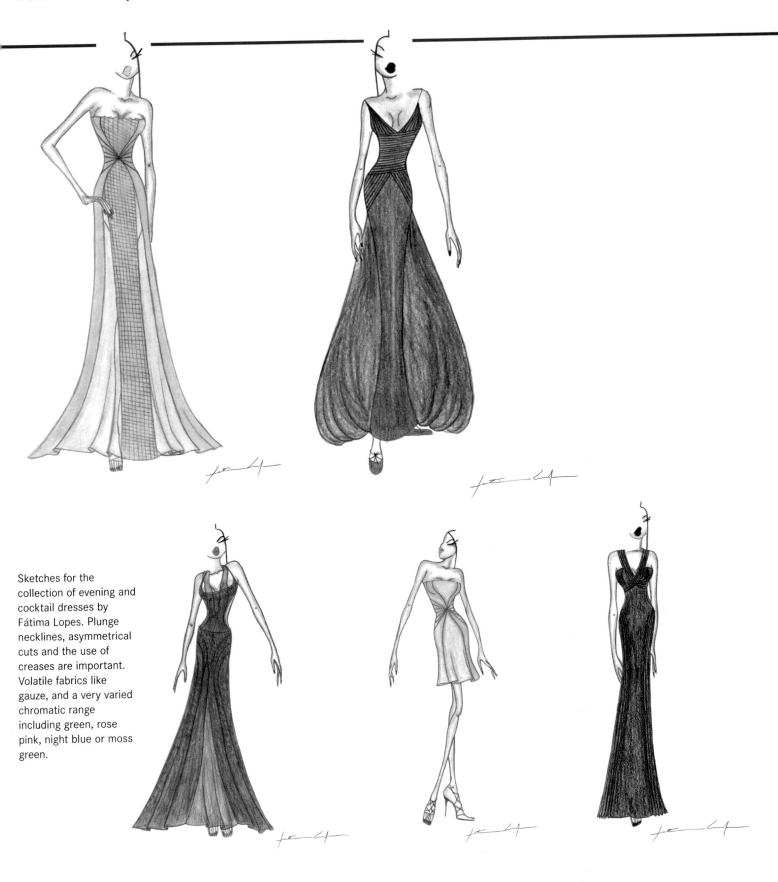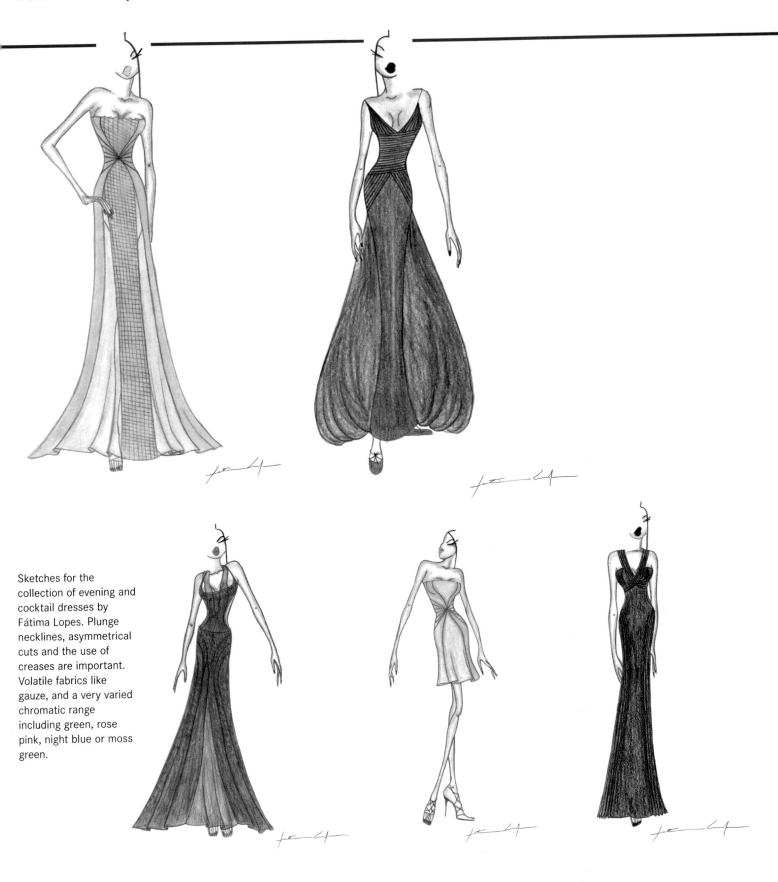

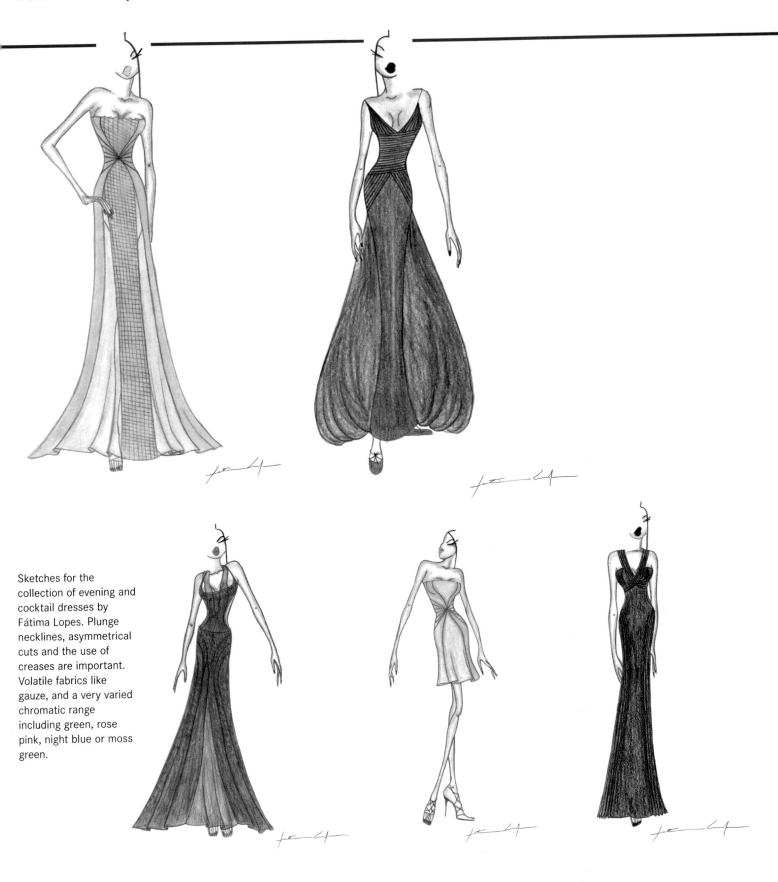

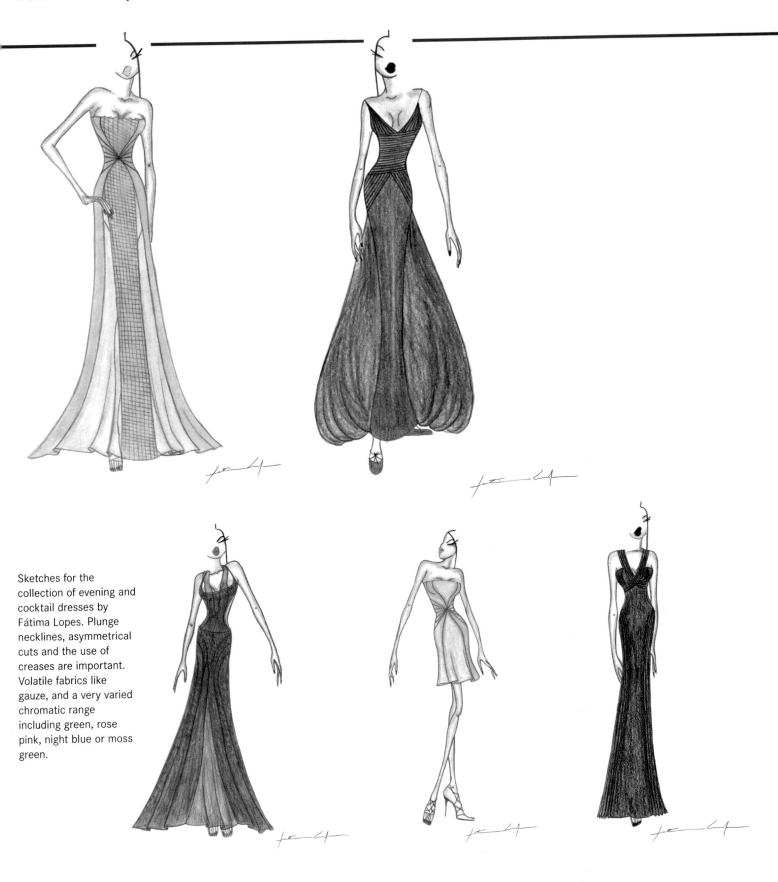

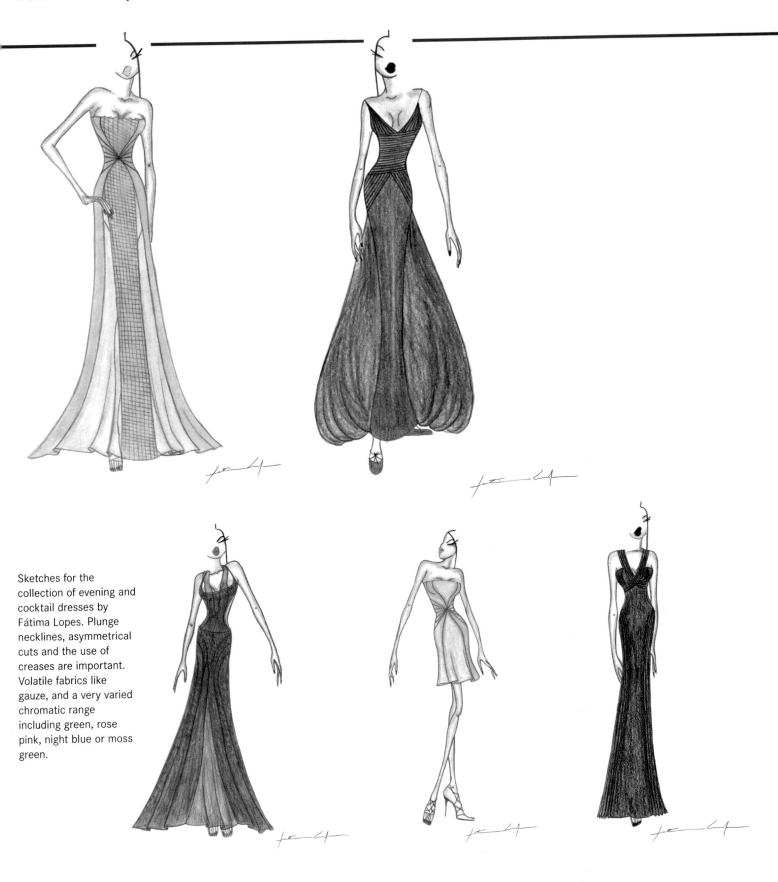

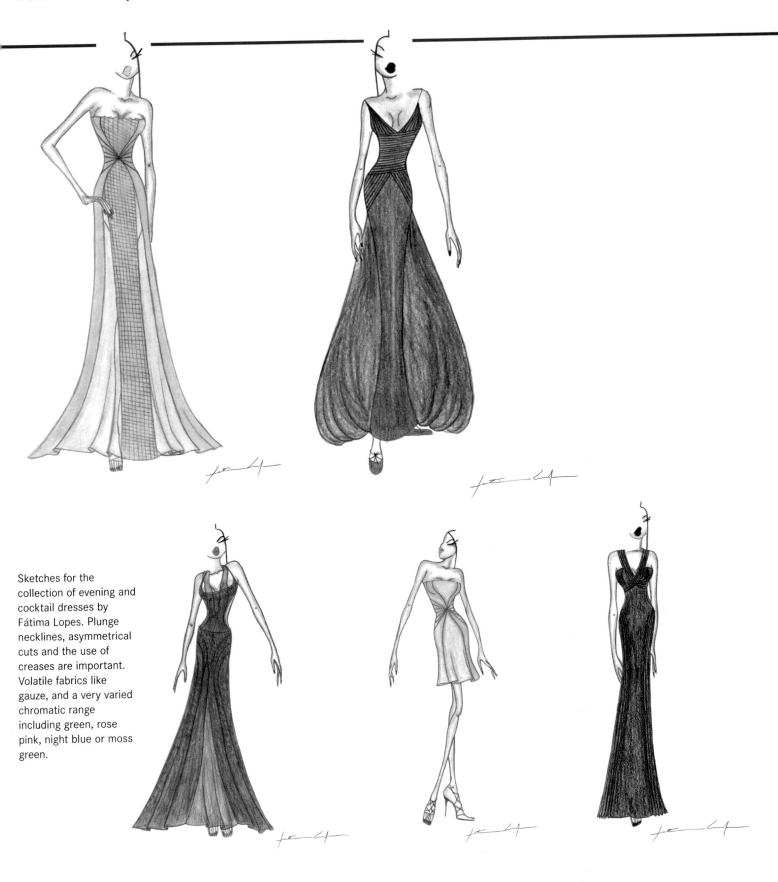

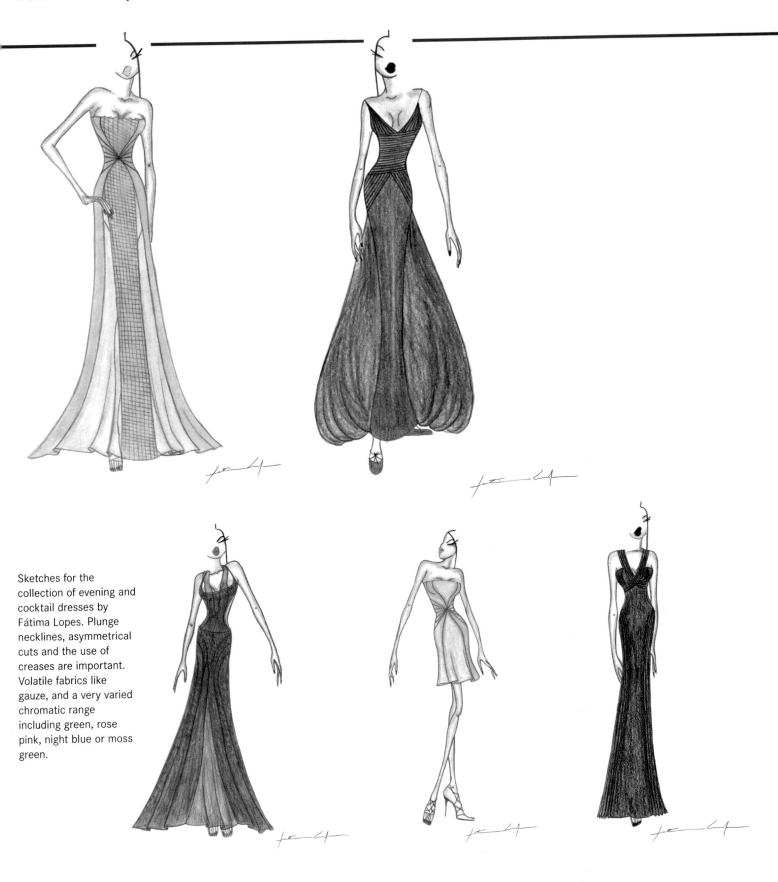

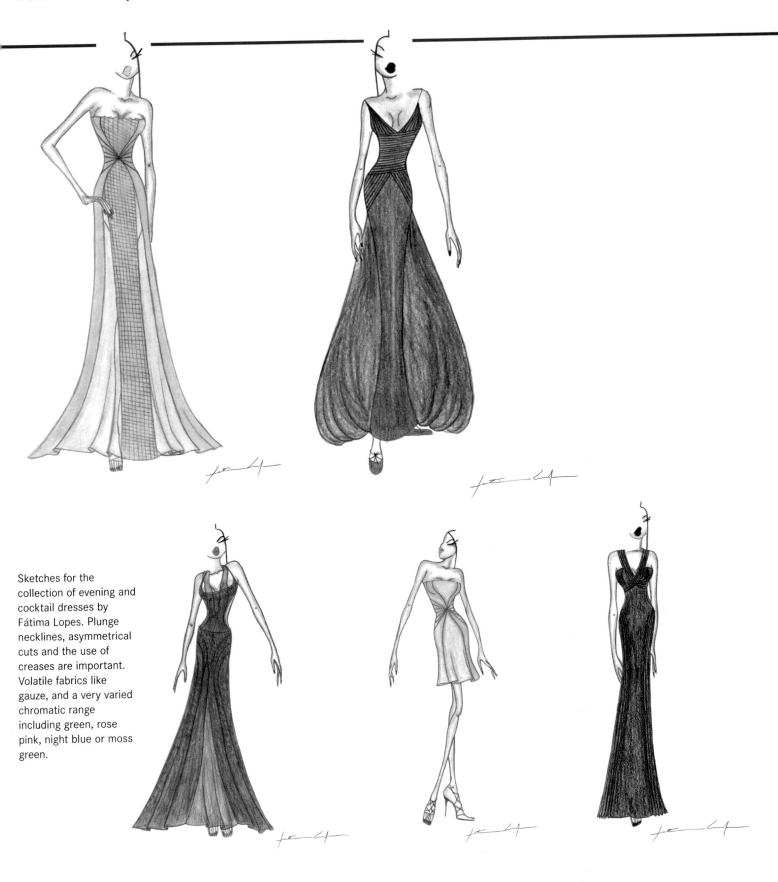

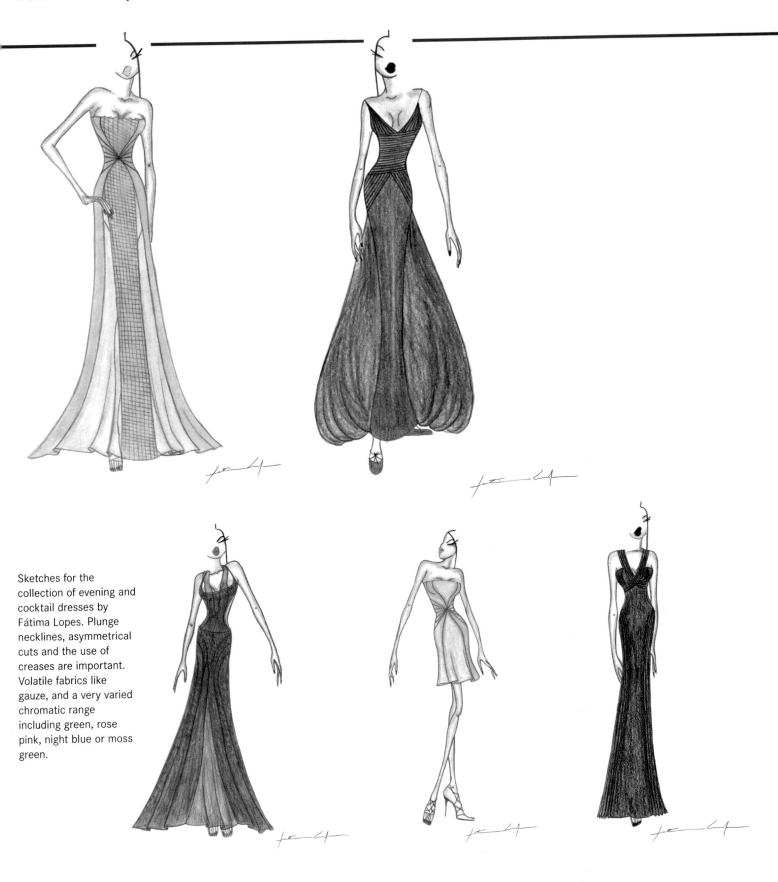

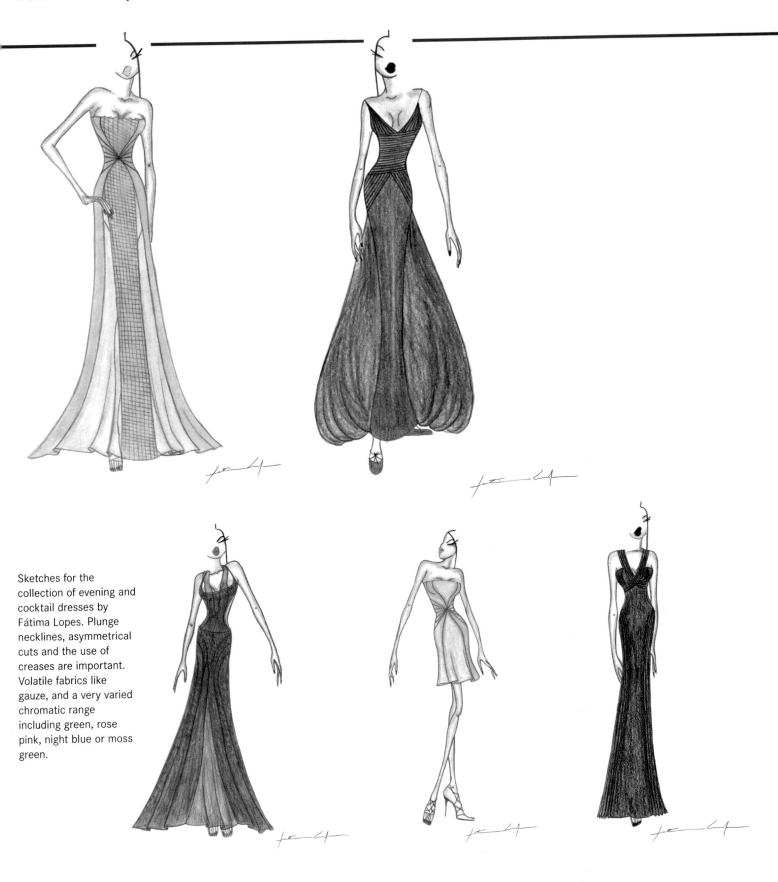

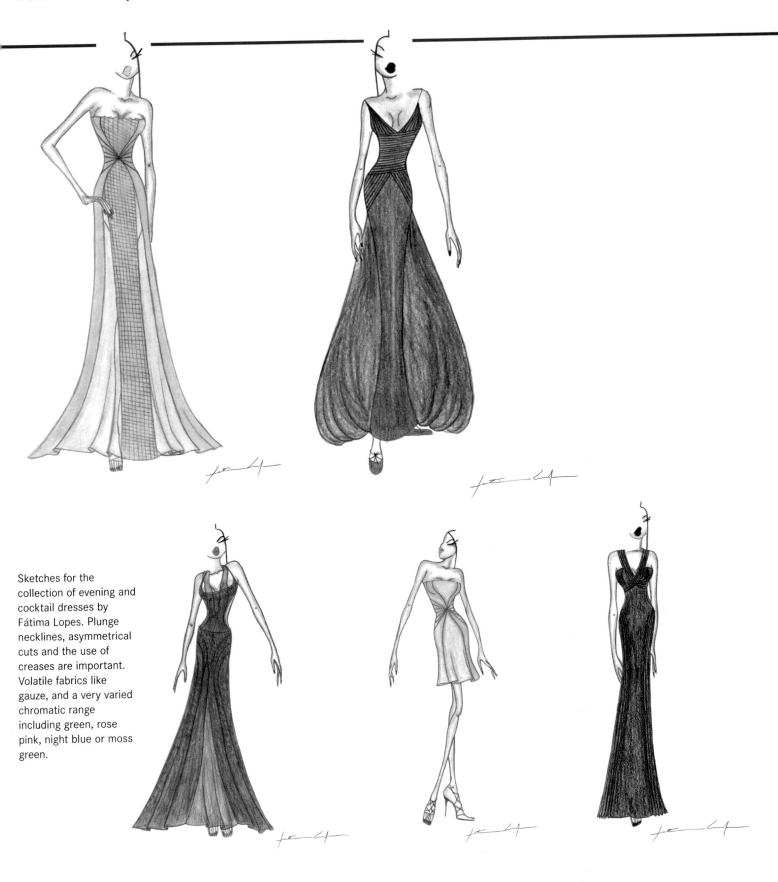

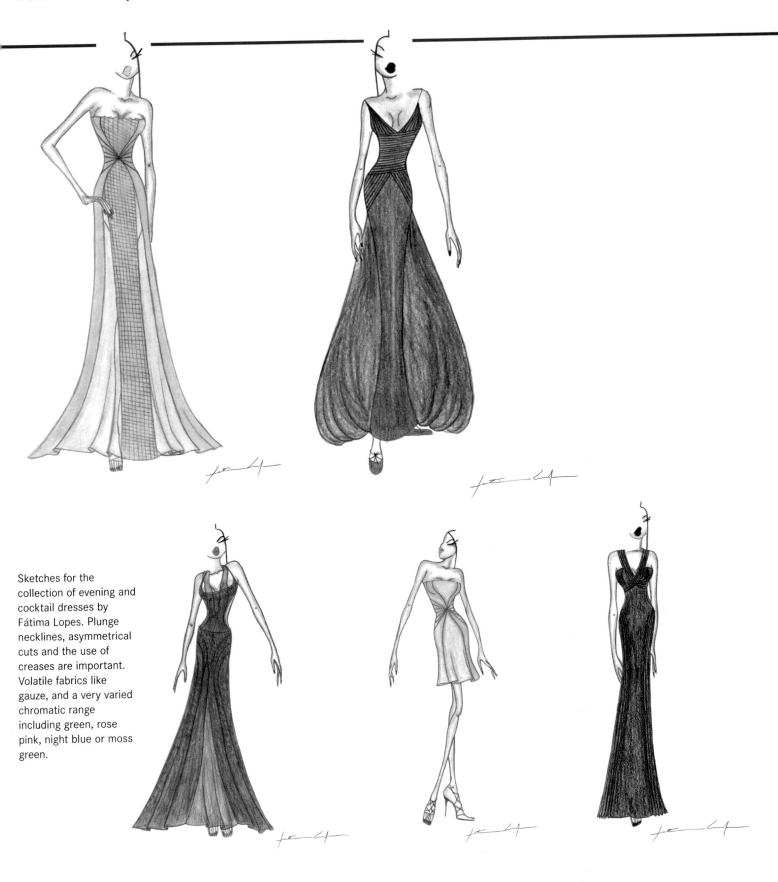

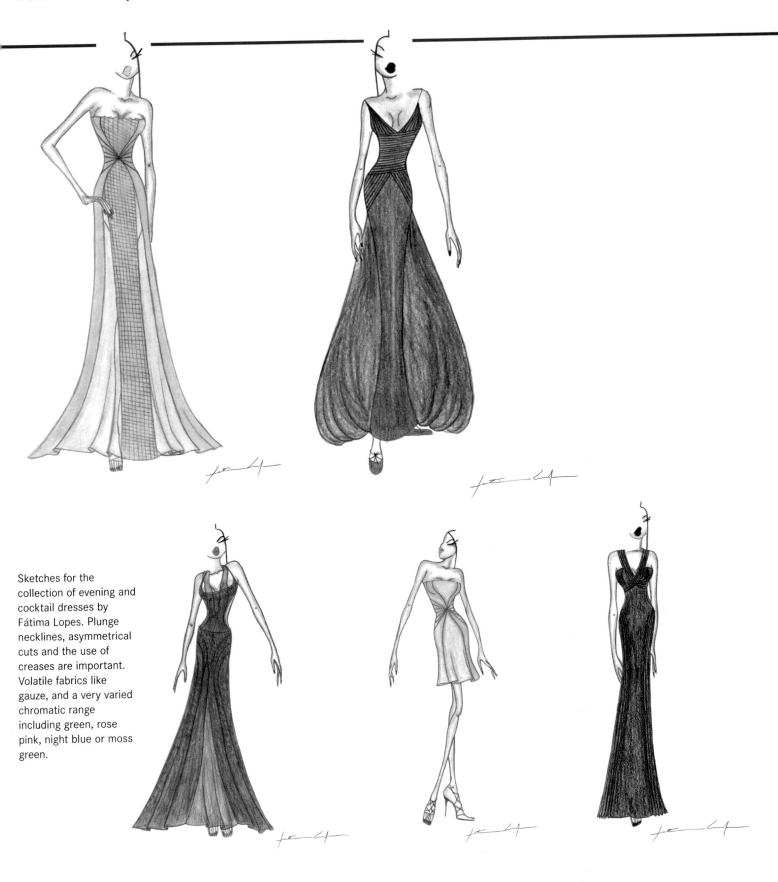

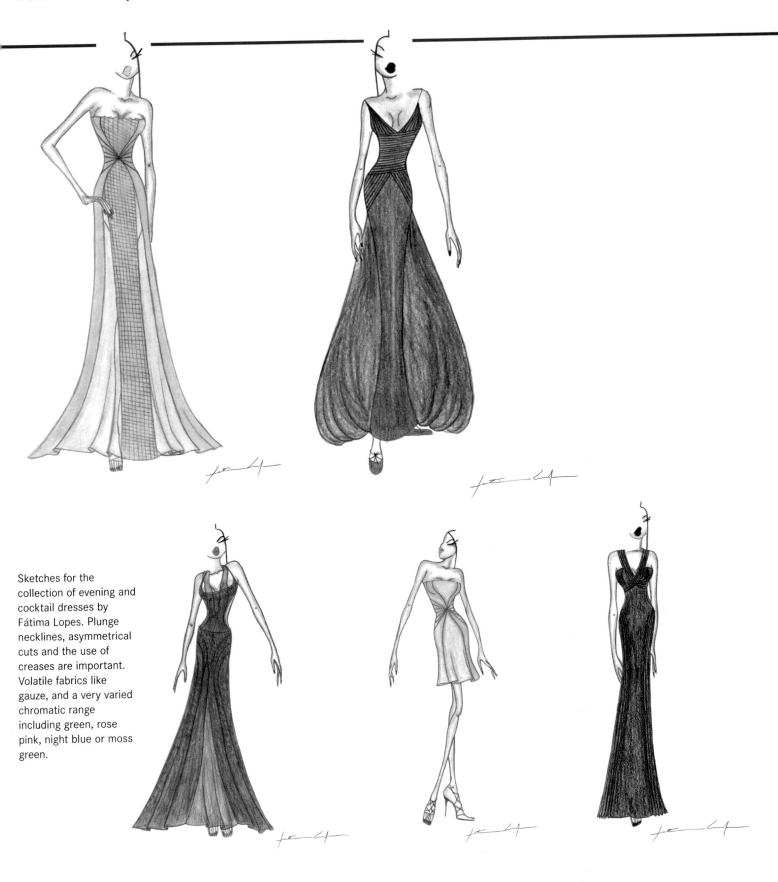

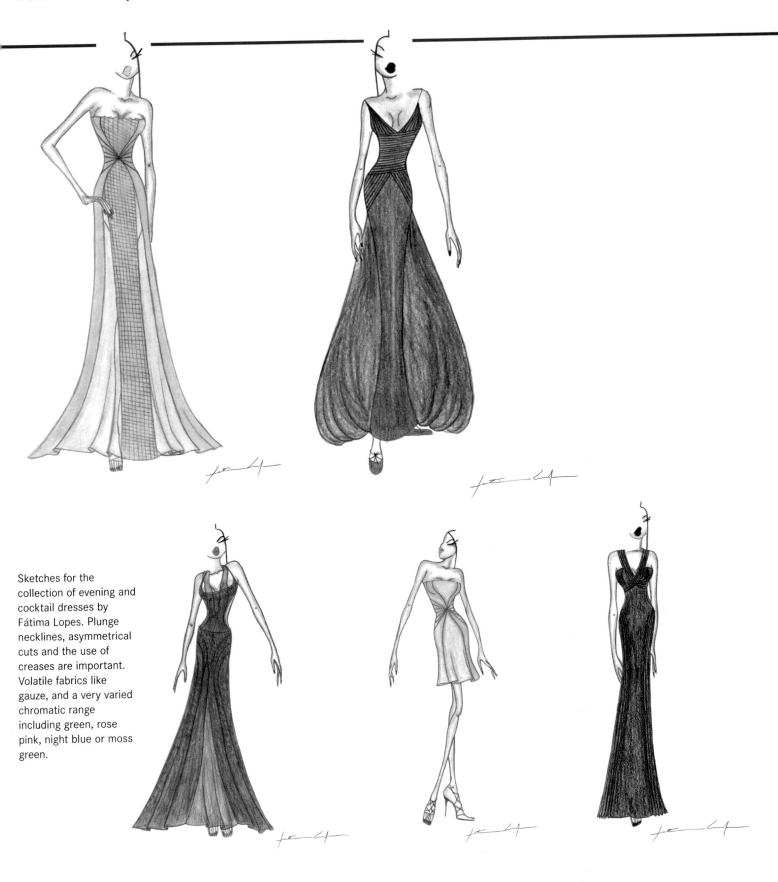

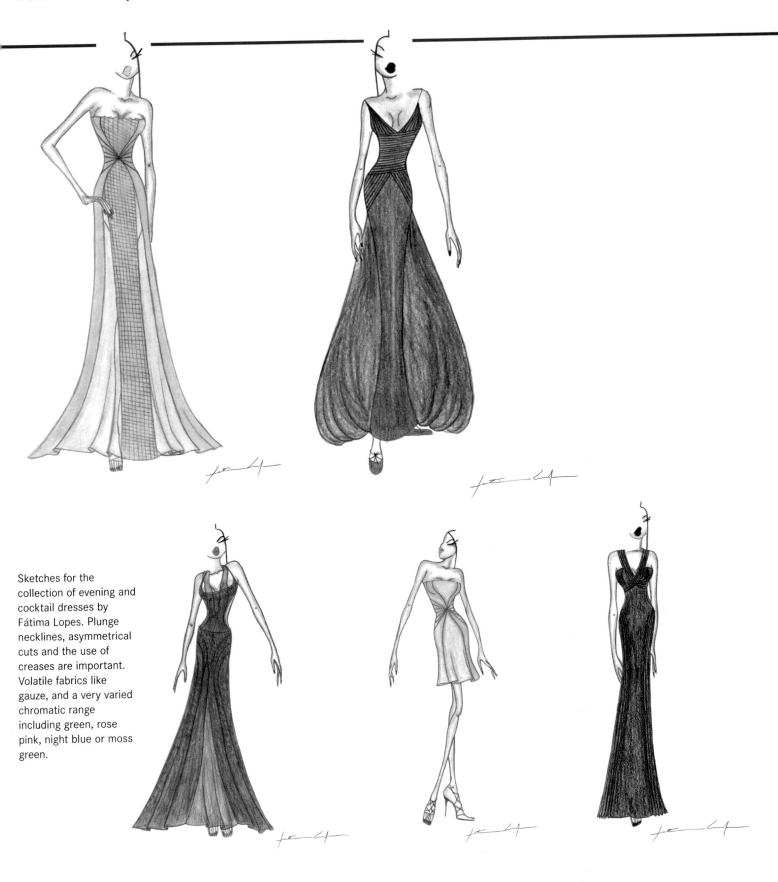

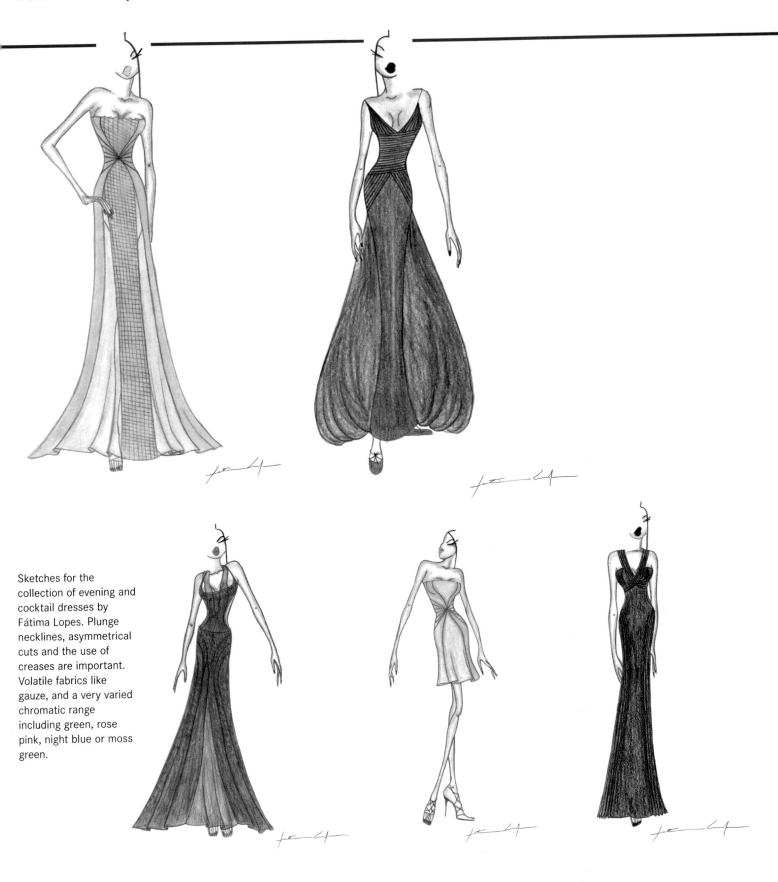

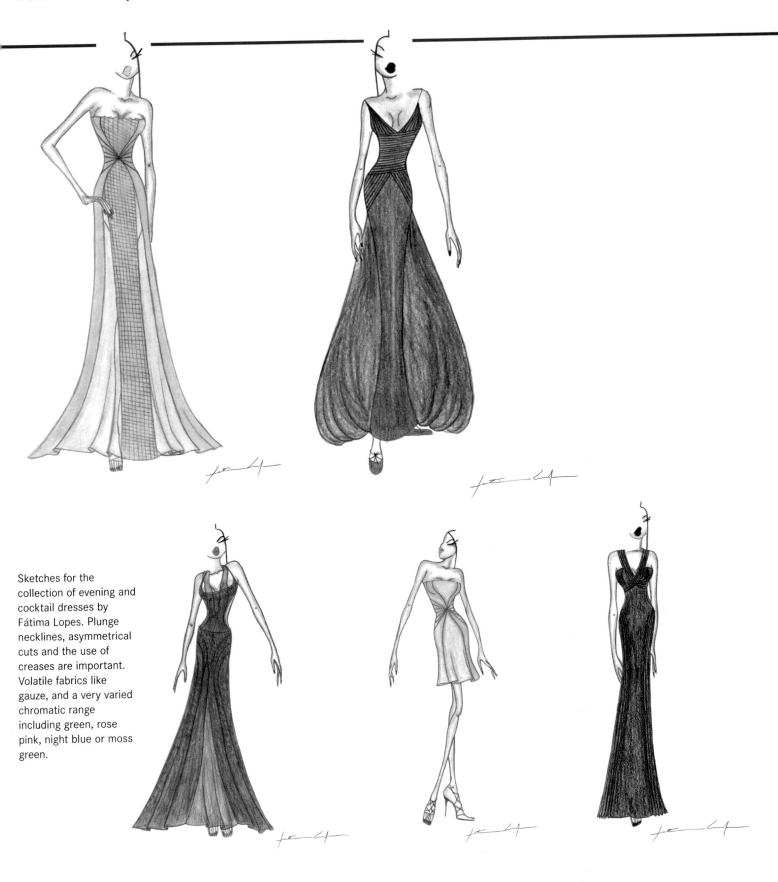

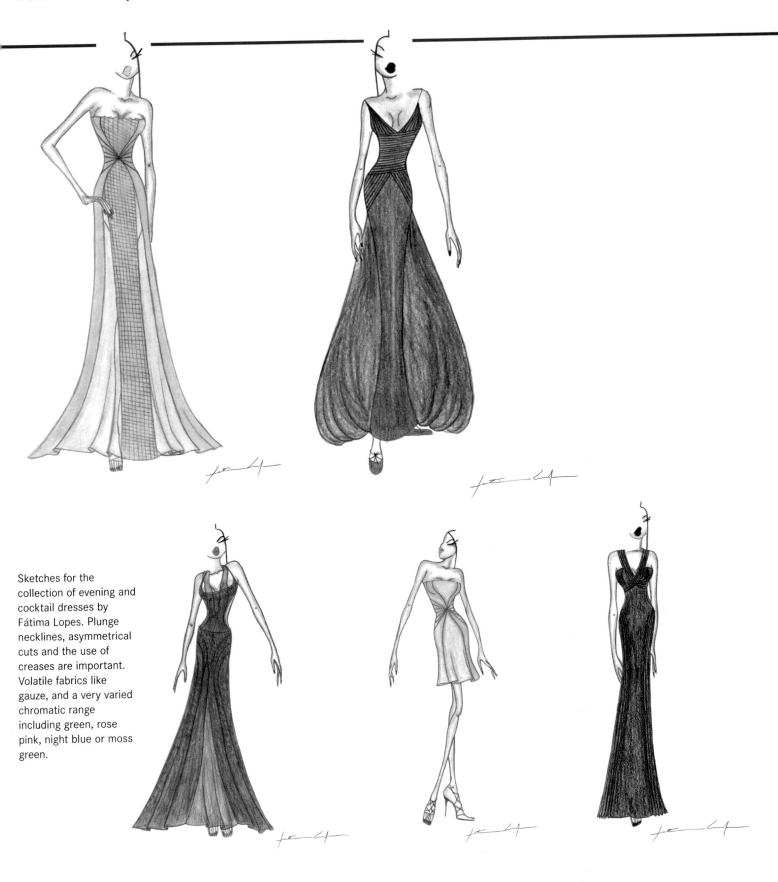

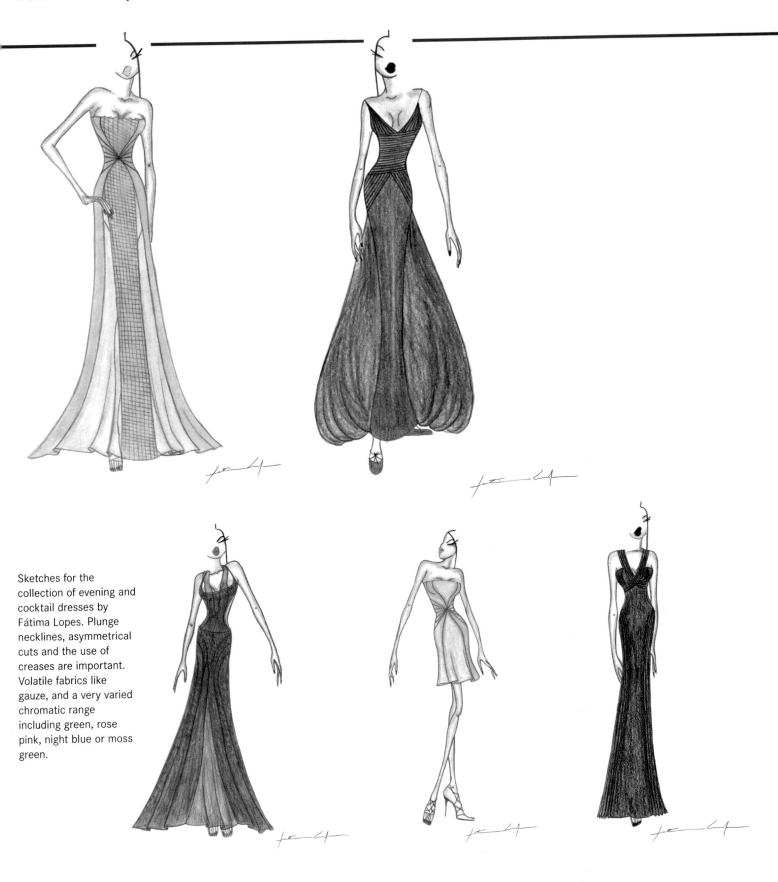

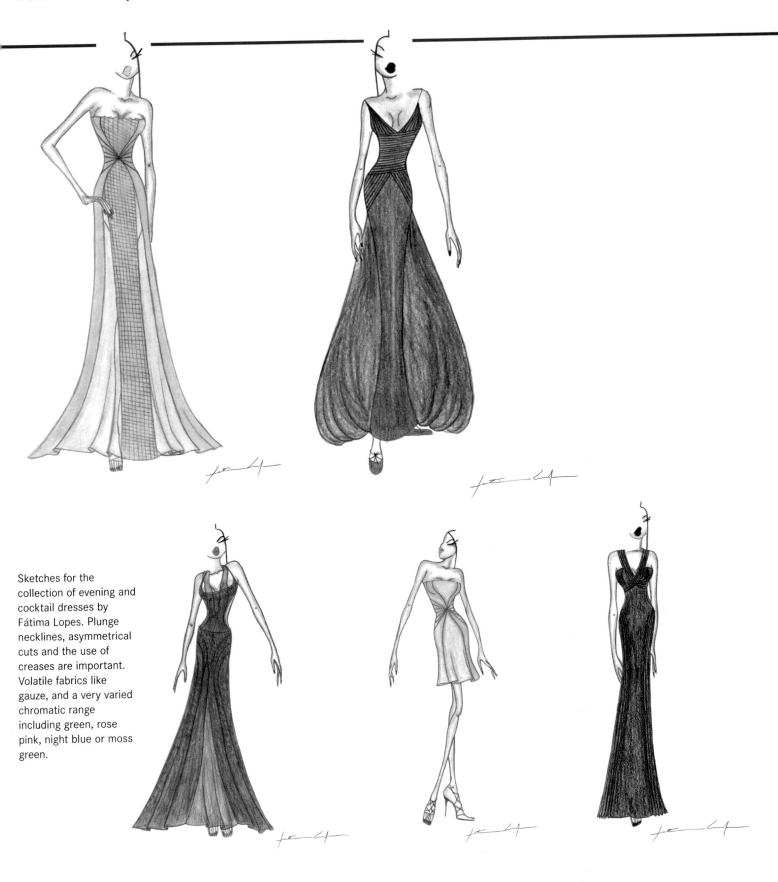

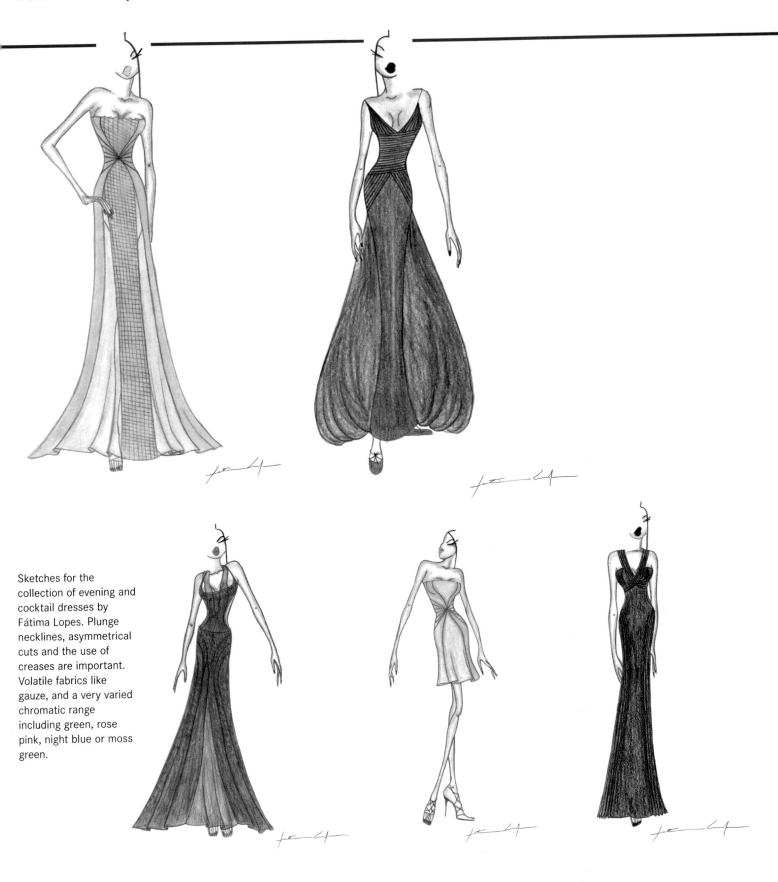

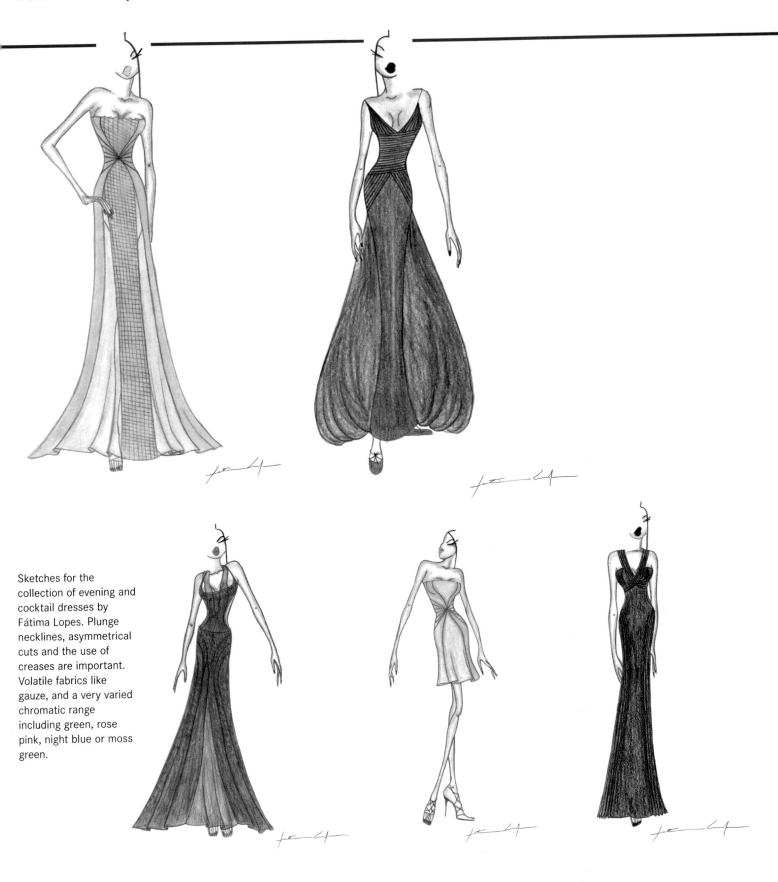

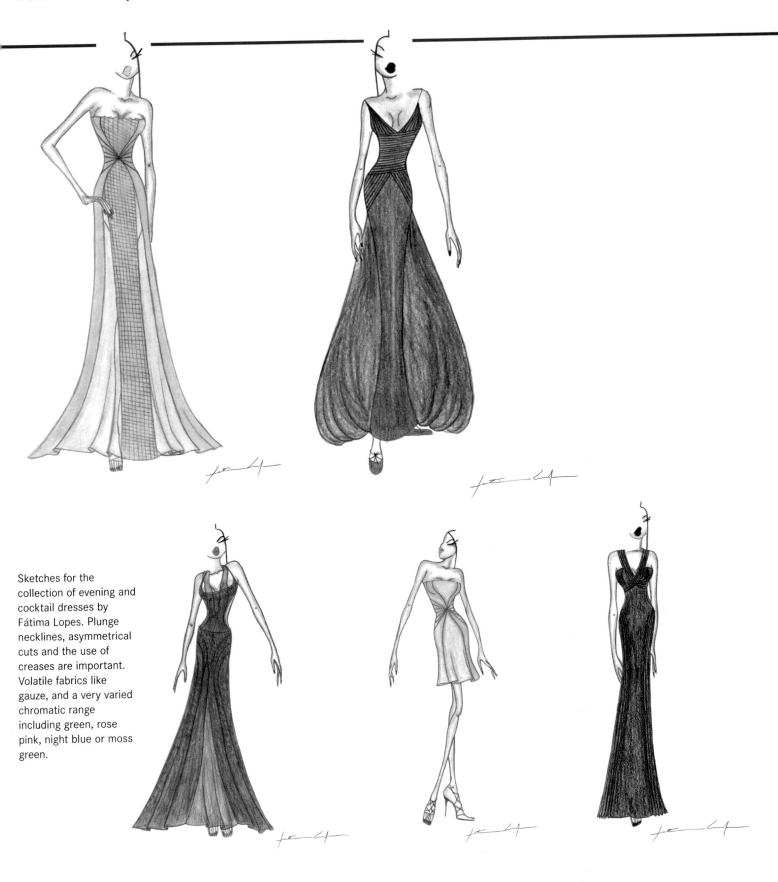

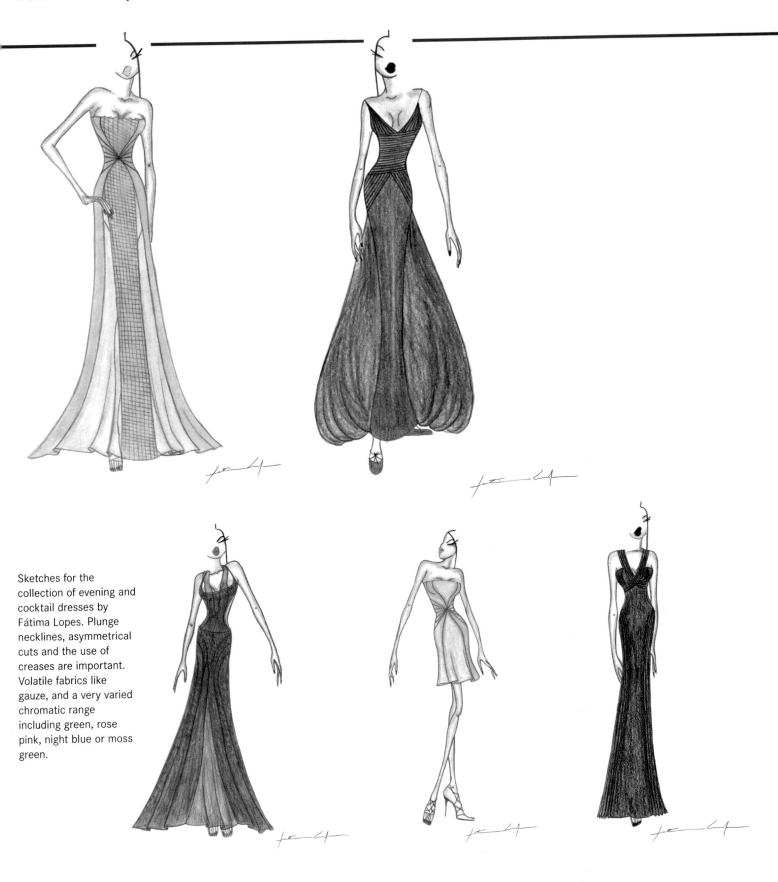

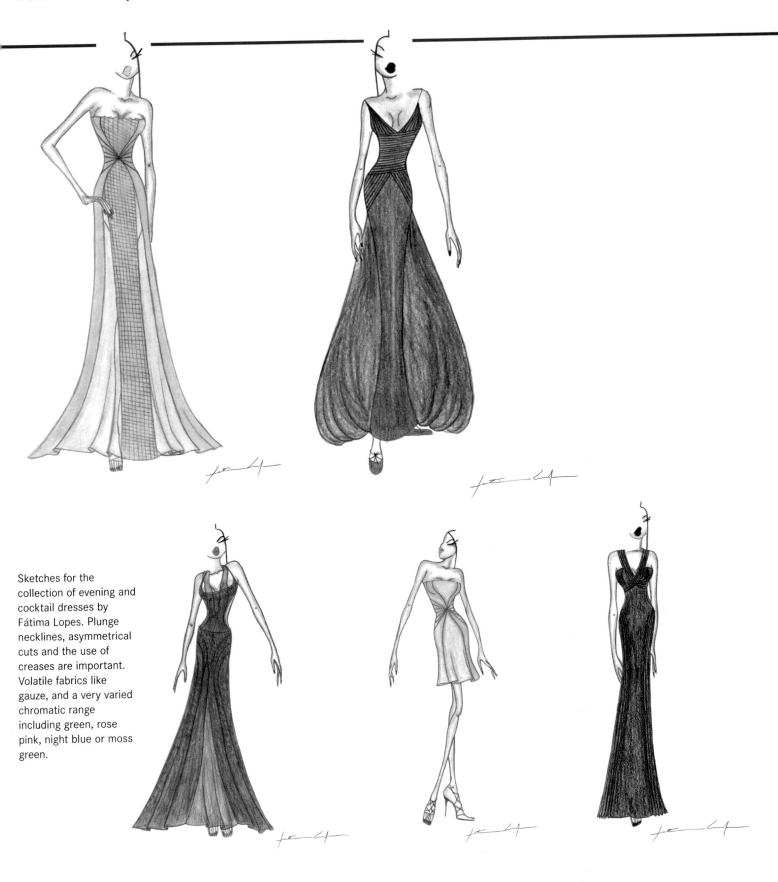

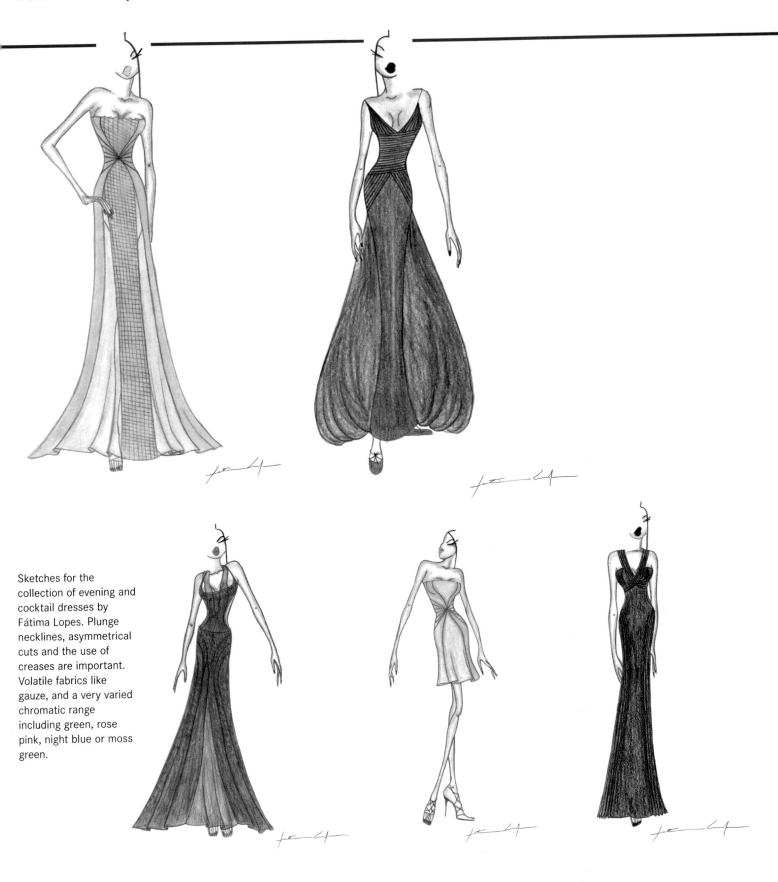

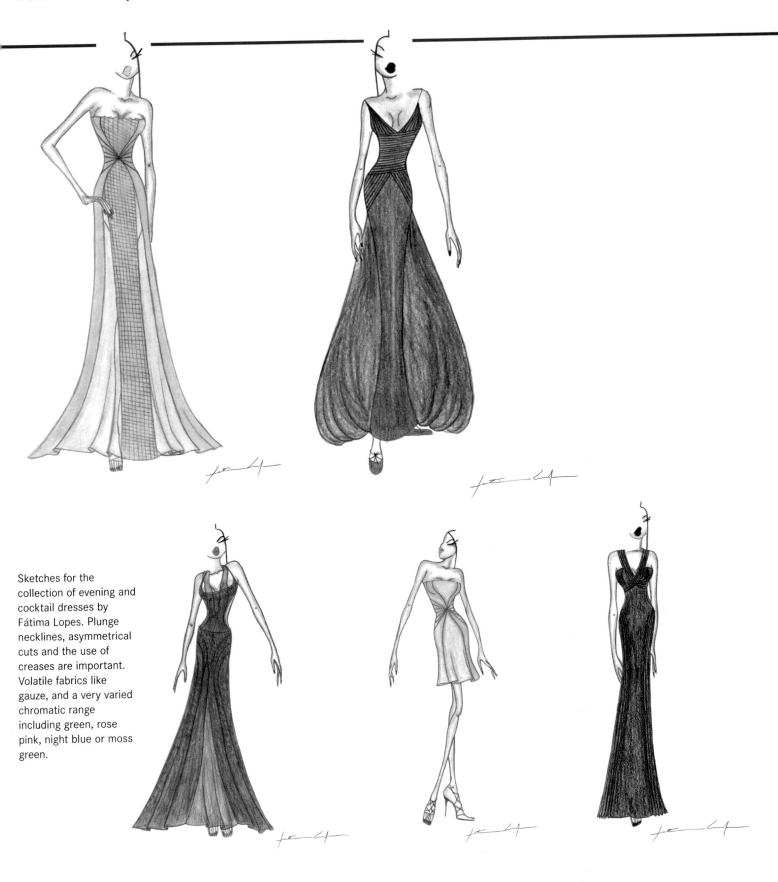

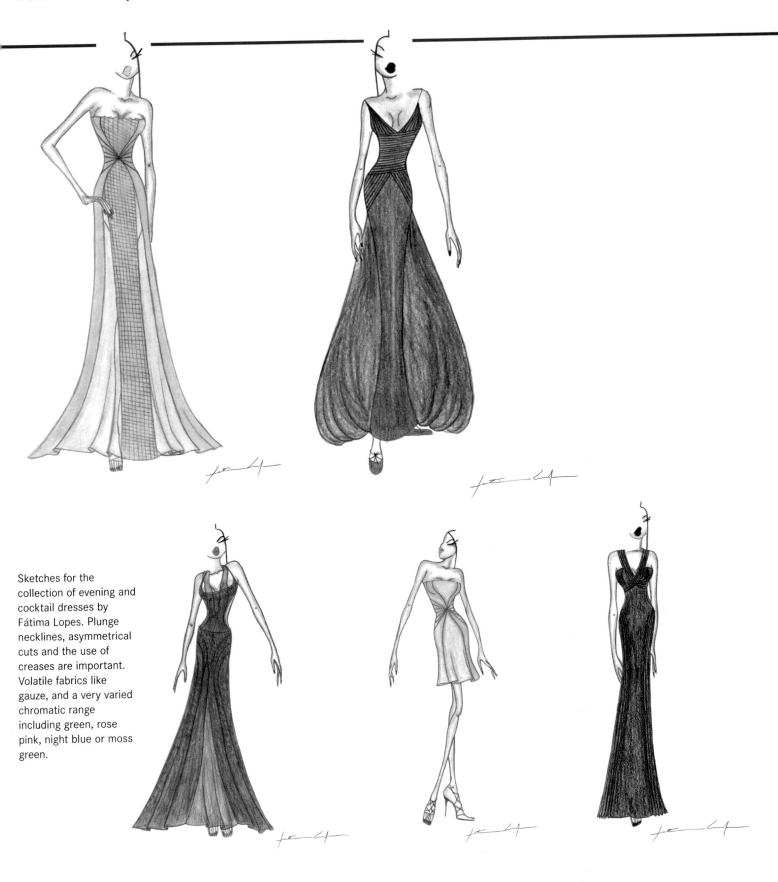

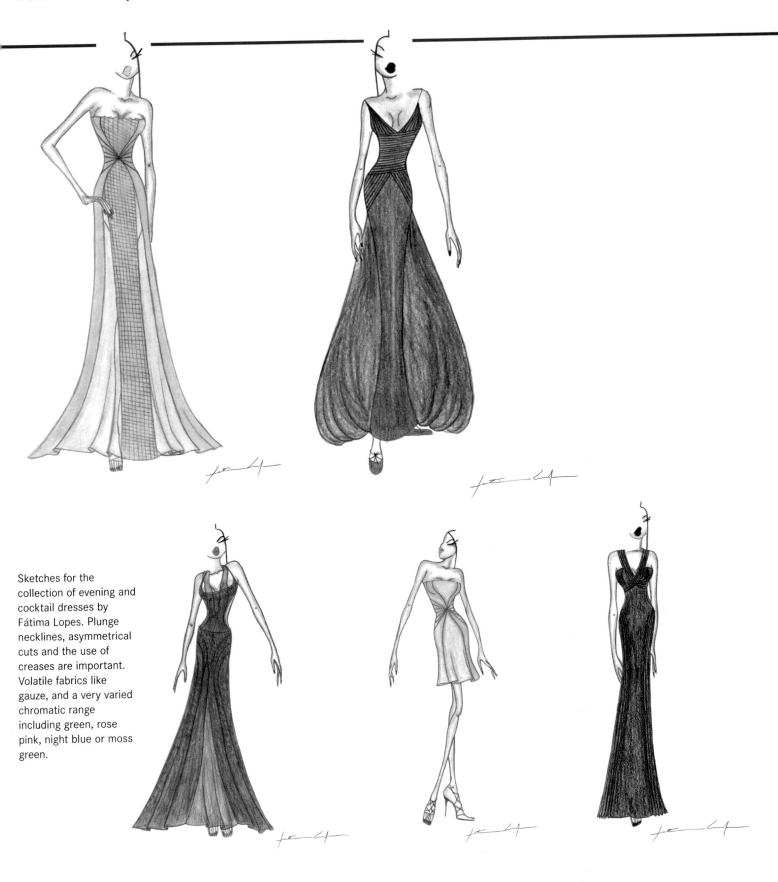

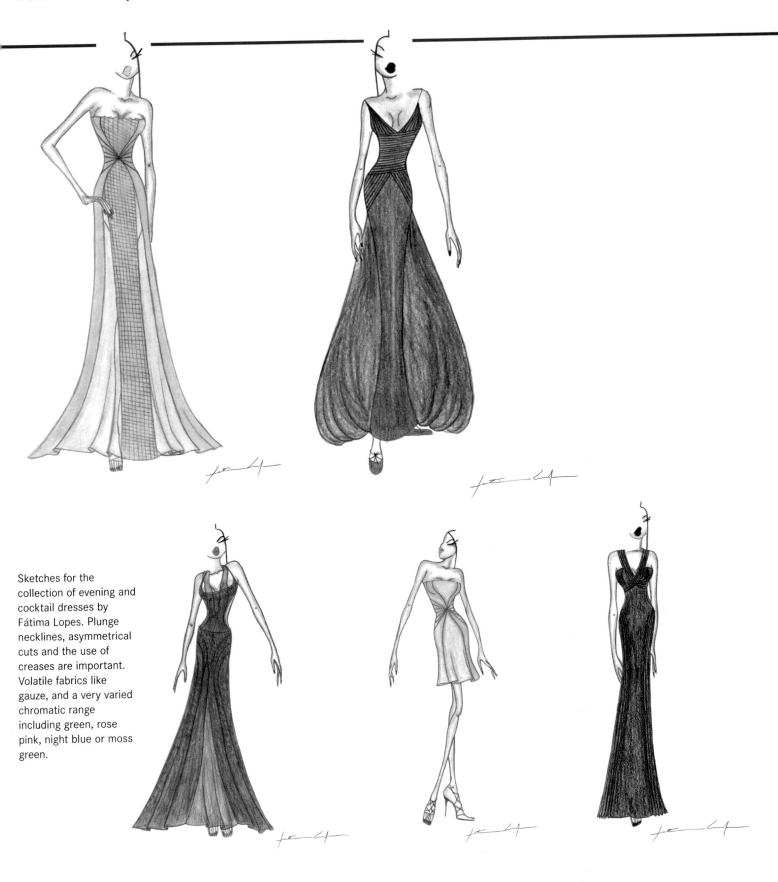

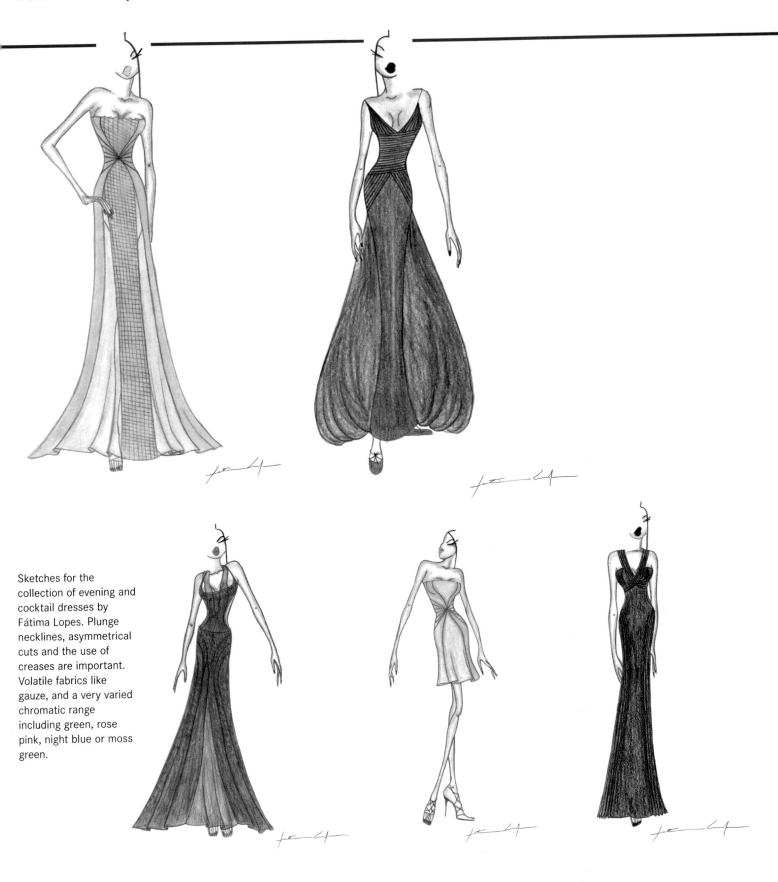

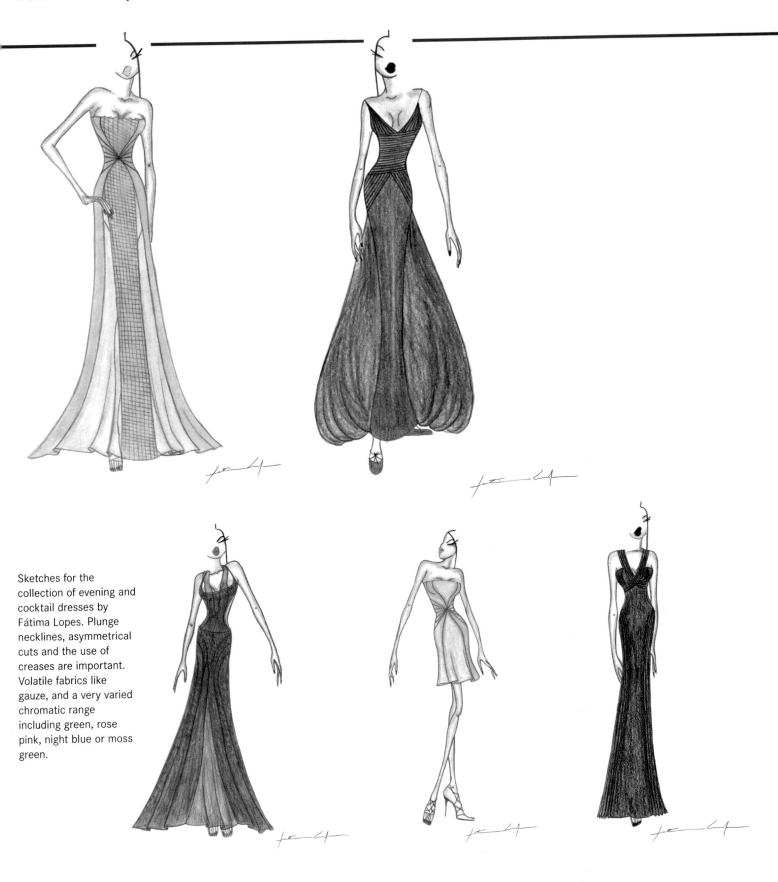

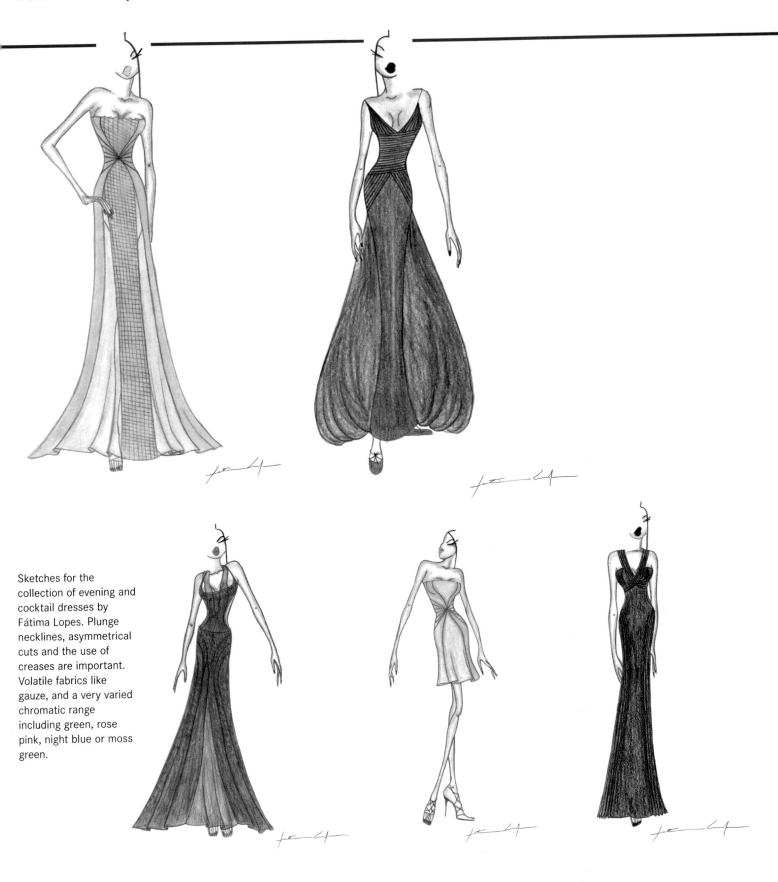

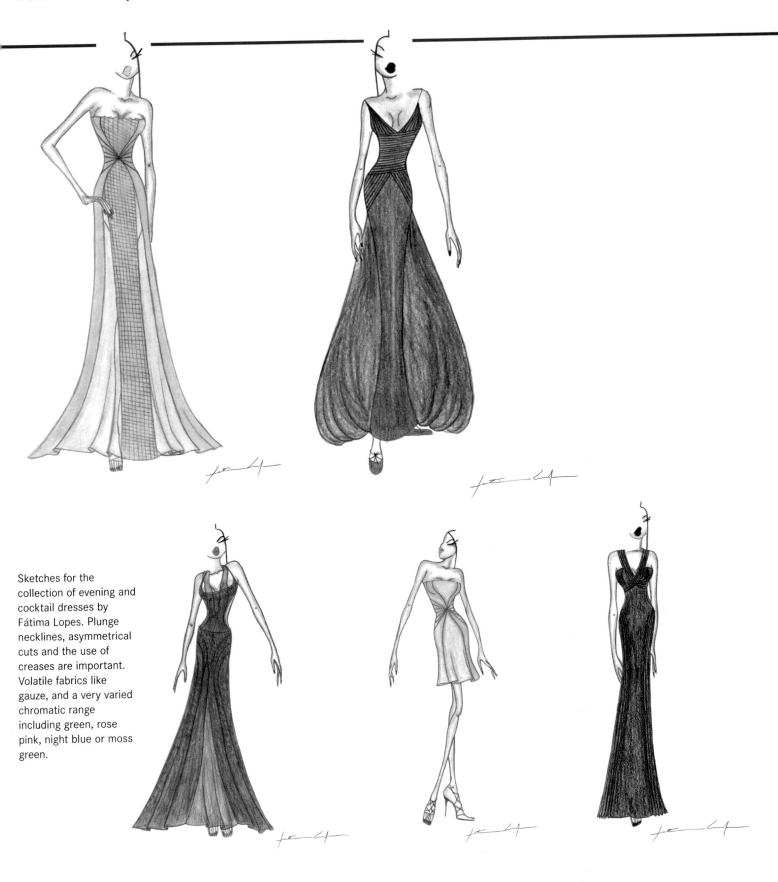

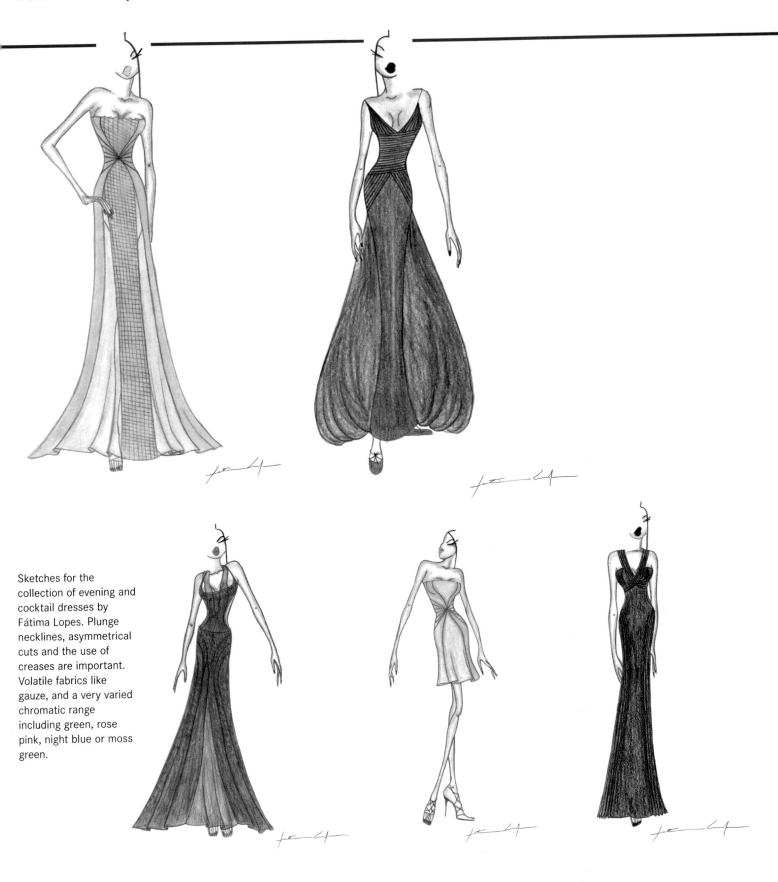

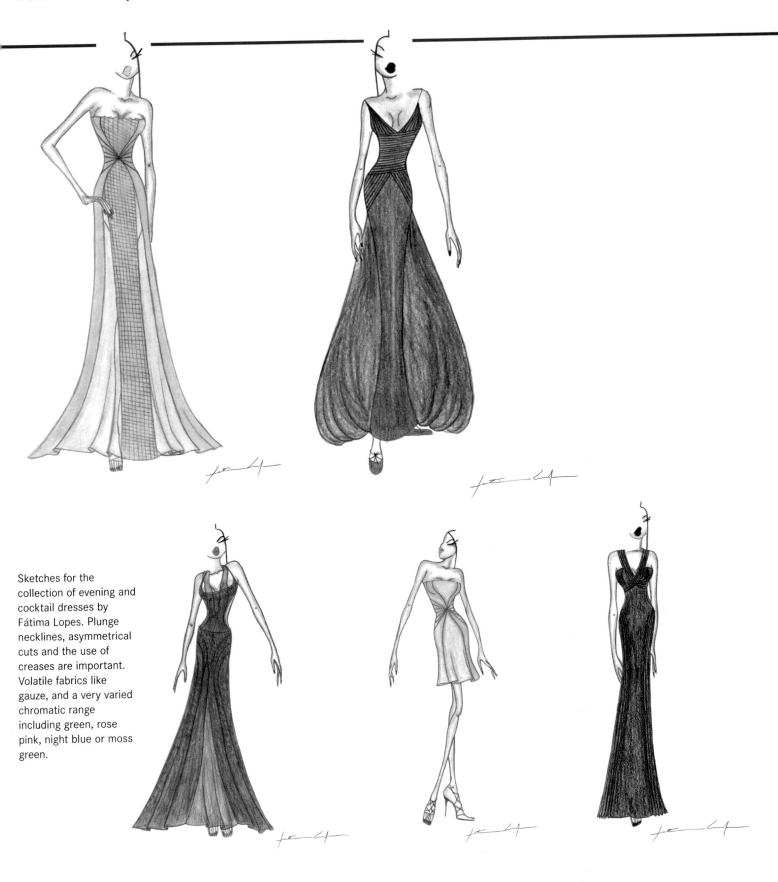

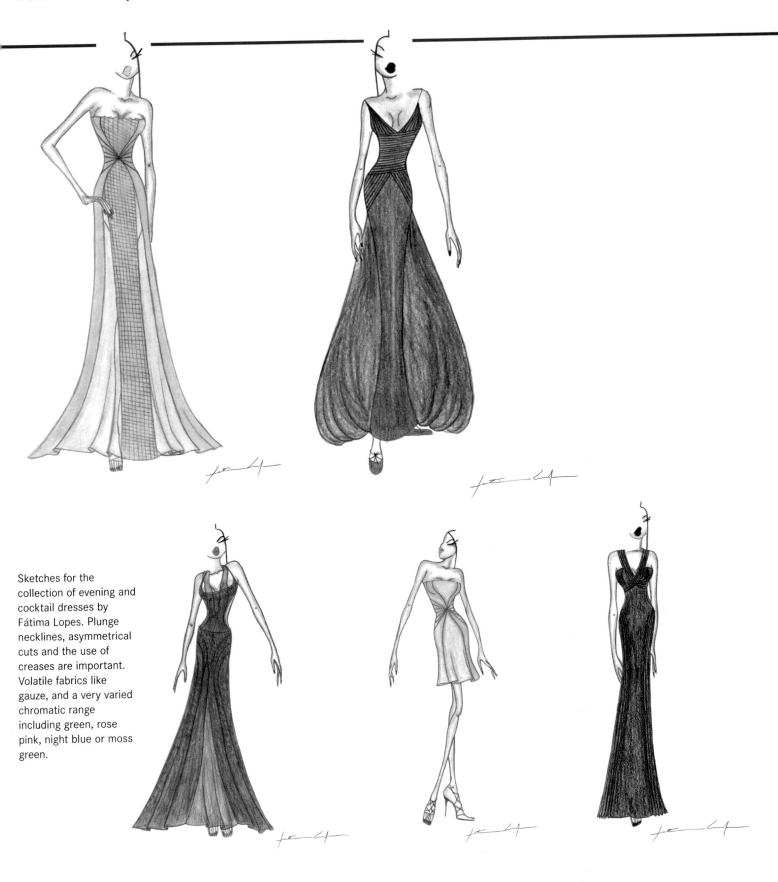

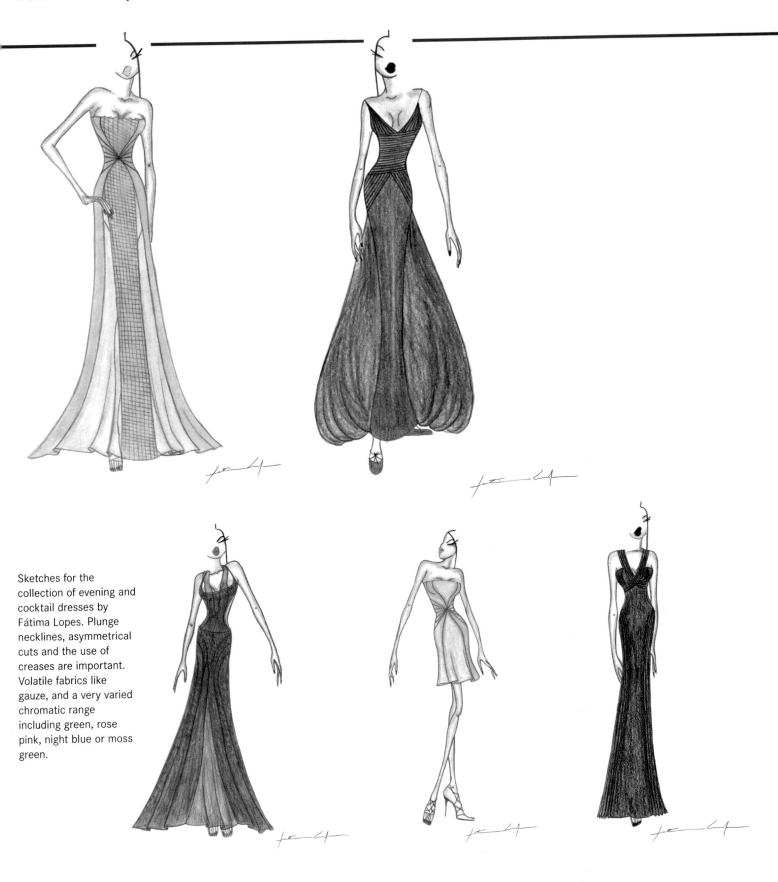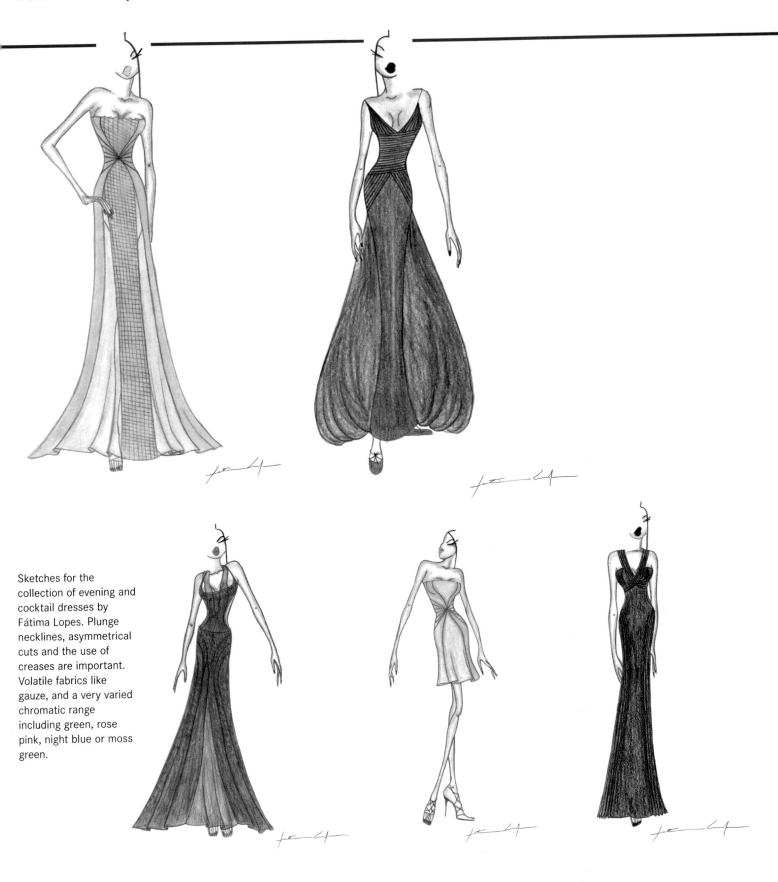

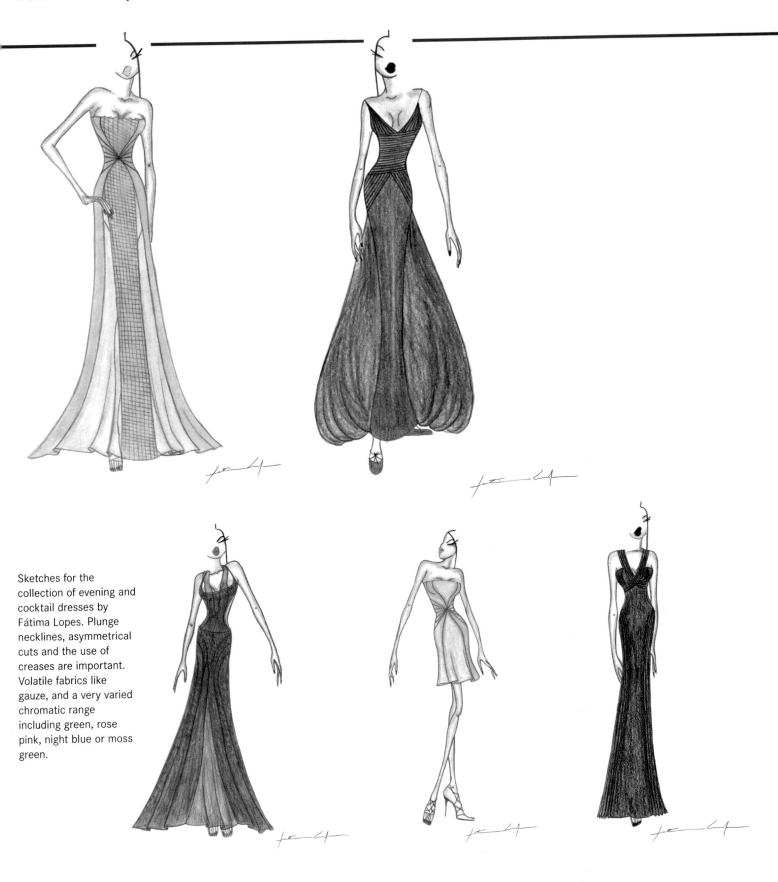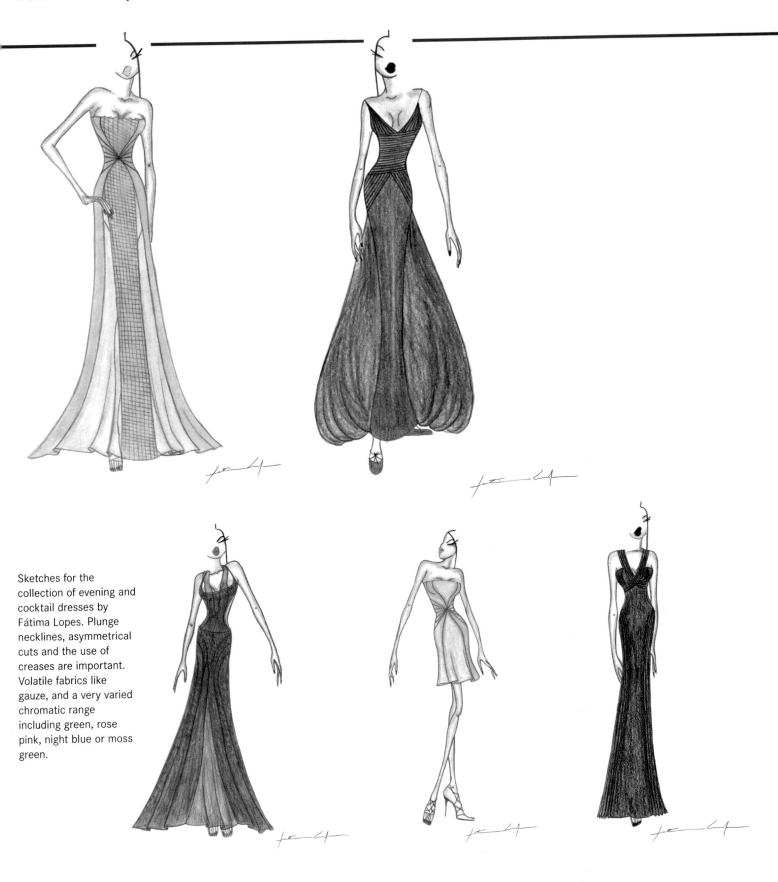

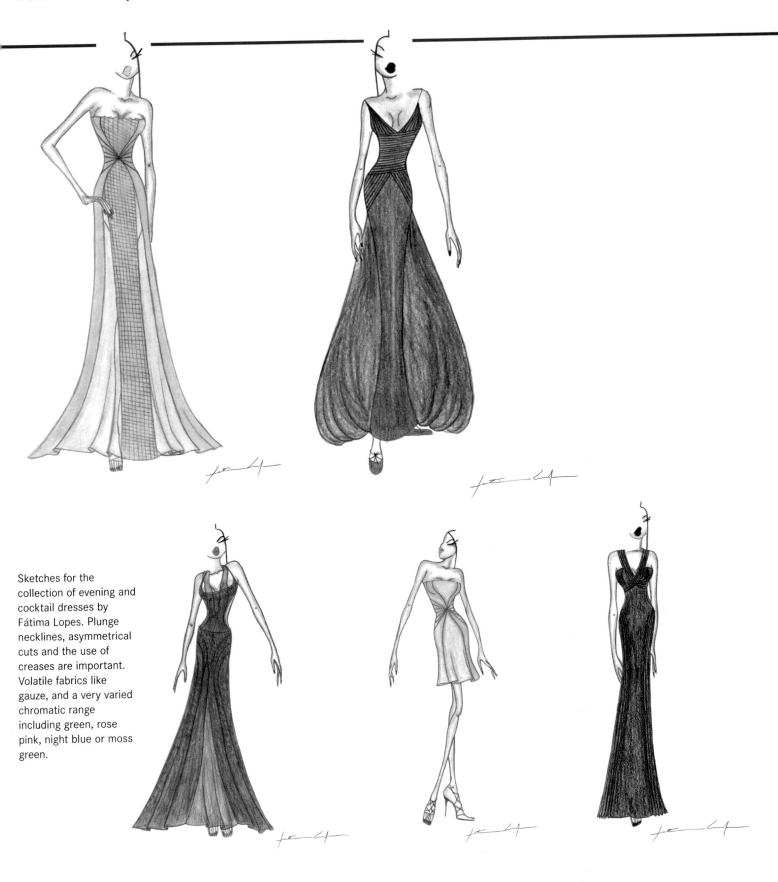

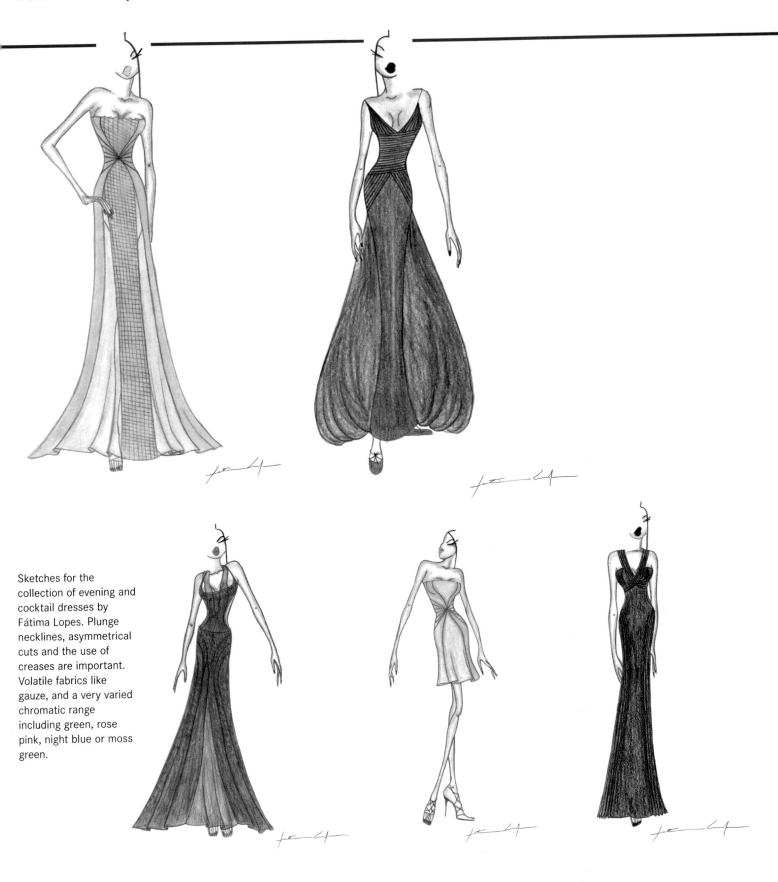

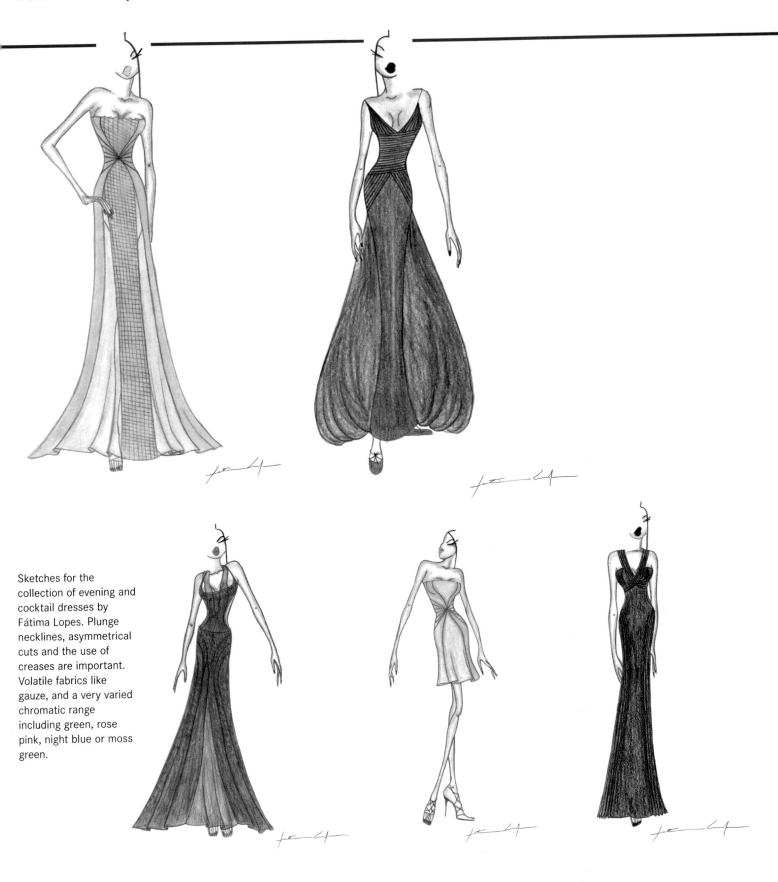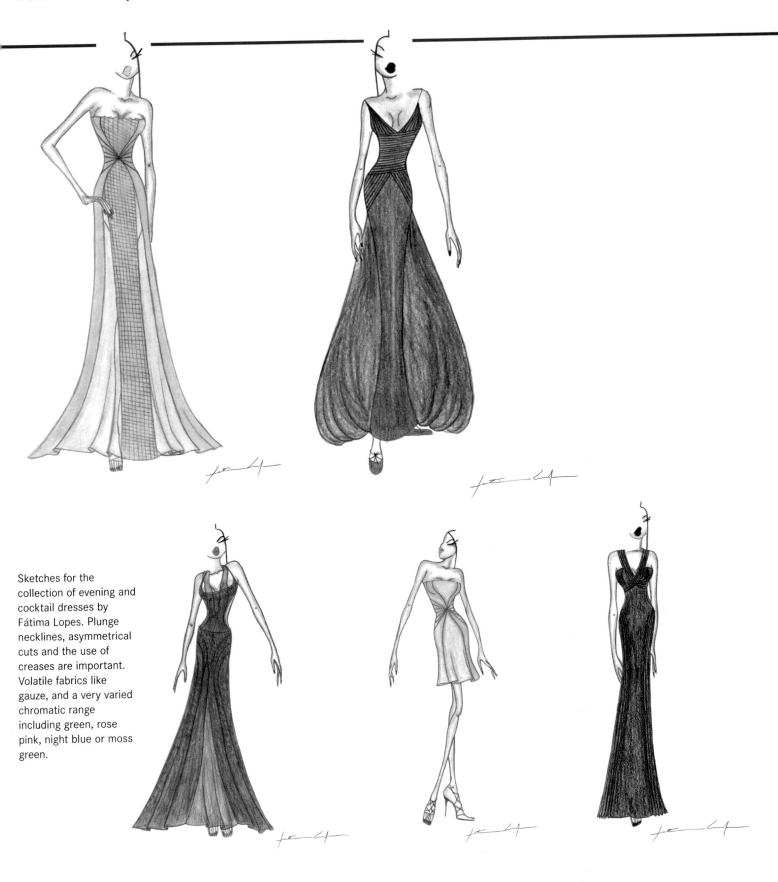

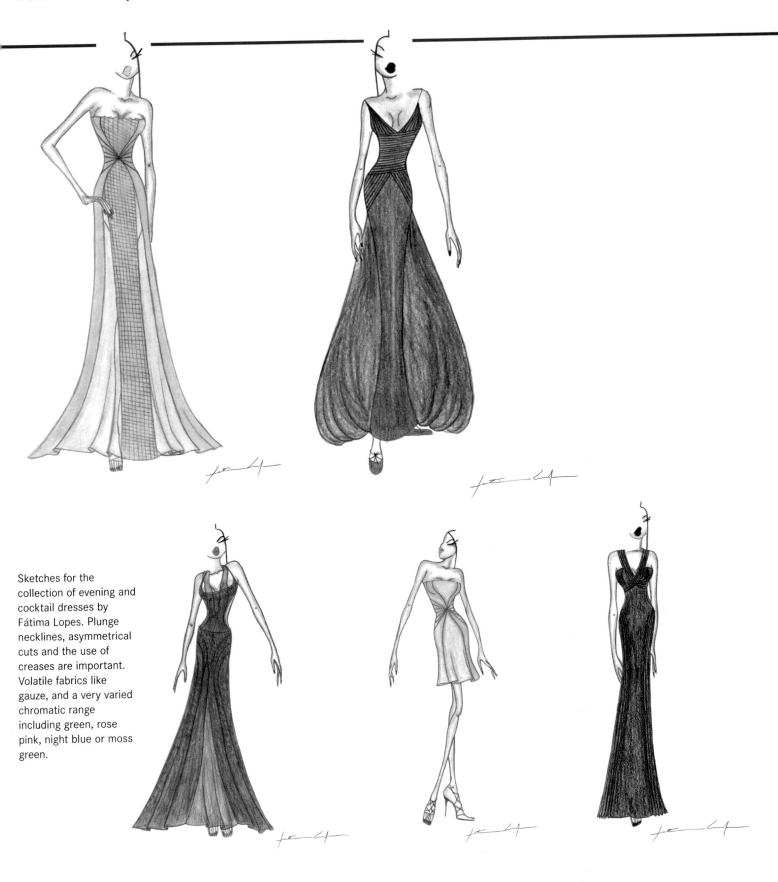

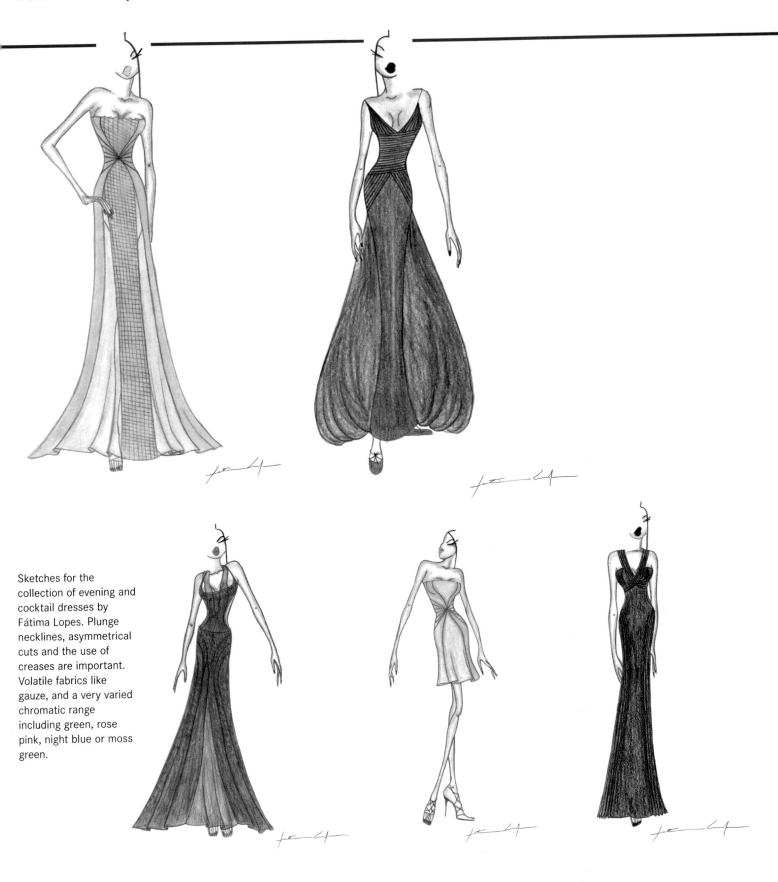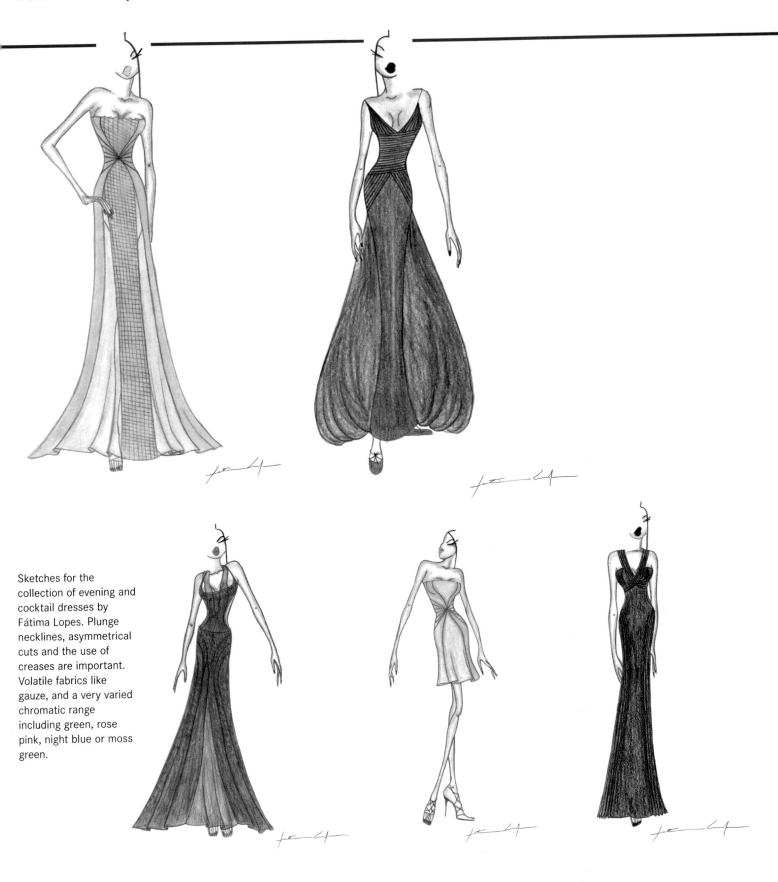

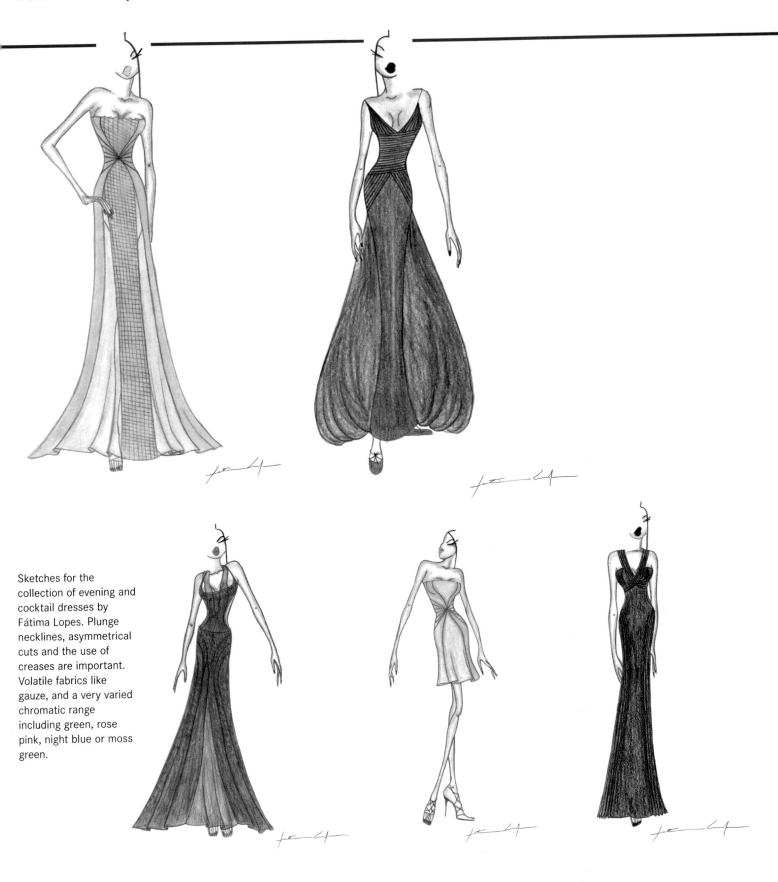

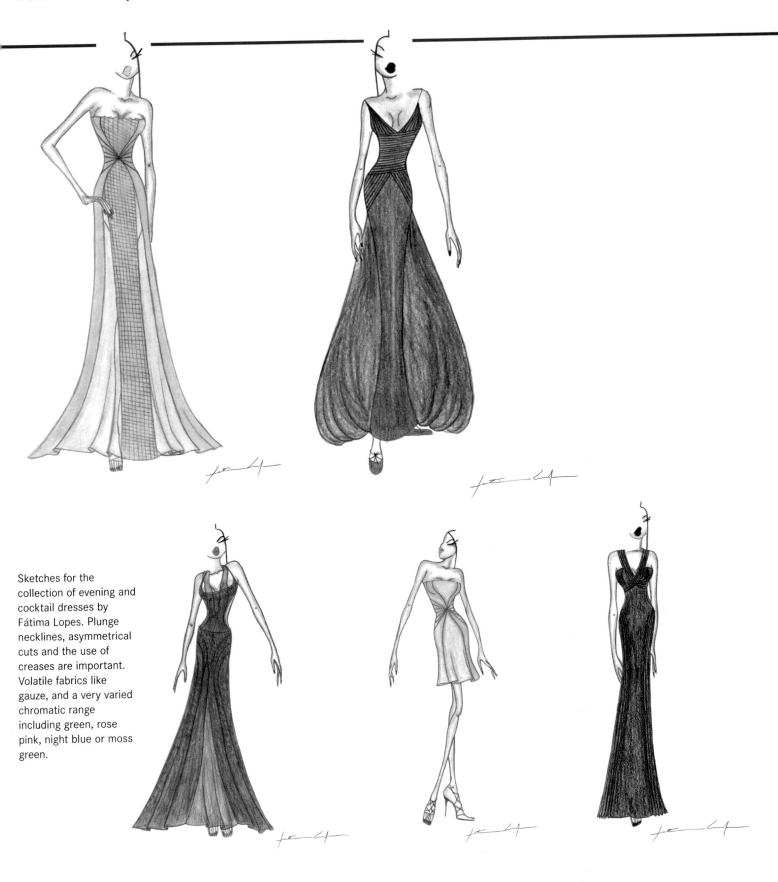

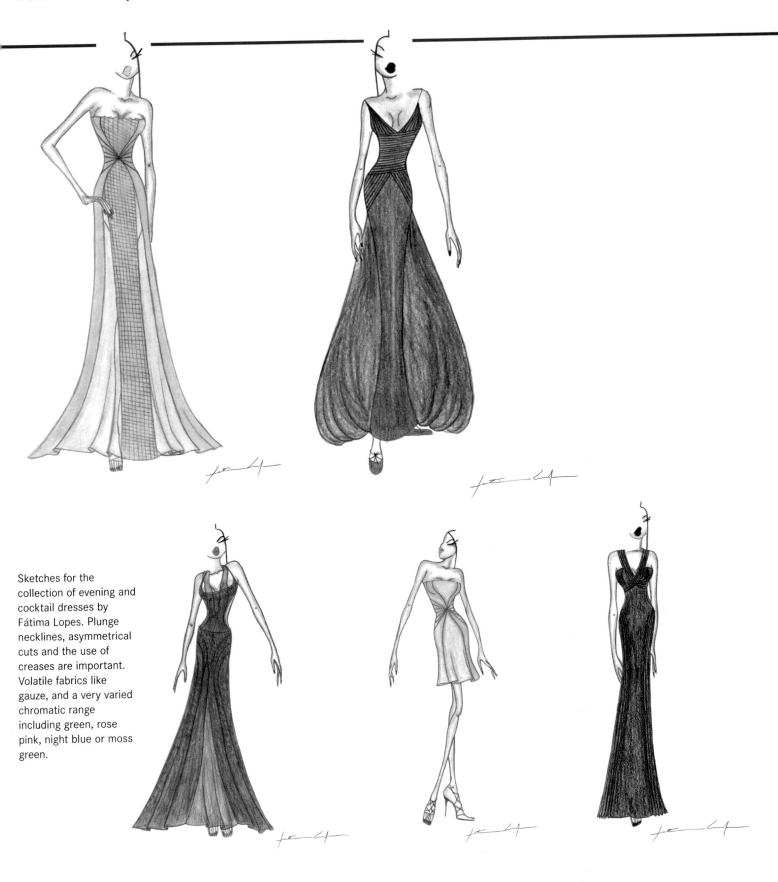

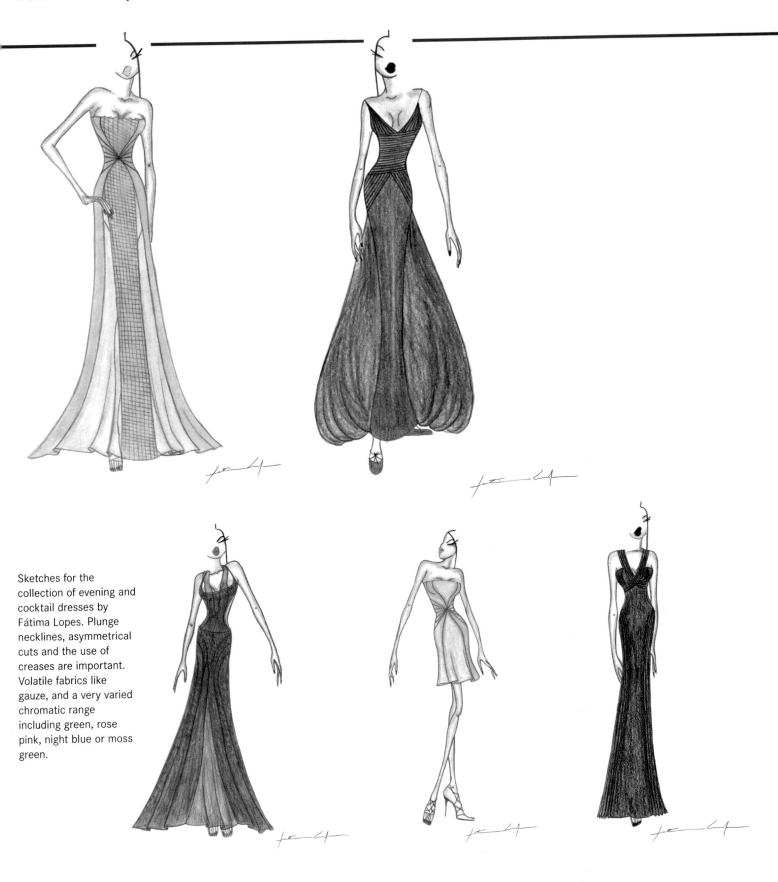

Sketches for the collection of evening and cocktail dresses by Fátima Lopes. Plunge necklines, asymmetrical cuts and the use of creases are important. Volatile fabrics like gauze, and a very varied chromatic range including green, rose pink, night blue or moss green.

"Timeless pieces are difficult to create."

Paris, France, 1961

INTERVIEW

How would you define your style?
My style is about mixing tradition and avant-garde: pure, sharp and graphic elegance.

Which is the most difficult piece to design?
Dressing pieces that are supposed to be "timeless."

Who or what is your main source of inspiration?
Contemporary choreography, movement, attitude, gesture ... and traditional tailoring.

What area of your work do you enjoy the most?
Sketching a proposal of a new silhouette every season, and researching new pattern-cuttings.

Who is your icon of style and good taste?
Romy Schneider.

What are your plans for the future?
To get better and better every season.

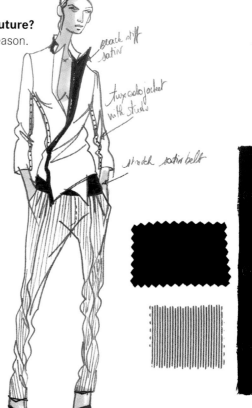

professional CAREER

Gilles Rosier

Born in France, he learned gentleness from his French father, and rigor from his German mother. He has lived in Algiers, Port Gentil in Gabon, Kinshasa in Zaire. His childhood in Paris gave him a taste for drawing and clothing design. From his long childhood journey he kept the immeasurable power of adapting to any situation, anywhere.

If he has learned a lot, as an assistant at arm's length to some of the most famous designers, he has also given a lot to others, as a creator himself. In the Balmain house, he discovered the structure of a fashion house and acquired a sense for methodology, with the highest respect for other's work. His instinct in the Dior house, initiated him in the cut and architecture of clothing, as well as the transposition of men's wear onto more feminine forms. He preferred, nonetheless, to leave the far too institutional fashion temples offering his talents to younger, "hipper" houses.

Gilles Rosier has observed the teachings of immediate application to production. He exerts himself in multiple tasks that stem from choosing the fabrics to organizing fashion shows, not forgetting pattern elaboration. After his apprenticeship in Balmain and Dior, and later in Jean Paul Gaultier and LVMH, he embarks on a new adventure in fashion: his own collection. His designs are always based on the architectural lines and the use of neutral colors. Black is his favorite and the romantic style is always present. In 2005, he created his first men's collection.

Maison Gilles Rosier
4-6 rue de Braque
75003 Paris, France
T: +33 1 49 96 44 44
info@gillesrosier.fr
www.gillesrosier.fr

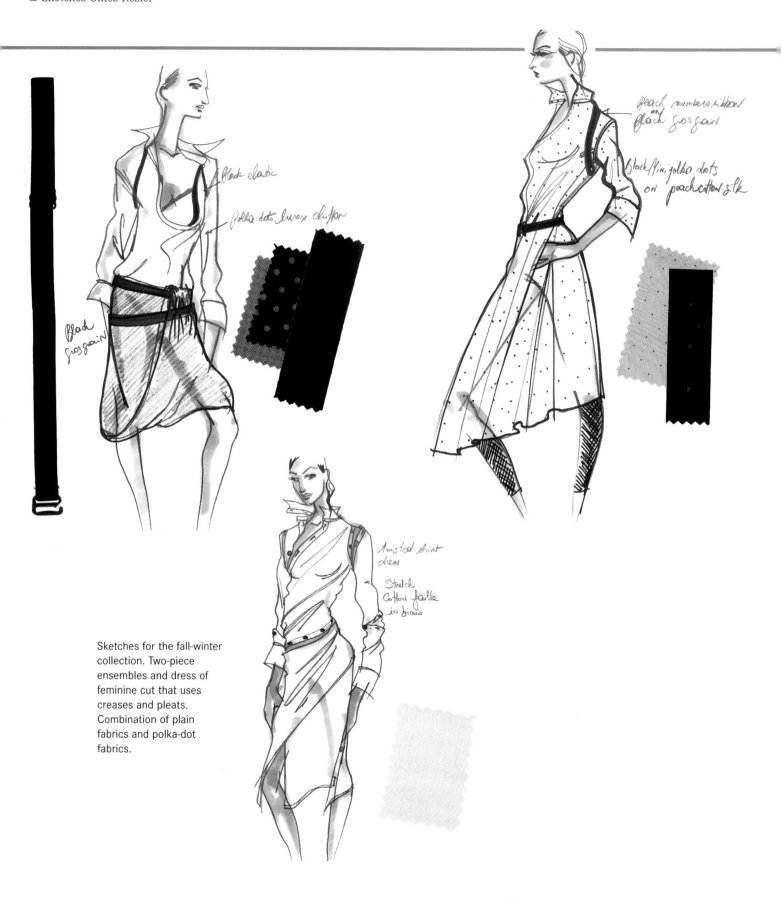

Black elastic

Polka dots lurex chiffon

Black grosgrain

peach numbers ribbon on black grosgrain

Black/pink polka dots on peach cotton silk

Twisted shirt dress

Stretch cotton faille in biais

Sketches for the fall-winter collection. Two-piece ensembles and dress of feminine cut that uses creases and pleats. Combination of plain fabrics and polka-dot fabrics.

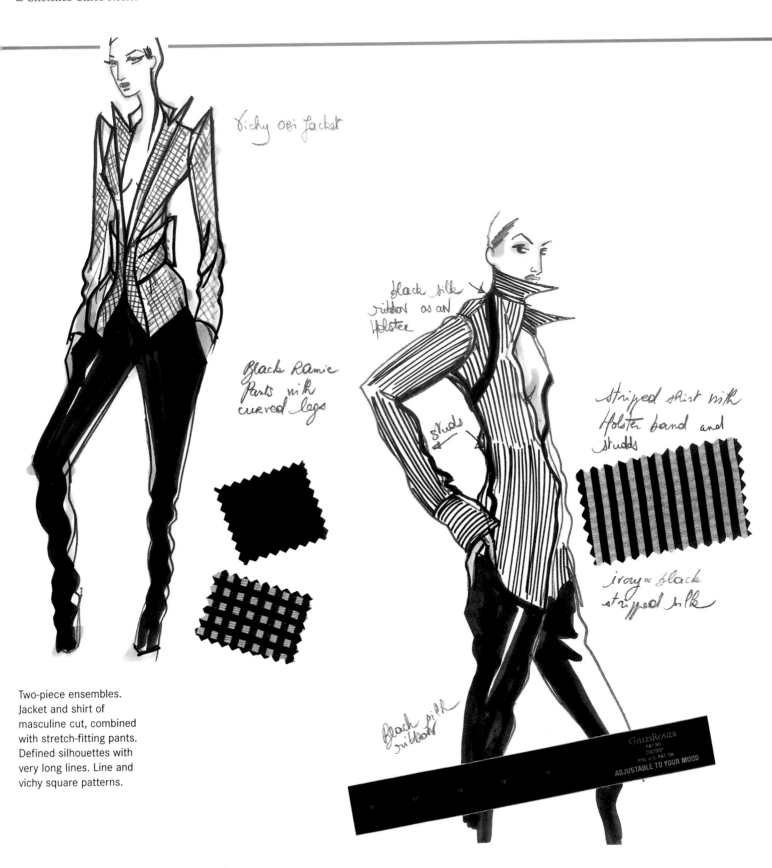

Vichy obi Jacket

Black silk ribbon as an Holster.

Black Ramie Pants with curved legs

studs

striped shirt with Holster band and studs

ivory & black striped silk

Black silk ribbon

GILLESROSIER
PAT NO
202918?
REG. U.S. PAT ON
ADJUSTABLE TO YOUR MOOD

Two-piece ensembles. Jacket and shirt of masculine cut, combined with stretch-fitting pants. Defined silhouettes with very long lines. Line and vichy square patterns.

Palma de Mallorca, Spain, 1976

"Transformation and deconstruction."

INTERVIEW

How would you define your style?
We follow the principles of transformation and deconstruction, revisiting different artistic moments that define our line, our style. Our personal interests mark the pace of development of each collection.

Which is the most difficult piece to design?
The first sketch when we start a new collection. The piece that is capable of inspiring us to develop our own universe in an original and coherent manner.

Who or what is your main source of inspiration?
We find inspiration in transcendent esthetic values, the feminine world with its load of sexuality, sensuality and the erotic, the human figure in volume and silhouette, the color black. The past also inspires our ideas about fashion and we do contemporary re-editions of it.

What area of your work do you enjoy the most?
We enjoy all the areas and creative processes, from the sketch in pencil to the organization of the show. Perhaps the biggest enjoyment comes from completing the cycle, when we see the final result.

Who is your icon of style and good taste?
We admire Mr. Saint Laurent with his impeccable image. He is capable of transcending his own personality and is the personification of good taste.

What are your plans for the future?
Oscar: To arrive to maturity as creators, continue to do coherent collections, work in what we like, as we like it. We are going through a process of creative incubation, collecting the fruits of the work we have done for the past three years. We think that "the best is yet to come."
Gori: We want to find ways for financing and diffusing our brand. We have been fulfilling objectives with illusion; now we want to grow more and widen our horizons. I am interested in integrating the firm into the market.

professional CAREER

Gori de Palma was born in Mallorca in 1976; he created his own brand after presenting his first collection "Confusion" at the Barcelona Fashion Week. His esthetics is influenced by different artistic movements and currents such as rock & roll, punk or bondage. His collections have been exhibited at various platforms and places, namely Pasarela Gaudí in Barcelona, the Círculo de Bellas Artes in Madrid, the BAC in Barcelona, Mid-E in Bilbao, Eurobijoux in Menorca, La Santa in Barcelona, Fame in Valencia, Murcia Joven in Murcia, Pasarela Cibeles in Madrid, FAD in Barcelona, Bread & Butter in Berlin and Barcelona, Textile Fair at Dusseldorf or Nipi in Milan. Among the different awards he has attained for his creative work, the most important are the prize for best collection in MerkaFAD, first place at the Feria Internacional de Muestras in Bilbao, as well as the Art Jove 2005 award in Palma de Mallorca. One of his most remarkable works is the one he has baptized "Trilogy of Black". The last part, "Fallen Women", is preceded by "Fade to Black" and „Die Rothe Rechte Hand", which include a series of clothing items in which black is the connecting thread.

93

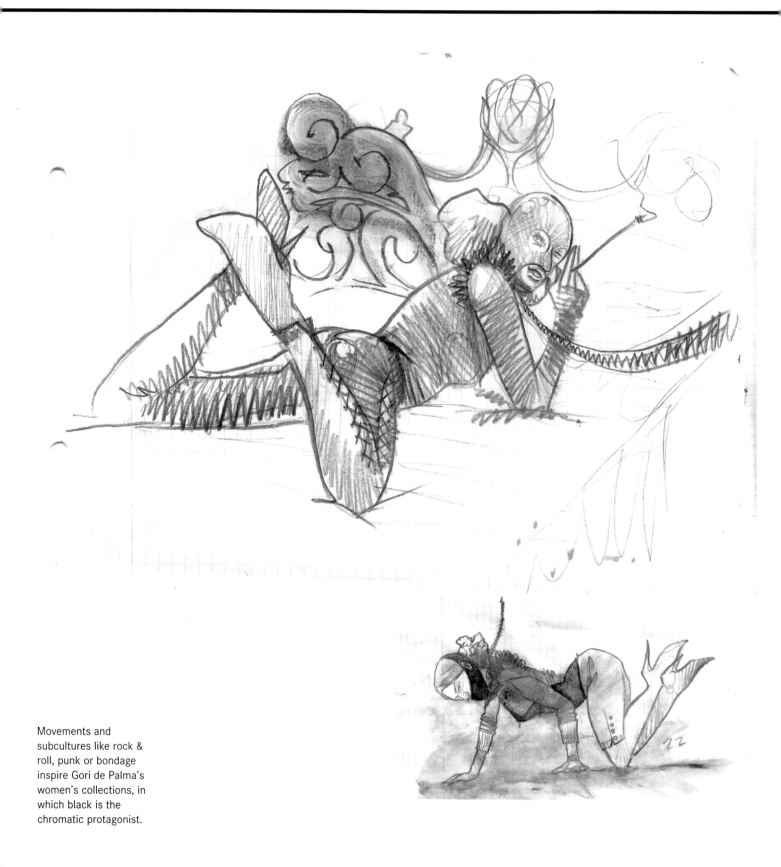

Movements and subcultures like rock & roll, punk or bondage inspire Gori de Palma's women's collections, in which black is the chromatic protagonist.

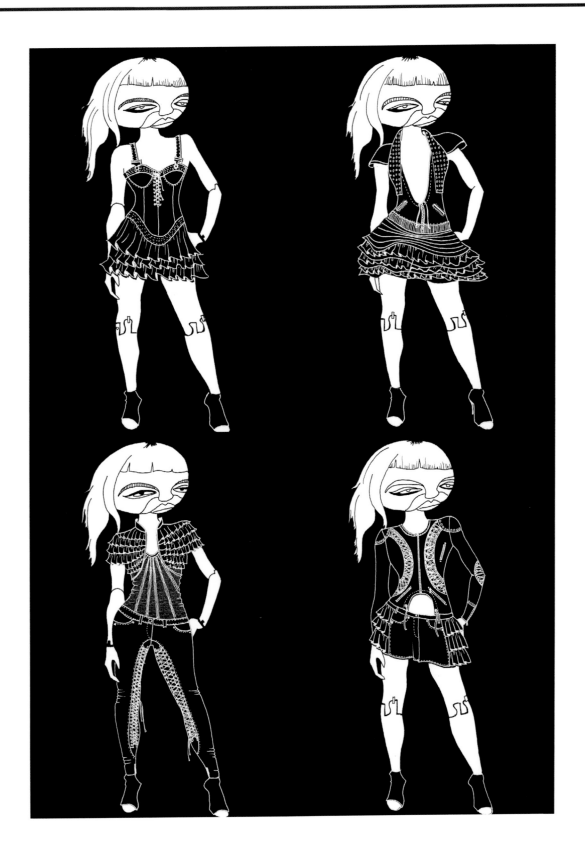

Durban, South Africa, 1968

"My style is a fusion of "old world" glamour with technology."

INTERVIEW

How would you define your style?
My style is a fusion of luxury with sport, "old world" glamour with technology, couture with industrial process and effortless lifestyle dressing that is non-seasonal and travels easily between places, situations and destinations, always modern.

Which is the most difficult piece to make?
The one that is forced, that does not come easily, quickly or spontaneously.

Who or what is your main source of inspiration?
I am inspired by everything that I see, but it is the simplest concepts and ideas that usually work best; very often one only needs to see the old from a fresh perspective in order to create something new. Man's ability to create infinite new variations on old ideas is in itself a wondrous and inspiring thing.

What area of your work do you enjoy the most?
Defining the concept for the season or project and then designing/creating it. The flow of ideas, balance, proportion, cut, construction, color, production and finishing and then finally creating image at the end of the process, communicating the ideas visually.

Who is your icon of style and good taste?
Anyone who lives and dresses in an effortless way with a definite, individual point of view that can be any style. Personally, I believe that too much good taste and style is not a positive thing.

What are your plans for the future?
To establish my brand as a lifestyle concept that is non-seasonal; clear in its modernity and one that remains coherent with my core beliefs while always remaining effortless in its creation.

professional CAREER

Born in South Africa, Hamish Morrow moved to London in 1989 where he studied fashion at Central Saint Martins. Economical problems forced him to leave school and he started to work as a designer and pattern designer until he was able to enter the Royal College of Art.

After getting a master's degree in men's fashion, Morrow started working as a designer for Byblos in Milan. He has also worked for several well-known international design firms such as Krizia, Fendi or Louis Féraud. In 2000, he went back to London and started his own firm.

In 2001, he held his first fashion show which, under the name "The life cycle of an idea", obtained excellent reviews. Since then, he has become a symbol of fashion thanks to the presence of first class fabrics and avant-garde style, as well as music and art which are a source of permanent inspiration for his collections.

Among his collaborations with other firms, it is important to mention the creation of a special line for the chain Topshop, and the creation of a collection of jeans wear and metal fabrics for Yoox.com.

Hamish Morrow

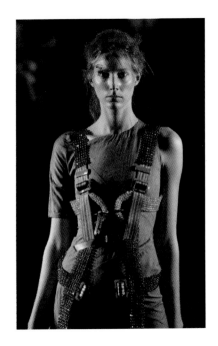

Unit 18 Links Yard
29 Spelman Street
London E1 5LX
United Kingdom
T: +44 207 377 9444
info@hamishmorrow.com
www.hamishmorrow.com

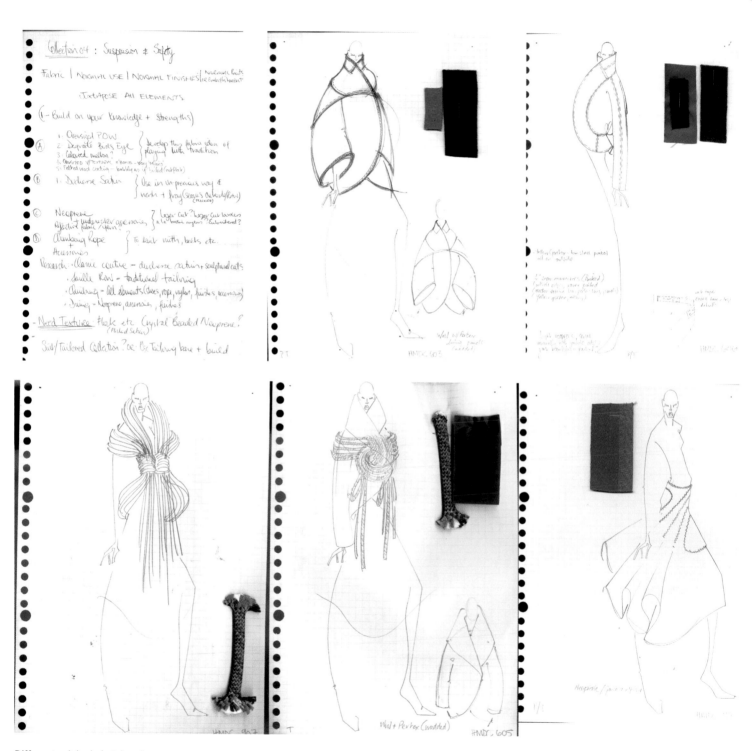

Different original sketches by
Hamish Morrow, accompanied
by color charts and samples of
wool, cotton or string knitting.

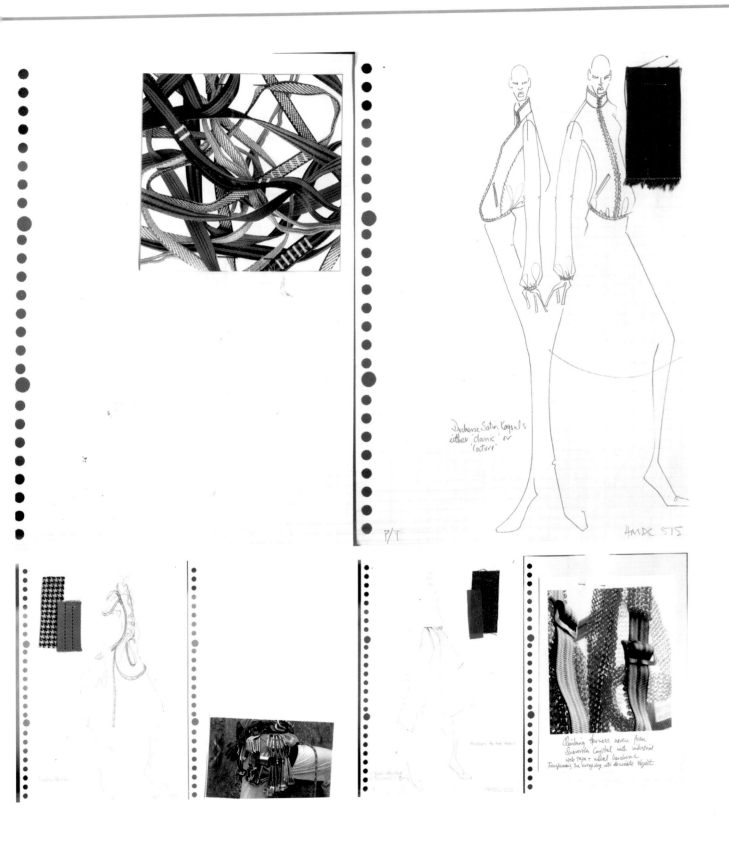

P/T

Duchesse Satin Kagoul's
either 'classic' or
'couture'

AMDC 515

Neuilly-sur-Seine, France, 1967

"My main source of inspiration is everyday life."

INTERVIEW

How would you define your style?
Urban, androgynous, contemporary, with a mix of world culture and inspiration from different ages.

Which is the most difficult piece to design?
I think that the most difficult pieces to do are the most simple, how to simplify without being boring.

Who or what is your main source of inspiration?
My main source of inspiration is everyday life, looking at people in the street, trying to analyze what they are looking for when they are buying garments.

What area of your work do you enjoy the most?
Starting a new collection! It is always very surprising for me to find out that even if I have been sweating on the past collection, as soon as it is finished, I am already looking forward to start a new one. I am always feeling that I did not totally reach the point that I wanted.

Who is your icon of style and good taste?
I do not really have an icon but there are a lot of women that I feel close to, such as Patti Smith, Jane Birkin or Françoise Hardy for their simplicity and androgynous attitude. However, there are other women that are equally inspiring such as Simone de Beauvoir and Diana Vreeland for their natural chicness and sense of mixing different styles.

What are your plans for the future?
I would like to develop my brand in many cities of the world while remaining a small artisan company to keep the strength of my style as it is today.

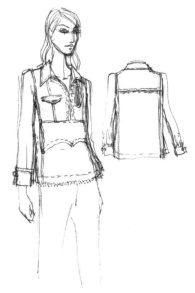

professional CAREER

Isabel Marant, born in 1967, creates her own world of "melting mode". Her French father, her German mother and particularly her west Indian mother-in-law, gave her a cosmopolitan education. It is also while traveling in India or Africa that she finds her inspiration.

Gifted with a range of skills, Isabel launched a first line of jewelry which would be the best way to finance her business. In 1990, she launched Twen, a small knitwear collection that would grow and become later the Isabel Marant we know today.

The Isabel Marant style is a culture mix, a cosmopolitan and urban world. Isabel's silhouettes show feminine, fitted and close-to-the-body elegance.

Etoile is the second line designed by Isabel Marant. It is defined by the paradox of proposing wardrobe that is not only accessible but very much of the moment. The collection is a collage of sportswear classics inspired by work wear or military garments combined with more feminine pieces and knitwear. Etoile also combines comfortable active sportswear elements to be worn alone or mixed with a dash of attitude for dressed-up pieces.

What makes this collection stand apart is the attention paid to textiles and texture: fabrics are washed and aged with boiled and wrinkled effects, faded, half-tone colors set off by bright highlights, seams are left raw and hems slightly frayed. Etoile offers clothes that are personal and strong but easy to wear.

Isabel Marant

3 passage Saint Sébastien
75011 Paris, France
T: +33 1 49 23 75 40
Fax: +33 1 49 23 09 73
improduction@isabelmarant.tm.fr

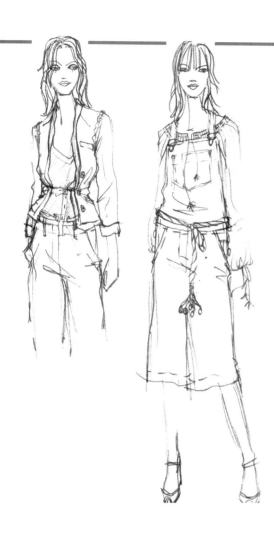

The Marant collections
are designed for a young
woman, between 15 and
35, and are completely
informal in style. It uses
fabrics like flannel
combined with lycra, and
designs that model body
volume, without clinging
to the body.

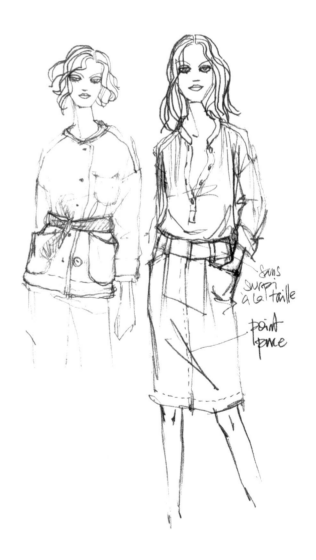

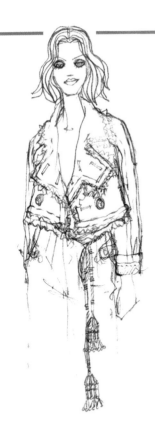

Proposals that emerge as
a result of cultural
mixtures, combinations
of past and present, and
clear ethnical influences.

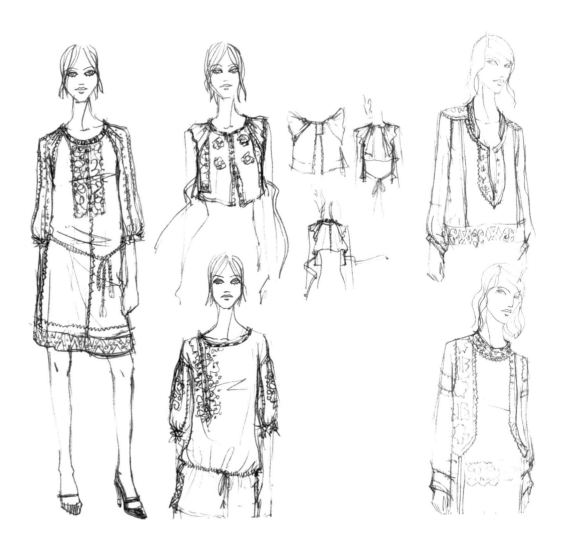

JANIÚMÉS 25

Alcanar (Tarragona), Spain, 1980;
Vinaròs (Castellón), Spain, 1980

"Our main reference is classical men's tailor trade."

INTERVIEW

How would you define your style?
We intend to show a rational, geometric and mathematical vision in our clothing items, through the austere abstraction of forms. We aim for reinterpreting classical men's tailor's trade and offer a sober focus, based on rigid silhouettes that are the opposite of the baroque. We want to transmit a strict and contained image.

Which is the most difficult piece to design?
All pieces have a certain degree of difficulty. The challenge is to create a different clothing item which is also minimalist, using patterns and watching out for details.

Who or what is your main source of inspiration?
Our fashion language has several references, but the main one is classical men's tailor's trade. Anything can be a source of inspiration, from Malevich, Joseph Kosuth, Friedrich or Peter Greenaway, to the Polanski film "Repulsion".

What area of your work do you enjoy the most?
The most exciting part is when the clothing item is finished, after having passed through all the problems found during development. We also like selecting fabrics.

Who is your icon of style and good taste?
Style and good taste are an attitude; we could not point out a particular person. For us, it would be a sum of various people.

What are your plans for the future?
To make our collections better known and to continue working on our project, Jan iú Més.

professional CAREER

Jan iú Més is a firm that makes menswear; it is comprised by Jan Zamora and Alfonso Peña. Although their career is marked by diverse experiences in areas as varied as styling, graphic design, photography or illustration, both consider themselves self-taught fashion designers. They presented their first spring-summer collection in 2005 as part of the group of Creadores Emergentes at the Barcelona Fashion Week, and afterwards they presented it at DemoCircuit. This is a group of proposals that revolved around black and white, and that were restructured by creating new pieces starting from deceitful patterns.

In 2006, they participated in Pasarela Abierta, in Murcia, where they were very well received by the public and the specialized press. On this occasion, the duet placed its bet on a collection of narrow silhouettes with black as the only linking thread. They have also taken part in El Ego at Cibeles or Futuromoda, and they work together with several music groups.

The Jan iú Més collections are characterized by deconstruction and austerity in the items, and by the constant reinterpreting of classical men's tailor's trade. Their clothes are made for a simple, strict man, with quiet sensuality, but who never loses sight of his masculinity. They share the same vision of obscure and minimalist esthetics which avoid stridencies.

Jan Zamora,
Alfonso Peña

Avda. República Argentina 91-93, 1ª 3ª
08023 Barcelona, Spain
T: +34 93 210 40 97
info@janiumes.com
www.janiumes.com

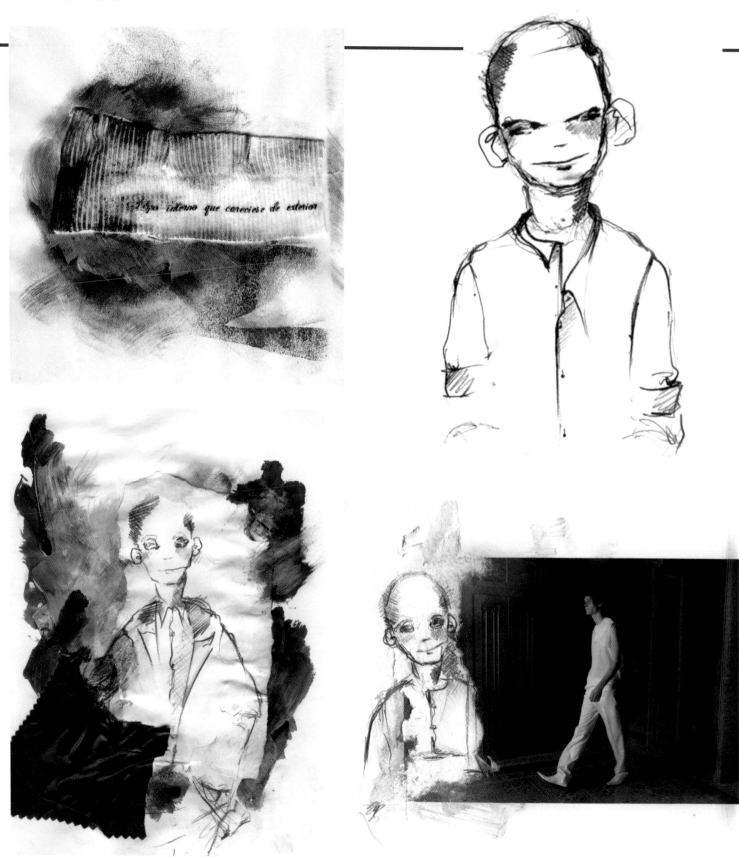

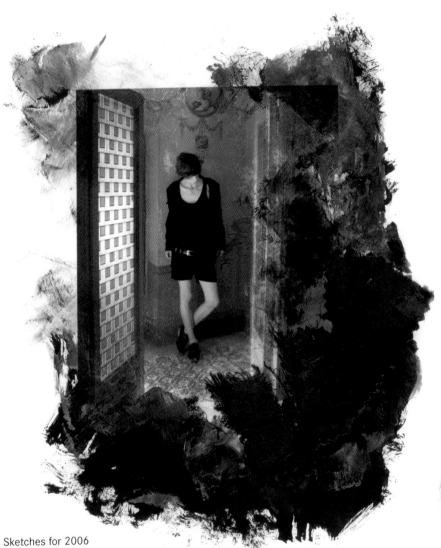

Sketches for 2006
spring-summer and
2006-07 fall-winter
collections.
Deconstruction, austerity
and reinterpretation of
the classical menswear
tailor's trade are the
constant item of this
creative duo.

jordiLABANDA 26

Mercedes, Uruguay, 1968

"Avedon is my reference."

INTERVIEW

How would you define your style?
Elegant, chic and ironic.

Which is the most difficult piece to design?
With a good team, no piece is a problem, it is a challenge!

Who or what is your main source of inspiration?
All the classic references from the 40s to 60s, from fashion photography to films or architecture ... but overall, the work of Cristóbal Balenciaga, Schiaparelli and Alexey Brodovitch.

What area of your work do you enjoy the most?
The moment the pieces come for the very first time from the atelier for fitting is like Christmas.

Who is your icon of style and good taste?
Avedon's picture *Dovima with Elephants* is my compass since I was a child.

What are your plans for the future?
I am currently at a very exciting point, since from now on I will be the absolute designer of everything that may carry my name, in other words I wont lean back on a design team to develop my collections, I've decided to become 100% in charge of the garments that leave my firm. I want everything to have a "very Labanda" air to it, very chic, very recognizable... To work hard for this to be just as I want it, pamper every garment and enjoy it as much as possible are my priorities for the future.

professional CAREER

Jordi Labanda was born in Mercedes, Uruguay and has lived in Barcelona since the age of three. He studied industrial design and began to work as a commercial illustrator in 1993.

In 1995, he began to collaborate widely in the international press, his work appearing in *The New York Times Sunday Magazine*, *Visionaire*, *Wallpaper**, *Flaunt*, *Tatler*, *W*, *+81*, *Vogue America* and *Vogue Italia*. His corporate clients include JVC, American Express, Alessi, Zara, Adidas, Puig Fragrances, Manga Films, Abercrombie and Fitch, Pepsi Light, Knoll International, Nissan Spain, Dior, Target and Neiman Marcus.

Noteworthy special collaborations include the design of the Nissan Micra Jordi Labanda and its limited edition; the fantastic murals at Sandwich & Friends in Barcelona; an exhibition for Salvatore Ferragamo in Florence; Louis Vuitton in their 150th anniversary celebrations; the cinema poster for Relative Values and various book and disc covers, such as the cover for Wallpaper* compilation CD. Jordi Labanda's latest projects include an Exhibition at MALBA (Museum of Modern Art at Buenos Aires), Argentina, AMAZE ME, a special collaboration with Nick Knight of SHOWstudio in London, and Dom Pérignon (LVMH) has named him ambassador of the emblematic champagne brand in Spain. Jordi's most recent collaboration with Dom Pérignon has been an art installation at the MACBA (Museum of Modern and Contemporary Art of Barcelona).

In recent years he has also expanded into the world of design: he has his own fashion collection and has created a line of notebooks, pens and accessories with his illustrations, design and brand, available in Europe, America, Australia and Japan.

In September 2006, Jordi Labanda opened his first flagship store in Barcelona.

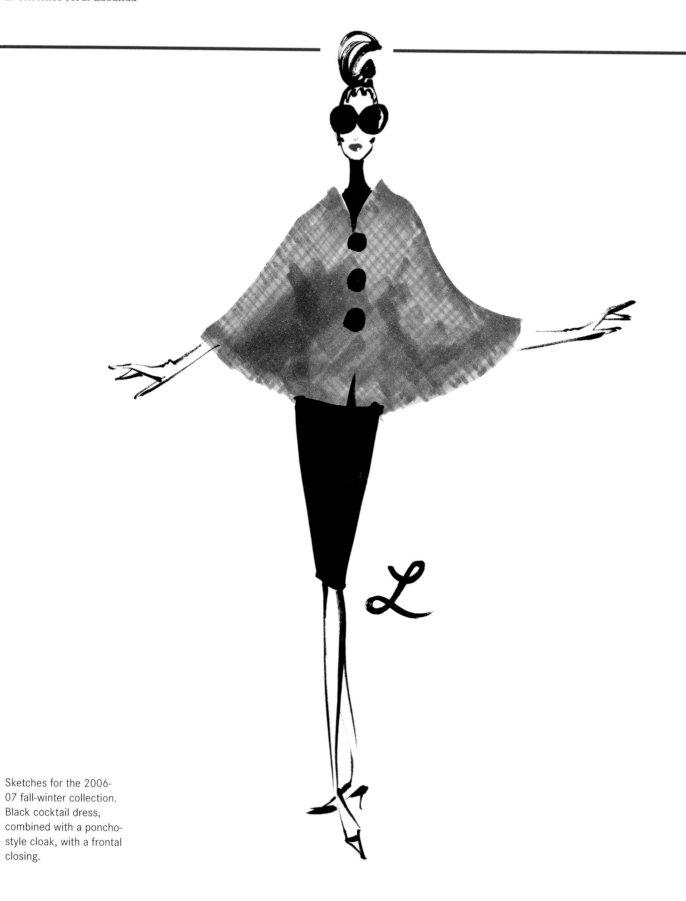

Sketches for the 2006-
07 fall-winter collection.
Black cocktail dress,
combined with a poncho-
style cloak, with a frontal
closing.

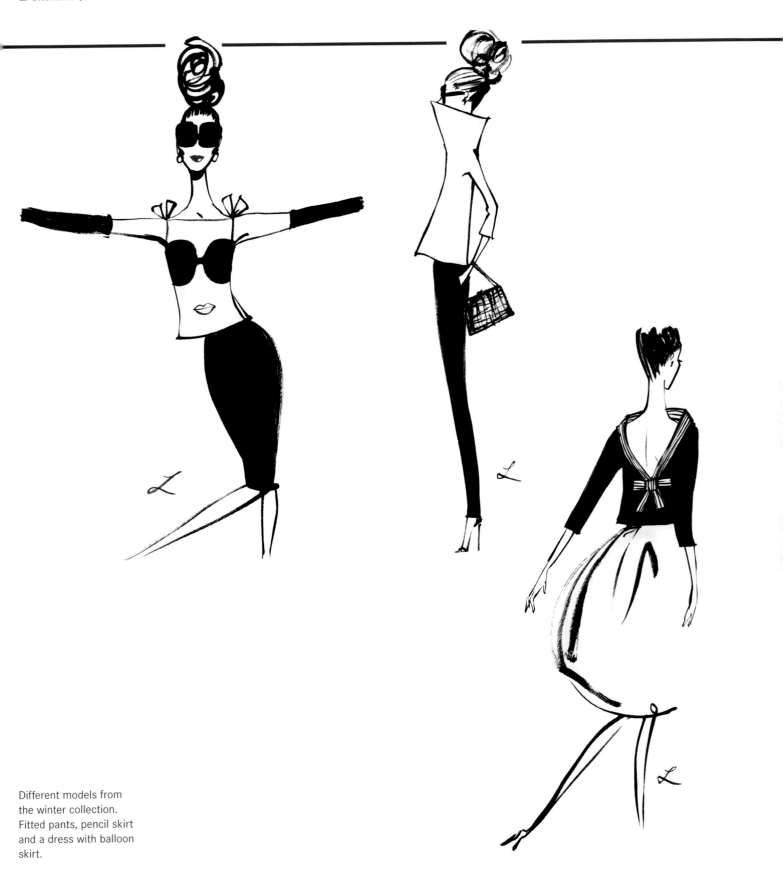

Different models from
the winter collection.
Fitted pants, pencil skirt
and a dress with balloon
skirt.

"Getting to the essence of anything is always the most difficult."

INTERVIEW

How would you define your style?

Timeless designs that follow no marked season tendency, with an esthetics that reminds us of the 40's and 50's, exquisite materials and an almost architectonic build.

Which is the most difficult piece to design?

I have always thought that a very low-cut sandal is the shoe in its minimal expression. For me, this is the essence of seduction: a nearly naked foot, a vertiginous heel and noble materials; to get to the essence of anything is always the most difficult thing to do... and the hardest thing to do is always the most attractive.

Who or what is your main source of inspiration?

All my work wants to bring together esthetic and use it to create pieces that can last, while fulfilling their function and not ending up in the back of the closet. My inspiration is research, discovering what has been essential for women as far as shoes go, and what has helped them to become more feminine.

What area of your work do you enjoy the most?

I love it when I suddenly see in a sketch, a flat figure, something that brings to my head a shape, a volume, a combination of colors, and I realize that I have created a starting point; then the whole process until I have the physical product right in front of me is fascinating.

Who is your icon of style and good taste?

In the fashion world, the Christian Dior & Roger Vivier tandem. For a woman, Ingrid Bergman.

What are your plans for the future?

To continue enjoying my job and to make other people enjoy it too.

professional CAREER

Classical shoes, slightly low-cut and with a fine, high heel: the images these bring to our minds are unending. These shoes have been through society salons, dark alleys in mystery novels, and miles and miles of celluloid without ceasing to fascinate. These steps have accompanied a certain way of understanding femininity. Elegance has a lot to do with this passing through life without losing the shapes. Juan Antonio López has dream about these shoes since he was born.

In spring 2002, Juan Antonio López presented his first collection under his name, supervised directly by him and maintaining artisan production systems just like those he was familiar with as a child. Until then, his expert design was the secret of several shoe collections belonging to many firms in our country.

Understanding the creation of a shoe as know-how, both in the technical and esthetical aspect, he defines himself more as a shoemaker than as a designer. His collections are a reflection of this premise. Timeless designs, a reduced variety of materials and an almost architectonic build, define his shoes. The passion with which he thinks them up, the sincerity with which he works on them and the dedication with which he follows the whole fabrication process results in the essence of the women's shoe.

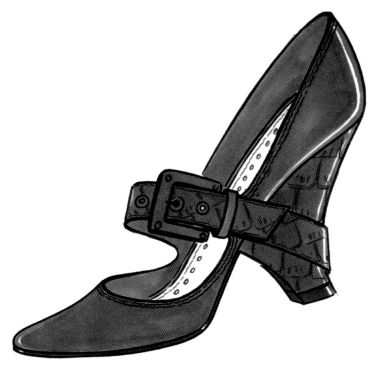

Juan Antonio López

C/ Cansell de Cent 240
08911 Barcelona, Spain
T: + 34 93 452 66 90
olga@juanantoniolópez.com
www.juanantoniolópez.com

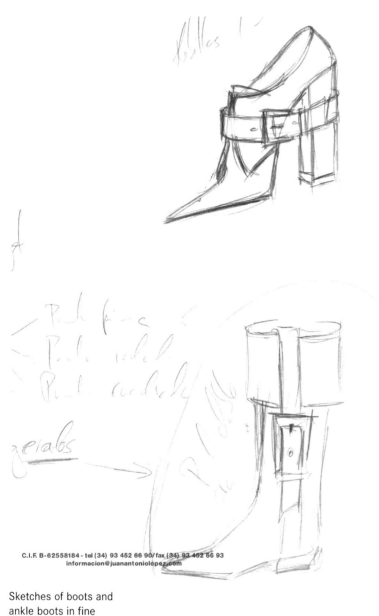

C.I.F. B-62558184 - tel (34) 93 452 66 90/ fax (34) 93 452 66 93
informacion@juanantoniolópez.com

Sketches of boots and
ankle boots in fine
leather and square heel;
buckles are present as
an ornamental detail.

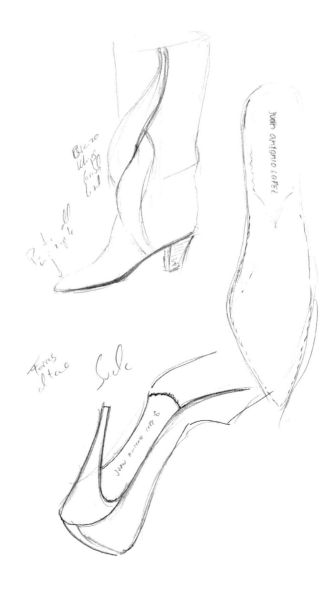

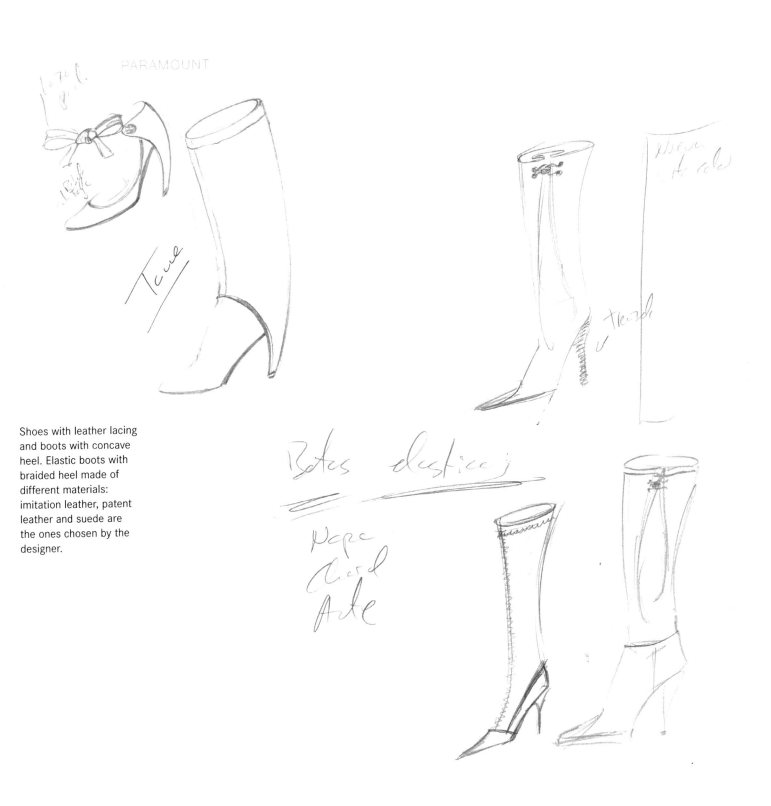

Shoes with leather lacing and boots with concave heel. Elastic boots with braided heel made of different materials: imitation leather, patent leather and suede are the ones chosen by the designer.

Madrid, Spain, 1967

"Designing, inventing, coming up with ideas..."

INTERVIEW

How would you define your style?
Irony and mixture, with an eye on the past and another eye on the future.

Which is the most difficult piece to design?
The one I have not yet thought about!

Who or what is your main source of inspiration?
Life and everydayness.

What area of your work do you enjoy the most?
Designing, inventing, coming up with ideas...

Who is your icon of style and good taste?
Bette Davis, Pipilotti Rist, Rufus Wainwright, Yositomo Nara, CocoRosie, Ava Gardner...

What are your plans for the future?
To continue working in what I like and to grow.

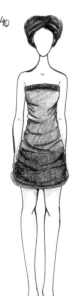

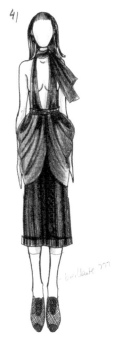

professional CAREER

Born in Madrid, Juan Duyos started working in 1992 with the designer Manuel Piña. Parallel to this, he designed his first collections together with Cecilia Paniagua, creating the brand Duyos & Paniagua. After several fashion shows at Pasarela Cibeles and the participation in the London Fashion Week in 1998, Juan signed his first independent collection as Juan Duyos in 1999. Under the name of "Recuerda y guarda", it was considered the best collection at Cibeles. Throughout his career, this charismatic Spanish designer has gained recognition from the specialized press. The result is a large number of awards granted by fashion magazines such as *Glamour* or *Vanity*, and by companies such as Lancia. To this facet of prêt-à-porter collections designer, one must add his task as wardrobe creator for different theater companies, as for example the one of flamenco dancer Rafael Amargo. In 2002, he was named creative director of the traditional firm Don Algodón, a task he has been doing as well as collaborating with companies like Levi's or Adidas, as well as his own brand. Since 2005, Juan Duyos also has a line of glasses, Duyos Vista, and another one of accessories; moreover, Fande Duyos, the second line of his firm, born in 2006, has already experienced positive acceptance.

Juan Duyos

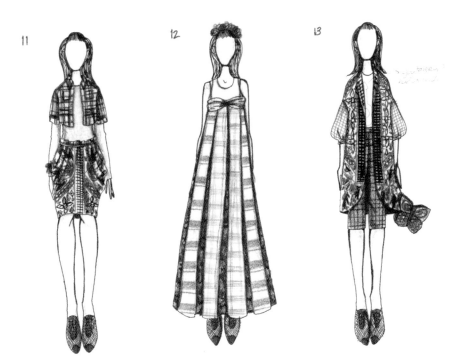

C/ Hortaleza 64, 3º centro
28004 Madrid, Spain
T: +34 91 531 50 42
vanesa@duyos.net
www.duyos.net

Sketches for the 2006-07 fall-winter collection. Skirts and mini-shorts are alternated with extra-long skirts.

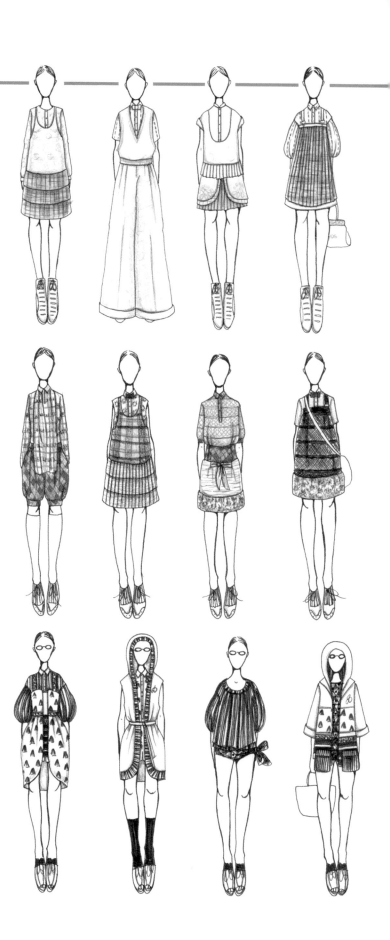

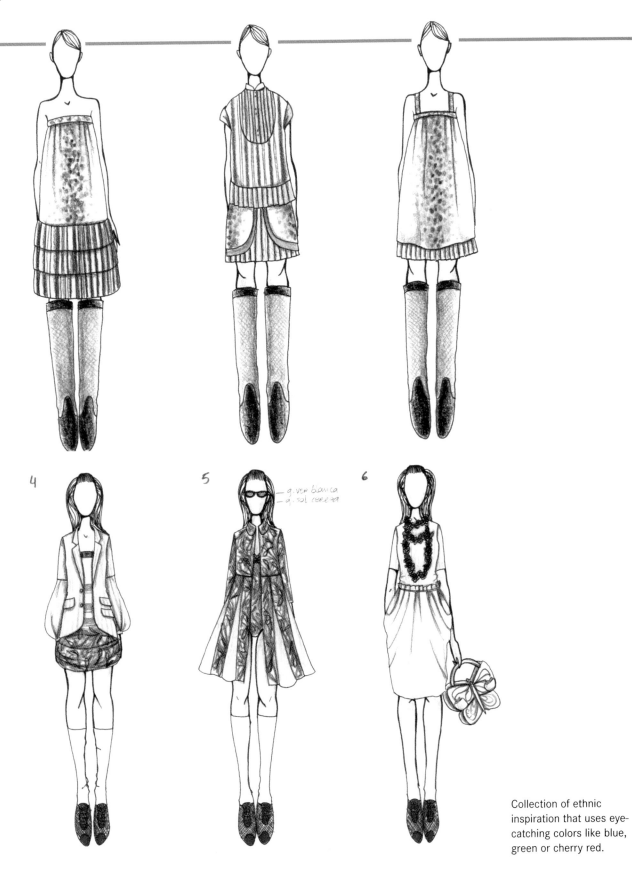

Collection of ethnic inspiration that uses eye-catching colors like blue, green or cherry red.

Elda (Alicante), Spain, 1980

"I mix and play with archetypes."

INTERVIEW

How would you define your style?
I am dedicating my collection more and more to a very sophisticate, feminine woman. I want them to see my clothes as a need, not as a whim.

Which is the most difficult piece to design?
Trousers. I didn't like to see my mother in trousers when I was a kid.

Who or what is your main source of inspiration?
Womankind in its totality. Very diverse and complex. I like to mix and play with different feminine archetypes.

What area of your work do you enjoy the most?
The beginning of a new collection. To think what I will do, how, to develop a lot of ideas at the same time, giving them a real form.

Who is your icon of style and good taste?
My mother, beyond any other famous mythic women. She has been, day after day, a lesson of style and good taste. I remember as if it was yesterday when she used to wake me up with a big shining smile before going to a ceremony or a dinner, just to check how she was dressed.

What are your plans for the future?
Not to stop the current rhythm. Keep on working and thank the people who are helping me.

professional CAREER

Juan Vidal was born in a family related to the world of fashion design, as his grandfather was a tailor. When he was 15, he designed a collection of wedding dresses and nightgowns. The success was overwhelming and everyone around him agreed that Juan's destiny was linked to the world of fashion creation. Some years later, he enrolled at the Universidad de Bellas Artes with the intention of improving his notions of sculpture and drawing, and of applying his learning to fashion design. A while later, he quit his university studies to start a career in design at the Escuela Superior de Diseño y Moda Felicidad Duce in Barcelona. At the time he was a student he presented his first collection at ModaFAD, an event in the Catalan capital that brings together a selection of the young promises of design in general, and received the award for Best Creator. The next step was to participate in the Bread & Butter salon in Barcelona, where good reviews were quick to appear, constituting his passport to the Barcelona Fashion Week, a witness of his second collection. His pieces are built with very fine lines, linear cuts and neutral colors. He avoids stridencies and superfluous details.

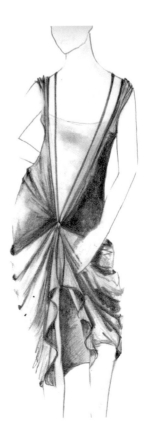
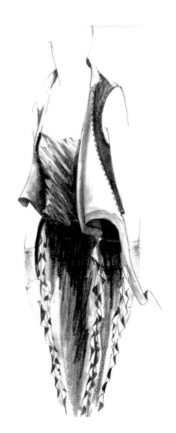

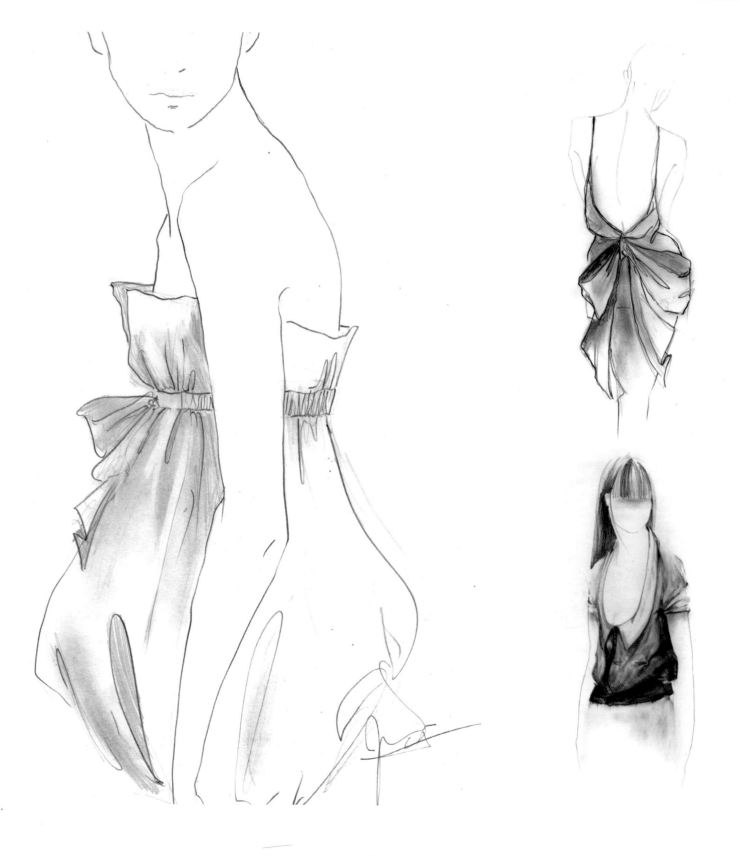

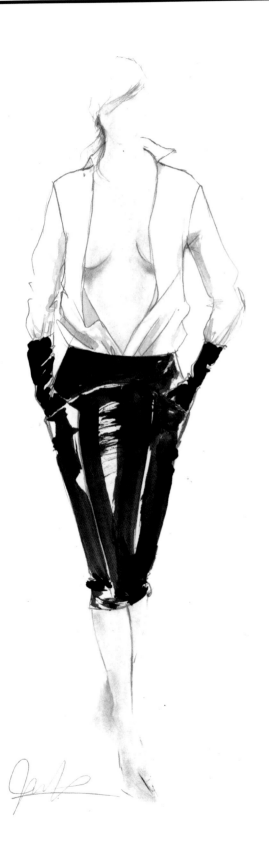

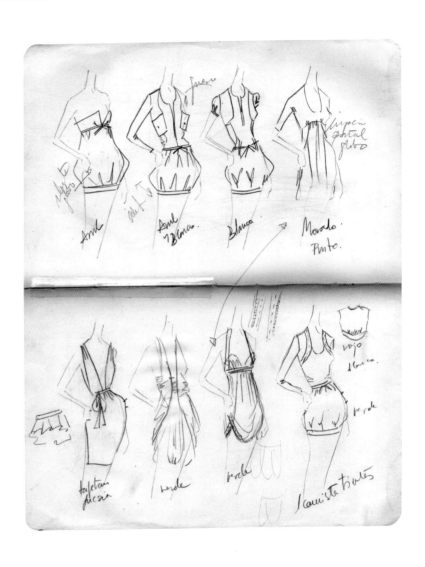

London, United Kingdom, 1974

"I am attracted by the potential of the street look."

INTERVIEW

How would you define your style?
Easy to wear, modern but not pretentious at all. I am attracted by the potential of the street look; I would like to turn it into something tidy, pure and realistic.

Which is the most difficult piece to design?
They all have a certain difficulty. I want to create clothing items with details that are liked by the fashion *connoisseur*, but that can be worn by anybody, nothing complicated. T-shirts, bombers, harringtons, sweat pants, shirts...

Who or what is your main source of inspiration?
I pay attention to England's musical and juvenile heritage, to soccer fans, to how street guys dress, to how they get to create their own style. Then there is also historic inheritance as that of Ray Petri, Leigh Bowery, Vivienne Westwood, Steven Linnard, PX, The Foundry, John Moore, Rachel Auburn, Richard Torry...

What area of your work do you enjoy the most?
I enjoy being able to create a visual language with my clothes, one in which there are all sorts of references to cinema, comics, literature, music...

Who is your icon of style and good taste?
Many people in my life have left an imprint on my style. Louise Wilson, my mentor; Andre Walker and my team; my family and especially my sister; Nicola Formichetti, Alister Mackie, Alasdair McLellan, Jo Ann Furniss...

What are your plans for the future?
To make menswear in England is difficult because the market is complicated, but this is what I like. I try to find moments that are not too hectic and then I travel.

professional CAREER

Kim Jones

Kim Jones is a designer of menswear fashion; since graduating from Saint Martins he has developed a casual and proper style which is extremely refined. Up to the moment, Jones has presented eight collections. He debuted at the Paris Fashion Week in July 2004. Aside from his own line, Kim designs a collection for the British firm Umbro, called "Umbro by Kim Jones". He has also collaborated on specific projects with Topshop, Mulberry, Hugo Boss and Louis Vuitton.

Jones has also worked as director of art and style for publications like *Dazed & Confused*, *Numero Homme*, *Another Magazine* and *The New York Times*. In 2004, *The Face* included him at number twenty of his annual list of the one hundred most influential people in the world of fashion.

Kim was the first designer that brought a pure fashion touch to streetwear, blurring the frontier between casualwear and fashion. After this, a lot of important fashion firms subscribed to this tendency of making luxury more sporty.

His great topics are the typically British, and the juvenile and musical movements of the 70's, 80's and 90's like house, punk, raves, the kids club, Madchester. He has published a travel book about the city of São Paulo in collaboration with photographer Alasdair McLellan. In 2006, Kim Jones won the prestigious annual award for Best Male Designer at the British Fashion Awards.

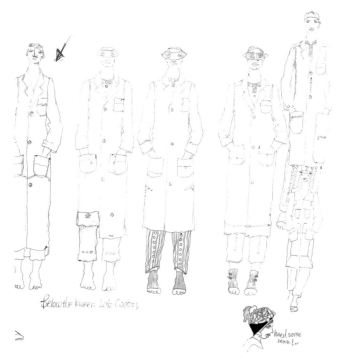

6 rue de Braque, 5ème étage
75003 Paris, France
T: +33 1 49 96 20 70
enquiries@kimjones.com
www.kimjones.com

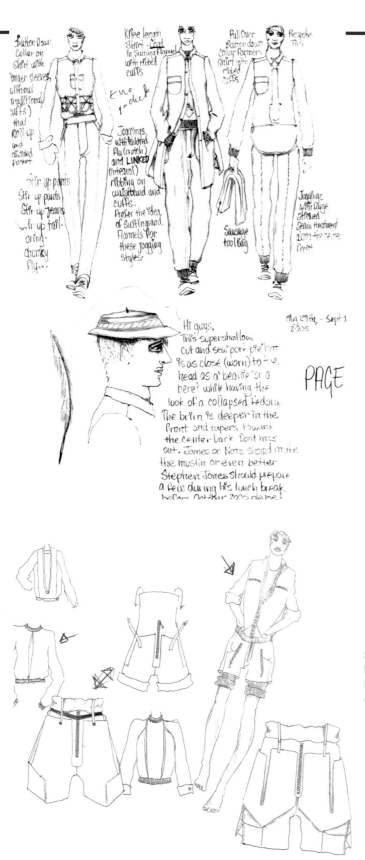

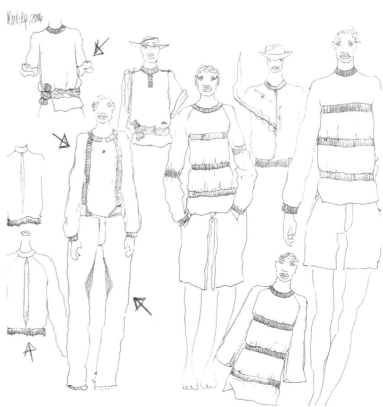

Sketches for Kim Jones'
latest collection, with
indications written by the
creator's own hand.

Different samples of
jackets and shirts with a
military cut, together
with indications in notes
by the designer; and two-
piece ensembles formed
by t-shirts, jackets or
sweaters with seams and
balloon-shaped, short,
puffy sleeves.

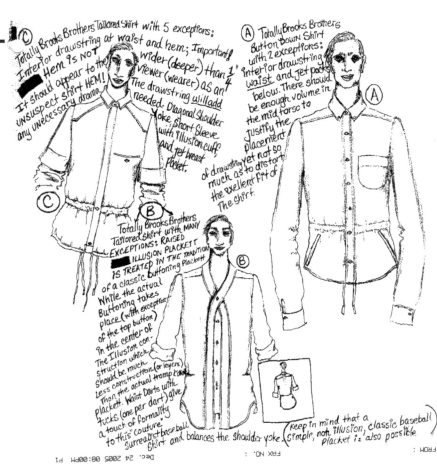

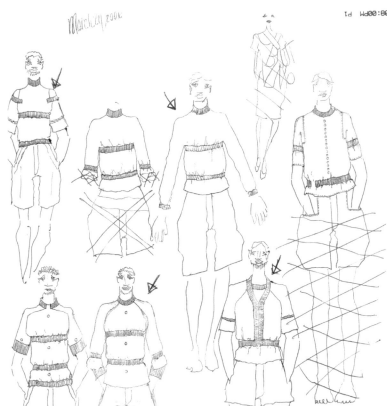

lauraBORTOLAMI

"Chains, buckles, stones, leather, silk, embroideries..."

Rome, Italy, 1962

INTERVIEW

How would you define your style?
Sophisticated and elegant, mixing the present with notes from the past, aimed to a very feminine and self-confident woman, and to a man who loves the classic with a hint of transgression.

Which is the most difficult piece to design?
I find it hard to design a bag because there can be many surprises when it is actually made; it is necessary to consider many details: the material, the proportions, the inner finish, the accessories and their quality, the balance between esthetics and practicality.

Who or what is your main source of inspiration?
Materials. The creative process of a new collection starts with a table covered with different materials: chains, buckles, stones, leather, silk, embroideries... Then, I choose the materials that fit my inspiration and start working on mannequins.

What area of your work do you enjoy the most?
We have been working with the metal net for several years, and this has become the "signature" of Laura B, an important part of the collection. The first part of the creation is the challenge of finding a new, interesting and attractive way to present it. And we manage to do it each time!

Who is your icon of style and good taste?
I don't have one character/icon of good taste. There are women and men I know well and admire. I am inspired by the subtle balance between elegance and esthetics harmony, details that are difficult to notice in public personalities.

What are your plans for the future?
We opened the first Laura B store in September 2006 with unique pieces, tailor-made clothes as if made in an atelier, and pieces from past collections. I want to have direct contact with my final customer and the possibility of creating special pieces for specific people.

professional CAREER

Laura Bortolami

Behind Laura B, the brand of accessories established in Barcelona, there is Laura Bortolami, born in Rome in 1962 to an Italian father and an Indonesian-Dutch mother.

After quitting her translation studies in Geneva, she made her first approach to fashion by working for Giorgio Armani in Milan. Next would follow her work with Versace, Anna Molinari and Dolce & Gabbana. Several years later, having acquired some experience, she started an adventure by going solo and designing a jewelry collection consisting of a selection of antique pieces such as coins, buckles, broaches, and so on, combined with very avant-garde materials. The result was a total success.

The next step was to move to Avignon, the city in which her next collection, Laura B Collection Particulière, saw the light. In 1995, she moved to Barcelona, a city that has been witness to the growth of her company thanks to the support of new clients and excellent reviews from specialized critics. Her pieces are a constant in the pages that reflect the fashion tendencies in magazines such as *Vogue*, *Elle* and *Marie Claire*.

In 2003, she designed her first collection of men's accessories, a line which can presently be admired in the most important shop windows of the fashion world capitals of such as Milan, Paris or New York.

C/ Ample 33, 2-2
08002 Barcelona, Spain
T: +34 932 683 071
laurab_bcn@yahoo.es

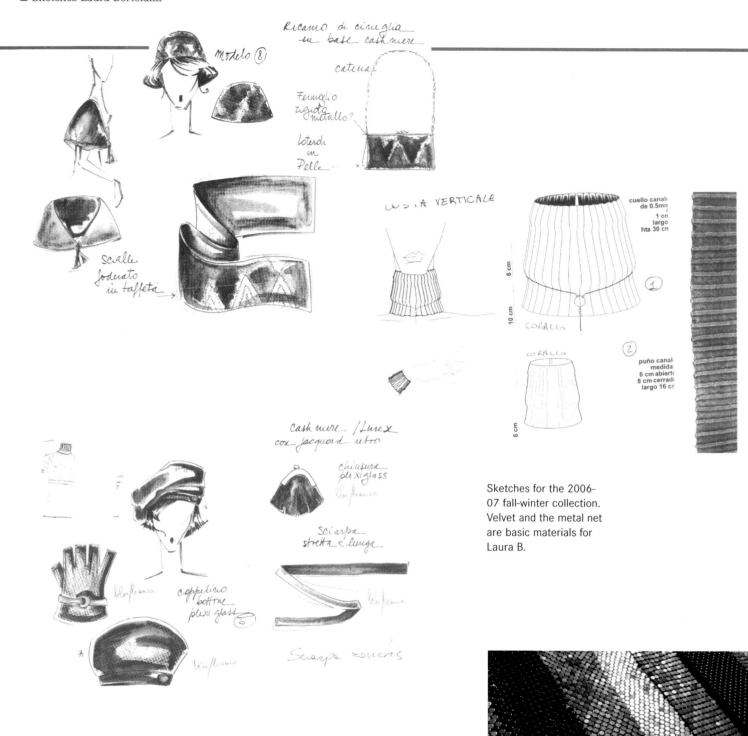

Modelo ⑧

Ricamo di ciniglia su base cashmere

catena

Fermaglio rigida in metallo?

Interni in Pelle

Scialle foderato in taffetà

COSIA VERTICALE

cuello canal de 0.5mm
1 cm
largo
hta 30 cm

6 cm

10 cm

CORALLO

①

CORALLO

②

puño canal
medida
6 cm abierto
8 cm cerrad
largo 16 cm

6 cm

cashmere / Lurex con jacquard retro

chiusura plexiglass

Sciarpa stretta e lunga

cappelino bottone plexi glass ⑥

Sciarpa zoucres

Sketches for the 2006-07 fall-winter collection. Velvet and the metal net are basic materials for Laura B.

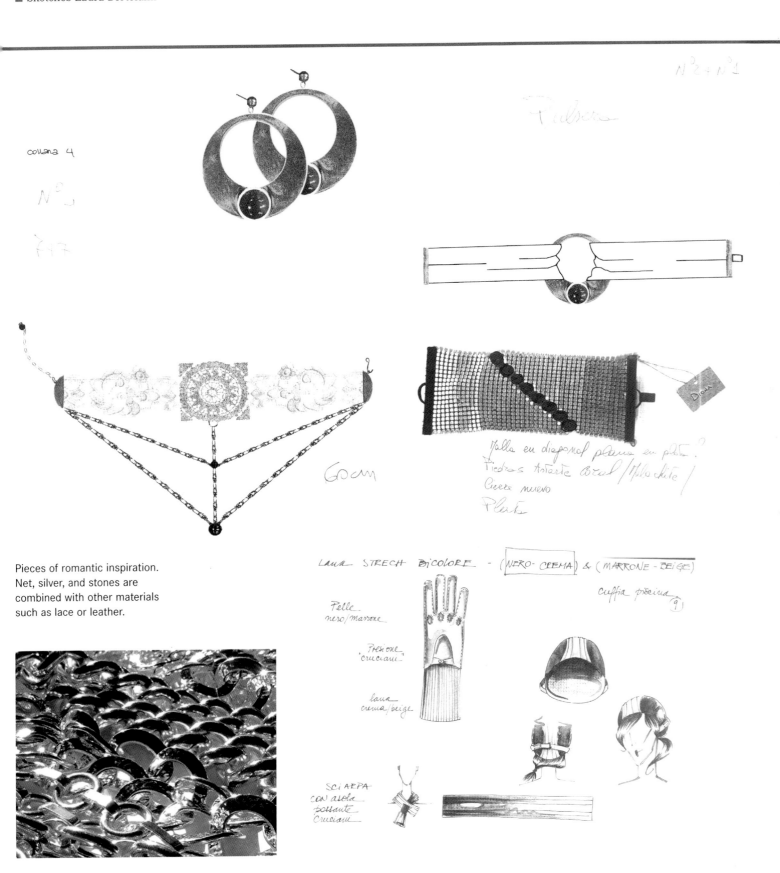

collana 4

N°₁

N°2 + N°1

Pulsera

Goocm

Pieces of romantic inspiration.
Net, silver, and stones are
combined with other materials
such as lace or leather.

Malla en diagonal plana en plata?
Piedras Astarté Coral / Malachite /
Cierre nuevo
Plata

LANA STRECH BICOLORE - (NERO-CREMA) & (MARRONE-BEIGE)

Pelle
nero/marrone

cuffia piscina
9

Presione
"cruciani"

lana
crema/beige

SCI AEPA
con asola
passante
cruciani

luciaBLANCO 32

Buenos Aires, Argentina, 1973

"I like designing opposites, mixing sophisticated and sporty pieces."

INTERVIEW

How would you define your style?
I define myself as a modern, yet romantic designer, eager to make unique pieces that require internal and external work, and that are also commercial.
I like designing opposites, mixing sophisticated and sporty pieces, shiny and opaque fabrics, and textured and smooth ones.

Which is the most difficult piece to design?
The most difficult pieces for me are classic tailor suits for men or women.

Who or what is your main source of inspiration?
I am inspired by art, from classic to modern artists; artistic movements like cubism have inspired my latest collections. I am also moved by the organic in forms, textures and color.

What area of you work do you enjoy the most?
Without a doubt I enjoy the creative process, in particular when I find the instrument or the thread that will guide the entire collection. The rest is magic.

Who is your icon of style and good taste?
No one in particular.

What are your plans for the future?
After opening my first shop in Barcelona, we have plans to open Lucía Blanco shops in different cities of the world like Paris, New York, London and Japan.

professional CAREER

Lucía Blanco was born in Argentina 33 years ago and lives in Barcelona since 2003. She graduated from the Universidad de Buenos Aires in Fashion Design and was the winner of the prize for Best Collection and Best Pattern of her native town for two consecutive years. She obtained the valuable Silver Scissors for the best collection of New Sewing in 2002. In 2004, she presented her collection at the Barcelona Fashion Week for the first time, and opened a shop there in 2005. Although she started her career as an emerging designer, critics were unanimous in calling her a revelation from the latest edition of the Pasarela Gaudí for her collection, inspired in mushrooms, in which asymmetrical volumes predominate in perfectly defined and finished pieces. Lucía likes neutral tones and uses a set of colors that include beige, black, gray or brown; she prefers soft textures like cotton, silk or satin. She usually makes dresses or shirts, although she clearly likes trousers that give her collection an urban note. Her clothes can be found, other than at her own shop, in multi-brand establishments in Spain, France, Italy, London and Japan.

Lucía Blanco

C/ Roger de Llúria 102
08037 Barcelona, Spain
T: +34 93 476 50 07
contact@luciablanco.com
www.luciablanco.com

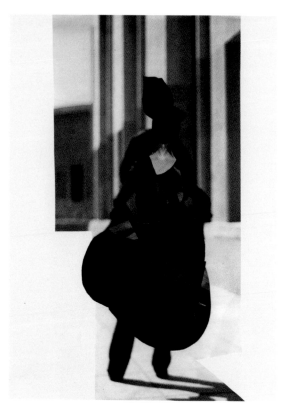

Sketches inspired by the
Cubist movement for the
2006-07 fall-winter
collection.

Card showing
human figures
together with
color and print
samples that
define future
clothing items.

martinGRANT 33

Melbourne, Australia, 1966

"Tailored – feminine – chic."

INTERVIEW

How would you define your style?
Tailored–feminine–chic.

Which is the most difficult piece to design?
Pants.

Who or what is your main source of inspiration?
Anything from a print to a tree.

What area of your work do you enjoy the most?
Hands-on toile draping.

Who is your icon of style and good taste?
Any woman with natural elegance.

What are your plans for the future?
I don't plan ahead.

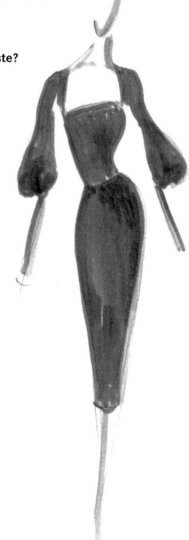

professional CAREER

Born in Melbourne, Australia, Martin Grant received the Cointreau Young Designer Award granted by the Australian Fashion Industry in Sydney in 1988. Since then, his life and career has changed.

After a meteoric rise, he took a creative recess to devote himself to sculpture, studying at the Victorian College of Arts. After graduation he moved to the United Kingdom where he learned the secrets of tailoring from the hands of Koji Tatsuno. A year later, in 1992, he moved to Paris and opened his first atelier in an old Montmartre hospital.

His first collection was a small sample of twenty pieces, but supplies quickly ran out in Australia, Japan, the United Kingdom and the United States. In 1996, he opened his first shop at an old barber shop in the Marais, in Paris, to receive his most faithful clients, among them Cate Blanchett or Lee Radziwill. In 2005, he moved to a new space on rue Charlot which became the stage for exclusive presentations for a small number of select critics and clients.

Grant's collections are characteristically inspired by refined tailor suits with sculptural touches. His suits are perfectly built with straight lines and a functional spaces that emphasizes the women's curves. They can be bought at shops like Barneys, for whom he designs a special collection since 2003, Neiman Marcus, Takashimaya or Penelope.

Martin Grant

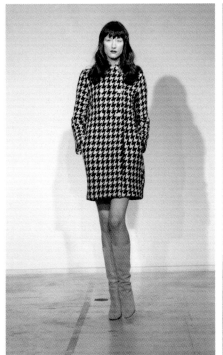
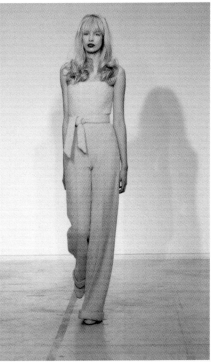

10 rue Charlot
75003 Paris, France
T: +33 1 42 71 39 49
contact@martingrantparis.com
www.martingrantparis.com

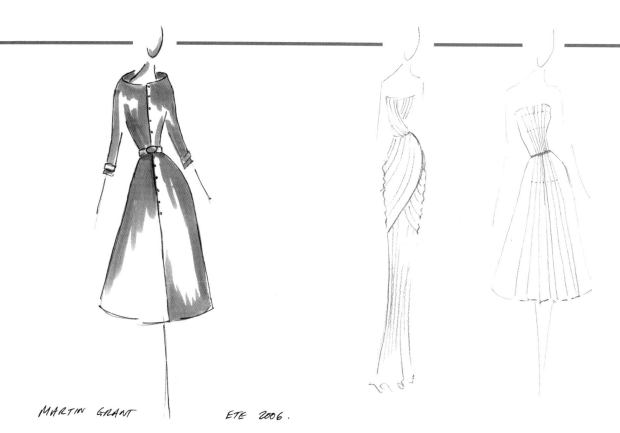

MARTIN GRANT ETE 2006.

Sketches for the 2006
spring-summer
collection. Day and
cocktail dresses, inspired
by the fashion of the
1950s.

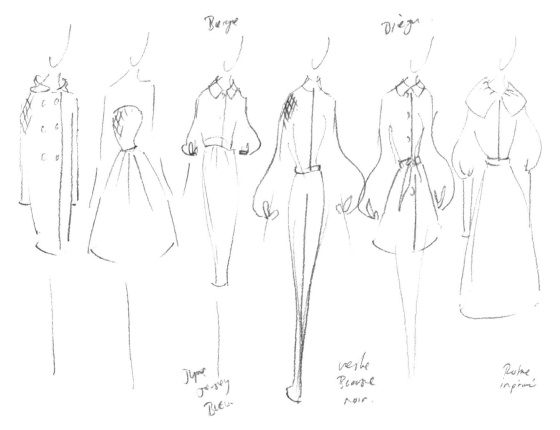

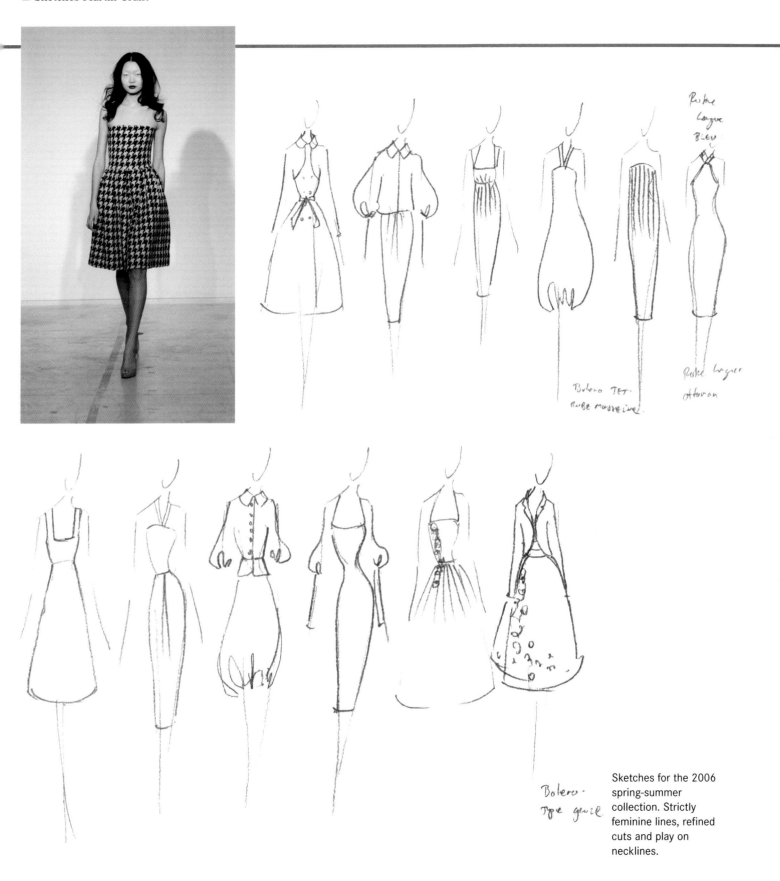

Sketches for the 2006 spring-summer collection. Strictly feminine lines, refined cuts and play on necklines.

MIMÓTICAMICOLA 34

Barcelona, Spain, 1976

"Paris is my icon."

INTERVIEW

How would you define your style?
Flirtatious, insolent, naughty, very feminine. Eager to stay away from the typical "girl power" message, but also very belligerent.

Which is the most difficult piece to design?
The design is always very clear inside the designer's head; the difficult part is to transmit it correctly. I was a design teacher in Singapore in 2006 and I frequently reminded my students: if you don't know what you want, the design will not come out of your head.

Who or what is your main source of inspiration?
I have many sources of inspiration; I pay attention to magazines and books, to films, to fairy tales. I like designer Josep Font, Catalan like me, and who now participates in the Paris Fashion Week.

What area of your work do you enjoy the most?
One of the best moments is going to markets. Bargaining with cloths, discovering treasures, rescuing forgotten buttons... I can almost see the bags already made as I touch what I buy. Another moment I love is me versus the blank paper. I first think up the name of the collection, and that is helpful. There is also the day, once a month, when I buy magazines. I buy those I want, sign them, scan them, and keep them in my album. I never cut them.

Who is your icon of style and good taste?
All of Paris: the city, the language and the people are my icon. Bakeries, bicycles, balconies at Montmartre... it's the capital of glamour.

What are your plans for the future?
Keep up the good results, sell in more countries and, perhaps one day, design shoes.

professional CAREER

Raquel Micola was born in Barcelona in 1976. She started working in fashion as a hobby, although she has designed since she was a girl. Her grandmother sewed up the holes in bullfighters' clothes and she was always her accomplice. She presented her first collection of accessories at the FAD fashion market and ran out of supplies in just one day which made her ask her family to sew new samples in one single night. Nowadays her bags, under her brand Mimótica Micola, are sold in over twenty countries. What cheers her up the most is when one of her customers tells her the messages written on the bags are a source of self-esteem. The name of the brand comes from her last name, Micola, and from 'mimótica', a science that she invented, consisting on doing things with loving care (in Spanish, 'mimo'). Mimo is also the name of the main character of the Mimótica story, and her reindeer-dog Rudolf accompanies her in all her mischief. Her boyfriend is Mr. Pain; his name gives a clue about his personality, but the most revealing part is to notice the illustrations in the bags... Her last collection is called "C'est pas facile d'être une fille." Raquel Micola is delighted to enter a world of flirtatiousness and careful details; she thinks of a bag as a way in which a girl can express her particular self.

Raquel Micola

Avda. República Argentina 6,
principal 1ª
08023 Barcelona, Spain
T. +34 93 217 63 58
contact@mimoticamicola.com
www.mimoticamicola.com

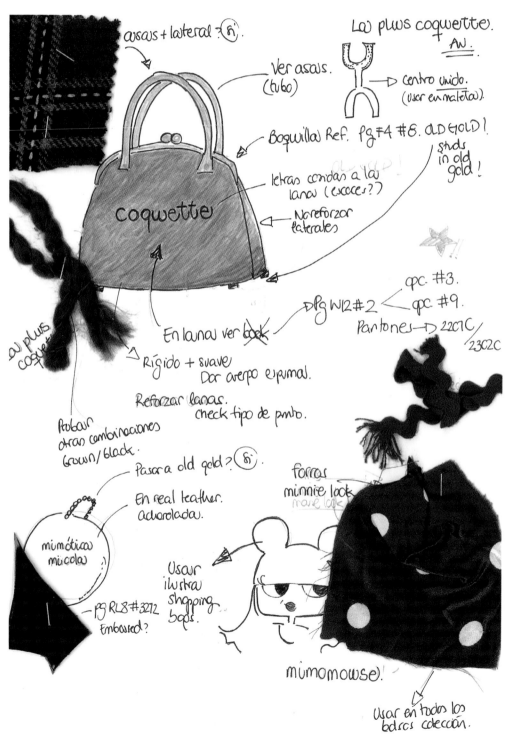

asas + lateral : (sí).

Ver asas.
(tubo)

La plus coquette.
+ AW.

→ centro unido.
(usar en maleta).

Boquilla Ref. Pg#4 #8. OLD GOLD!
studs
in old
gold!

letras cosidas a la
lana (excoces??)

No reforzar
laterales

coquette

al plus
coquet

En lana ver look

Pg W12 #2

qpc. #3.
qpc. #9.

Pantones→ 2201C/
2302C

Rígido + suave
Dar cuerpo espuma.

Reforzar lanas.
check tipo de punto.

Probar
otras combinaciones
brown/black.

Pasar a old gold? (sí).

En real leather.
achorolada.

forras
minnie look
mouse look

mimótica
micola

Usar
ilustra
shopping
bags.

Pg RL8 #3272
Embosed?

mimomowse!

Usar en todos los
bolsos colección.

Sketches for the 2006-
07 fall-winter collection.
Colors like pink and the
use of prints like plaid or
dots. Purse in retro style,
box-like shape, with
double short handle.

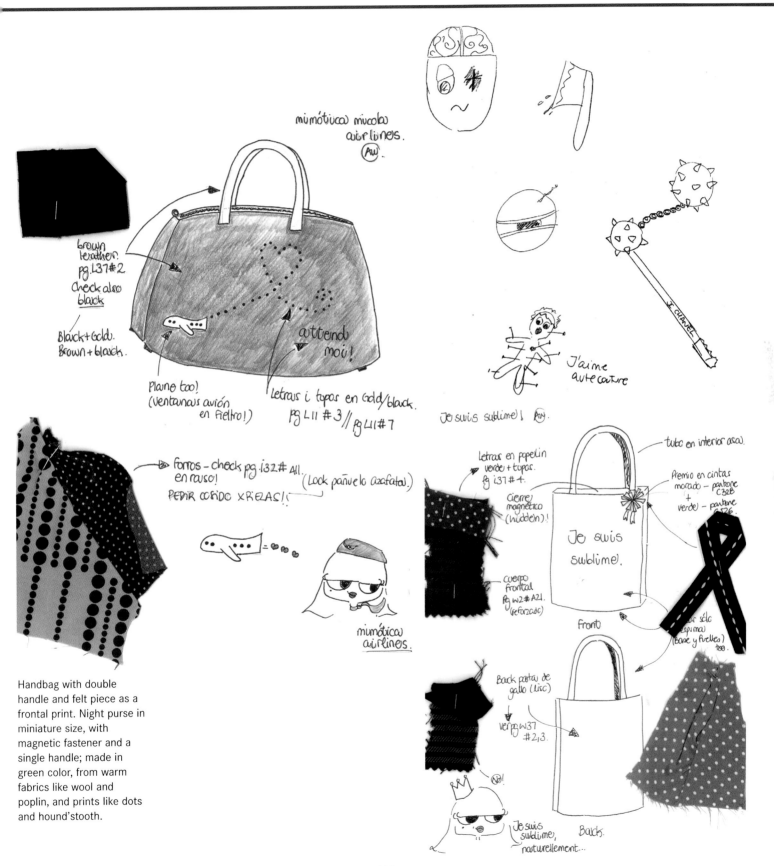

mimótica micola
airlines.
(Aw).

brown
leather.
pg.137#2
check also
black

Black+Gold.
Brown+black.

Plane too)
(Ventanas avión
en fieltro!)

attend
moi!

Letras i topos en Gold/black.
pg L11 #3 // pg L11#7

J'aime
autecouture

Je suis sublime! (Aw).

JE CHANEL

forros - check pg.132#All.
en rosa!
(Look pañuelo azafata.)
PEDIR COSIDO XRELAS!!

mimótica
airlines.

Handbag with double
handle and felt piece as a
frontal print. Night purse in
miniature size, with
magnetic fastener and a
single handle; made in
green color, from warm
fabrics like wool and
poplin, and prints like dots
and hound'stooth.

tubo en interior asa.

letras en popelin
verde + topos.
pg i37 # 4.

cierre
magnético
(hidden).!

Premio en cintas
morado - pantone
C328
+
verde - pantone
C126

Je suis
sublime.

cuerpo
frontal
pg w2#A21.
(reforzado)

Front

or sólo
espina
(Base y fuelles)
too.

Back pata de
gallo (liso)
ver pg w37
#2,3.

Je suis
sublime,
naturellement...

Backs.

miriamOCARIZ 35

Bilbao, Spain, 1968

"My future plan is to create a kids collection."

INTERVIEW

How would you define your style?
As a mixture of subtle contradictions: fragility and strength, rigor and fantasy, memories, innocence and sophistication.

Which is the most difficult piece to design?
I would not say there is a difficulty in designing a specific piece, but there is one in superimposing pieces. When you do this you are forced to leave important details aside.

Who or what is your main source of inspiration?
I do not have a specific source of inspiration, but I am inspired by different aspects of life in its widest sense like art, the street, the cinema...

What area of your work do you enjoy the most?
All that refers to drawing, from the creation of figurine sketches, to the design of the prints.

Who is your icon of style and good taste?
Coco Chanel.

What are your plans for the future?
To develop a women's line and to create a kid's collection.

professional CAREER

Miriam Ocariz graduated in Fine Arts from the Universidad del Pais Vasco in 1992, with a specialization in the techniques of engraving and serigraphy. At the same time, she specialized in Fashion at LANCA school in Bilbao. As she was interested in clothing, she decided to turn towards fashion and use the printing techniques she had learned, mainly serigraphy, in fabrics and t-shirts; these last items are the ones that allowed her to enter the market and consolidate her women's wear line. Influenced by her experience in fine arts and constantly interested by this field, Miriam Ocariz uses clothing items as means of communication. From the start, her prints have been the most characteristic element of her design, although she has progressively developed other technical aspects thus building her patterns carefully and making sure the fabrics are of excellent quality. Miriam Ocariz has been one of the frequent firms at the Pasarela Gaudí in Barcelona or Cibeles in Madrid since 1997; in this last one, she received the prize for Best Collection by a Young Designer in the February 2002 edition. Between the years 2004 and 2006, she was the director of the women's line for the Catalan firm Armand Basi. Her work is exhibited in many art galleries, where they not only show her fashion-oriented work, but also her designs and drawings presented in other mediums.

Miriam Ocariz

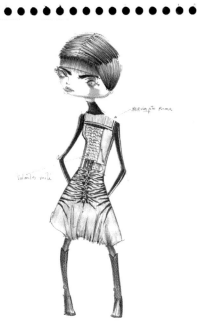
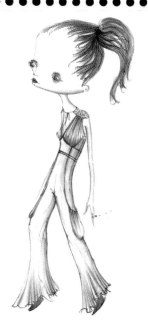

C/ Iruña 1 bis, 5ª planta, locales 5 - 6
48014 Bilbao, Spain
T: +34 94 475 14 57
info@miriamocariz.com
www.miriamocariz.com

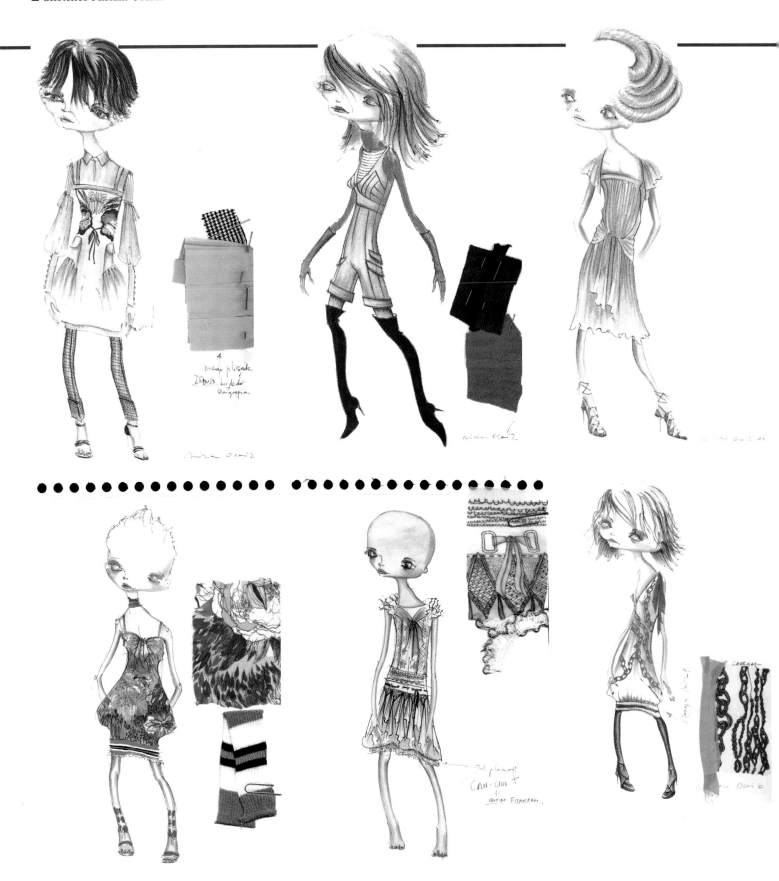

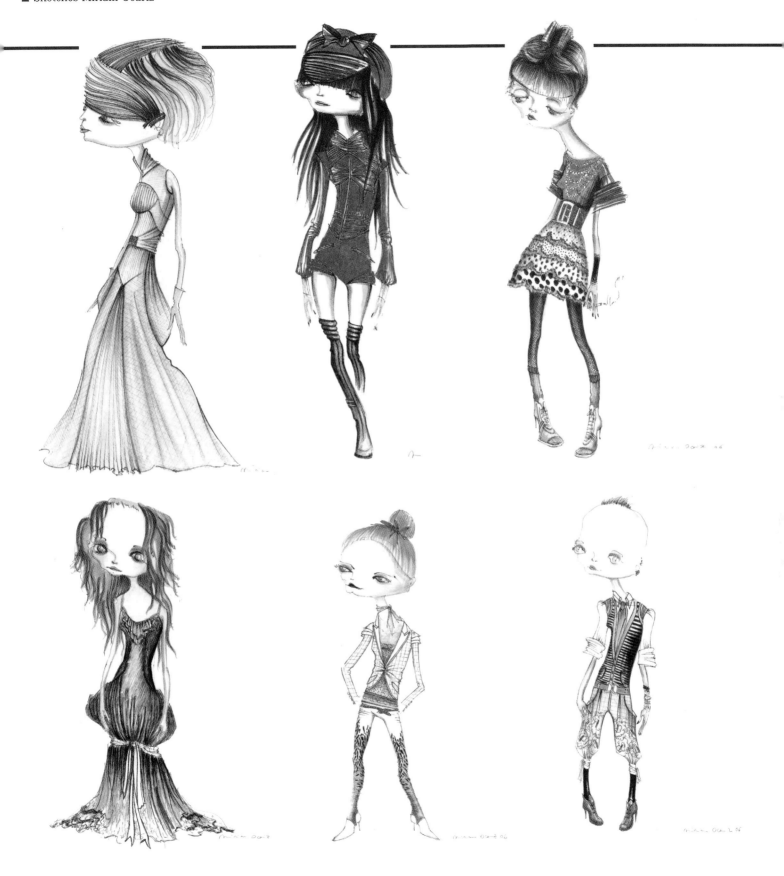

Manresa (Barcelona),
Spain, 1974

"What happens to me today is reflected on my clothes tomorrow."

INTERVIEW

How would you define your style?

My style is the result of constant research through my own experiences, of the flow that comes from letting the unconscious carry me away. The research I do is totally free and not at all planned. I undertake collections as something really personal, obtaining as a result what can be defined as creator's clothes.

Which is the most difficult piece to design?

It is hard to create physically what only exists in the mind. Sometimes I start working with a t-shirt shape as a basis and it ends up turning into a fantastic jacket.

Who or what is your main source of inspiration?

Collections reflect my beliefs and the way in which I try to lead my life. What happens to me today is reflected on my clothes tomorrow. That is why some collections have very descriptive and personal names.

What area of your work do you enjoy the most?

I enjoy investigating about fabrics and seeing samples of the collections for the first time. I am also interested in the new processes for finishing clothes.

Who is your icon of style and good taste?

I do not have anyone famous as a reference for style. Several anonymous references are recurrent.

What are your plans for the future?

We are working to expand our collection so that it is present at the best shops in the world. We also want to open more shops of our brand and find out which are the best fashion platforms to present our collections.

professional CAREER

Miriam Ponsa

Miriam Ponsa studied Fashion Design at Southampton University, United Kingdom, and specialized in Knitted Fabrics Design and Techniques at the city of Igualada, in Barcelona. Miriam comes from a family of clothes retailers and tailors, which goes back to 1820.

Her theory of fashion is far from conventional. This young creator prefers to design her collections by paying particular attention and care to each one of the clothing items, thus offering a feeling of individuality to her followers, instead of creating pieces that are limited to one special figure type.

Her collections always see the light at an old family mill that has been turned into a peculiar creative study. "The atmosphere here is connected very closely to my family and my childhood. I realize that this has an influence on the clothes I design." This is where her mark Creasilk came up, inspired by the silk which her ancestors made. "The fact that this place is over a hundred years old makes it more special than if it were a simple workshop where I produced my clothes. It is a place that is tinged with historical and textile elements, something that has been disappearing and something I consider valuable."

Currently, Ponsa has several points of sale in France, Belgium, Denmark, Norway, Saudi Arabia, Russia, Japan, and in the main Spanish cities. Her collections are always praised by the specialized press because of the unique style with which she makes her clothes known, a style that is closer to performances than to traditional fashion shows.

C/ Bruc 25
08240 Manresa (Barcelona)
Spain
T. +34 93 872 17 58
info@miriamponsa.com
www.miriamponsa.com

149

Samples of original drawings that accompany the human figures and help clarify the aesthetics of the collection.

Poster for presenting Miriam Ponsa's latest collection, and sketches of accessories and pieces as a two-piece ensemble in warm fabrics like suede or corduroy.

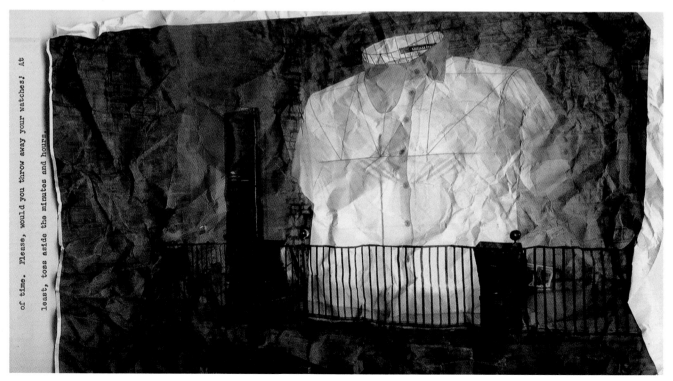

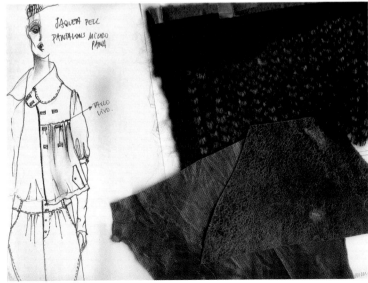

MOHTSTUDIO 37

Madrid, Spain, 1971;
Buenos Aires, Argentina, 1975

"As we develop the collections, stories emerge."

INTERVIEW

How would you define your style?
Simple and sober lines, where the retro and the avant-garde can co-exist, and it is always very feminine.

Which is the most difficult piece to design?
We design several collections. We started with handbags, the great protagonist of this decade. Then we included lingerie and swimwear. The next logical step was to move towards a collection of clothes. Each collection has its own complexity.

Who or what is your main source of inspiration?
We develop the collections based on sensations and experiences that we have during the creation moment. They all have a connecting point and are a consequence of the previous one, as if we were telling a story. This is more evident as time goes by and we see the evolution of our style.

What area of your work do you enjoy the most?
The part we enjoy the most is the creative part, the moment when we start to lay out ideas that later on become the collection.

Who is your icon of style and good taste?
We could not name anyone well-known as a symbol. There are many types of women, and we get impressions from every one of them which later become the details of our pieces.

What are your plans for the future?
To widen our field of action, projecting design to other sectors besides that of fashion. It makes sense, since our interests are also diversified into art, literature, films...

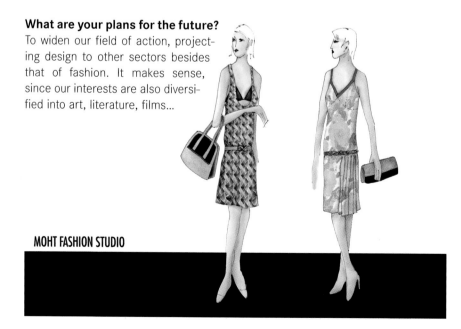

MOHT FASHION STUDIO

professional CAREER

Moht Studio is composed by Martina García and Leo Volpe Prignano. Martina, Spanish, studied Fashion and Pattern Design; Leo, Argentinean, comes from the area of Graphic Design and Fine Arts. They met in Madrid in 2001, and decided to create their own design studio in 2004. It was then that they developed their first collection of limited edition hand bags, an identity seal of Moht Studio. The following season they introduced bath and lingerie collections, and they finally presented a complete women's clothes line for summer 2007.

The natural fabrics and the chromatic range used by Moht both refer to nature. They use cotton, leather, silk or wool in earth colors, greens, mustards or camel; black, red and off-white are also always present in the proposals of this pair.

Moht's style is very simple, both in the patterns as in the fabrics they choose for usage. It is a sophisticated, retro style, which finds inspiration in the two most feminine decades: the 20's and the 50's. The new pieces get a historical aspect by combining the sober as a basis and an aged-looking finish.

Moht women are positioned at the margin of the tendencies. They bet on very feminine clothes, without resorting to the usual esthetic clichés. It is a romantic style *à la garçonne*, that encompasses the whole inner and outer universe, and that includes everything from lingerie to overcoats.

Martina García
Leo Volpe Prignano

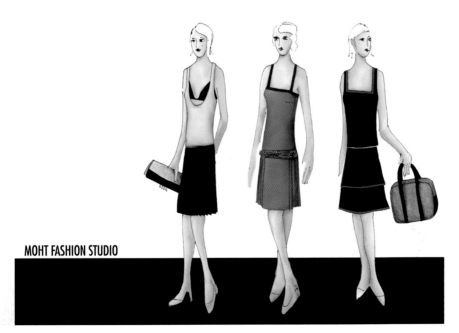

MOHT FASHION STUDIO

C/ Ilustración 4, 4º C
28008 Madrid, Spain
T: +34 91 541 72 43
info@mohtstudio.com
www.mohtstudio.com

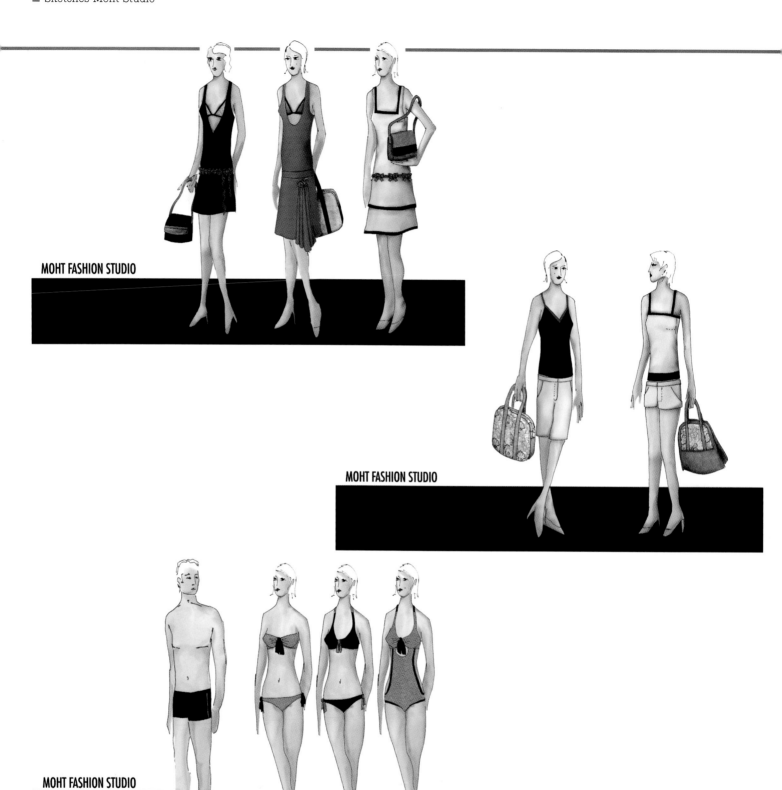

MOHT FASHION STUDIO

MOHT FASHION STUDIO

MOHT FASHION STUDIO

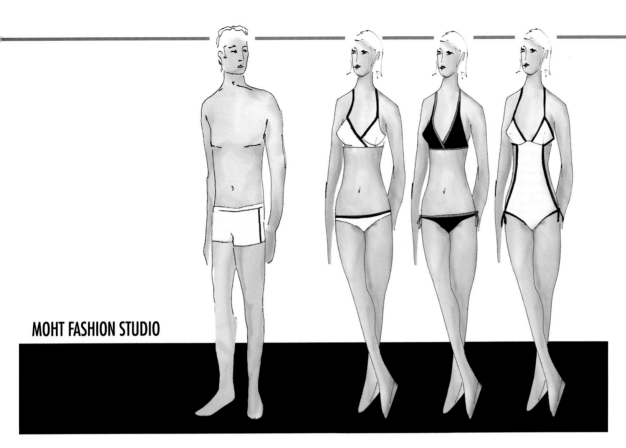

MOHT FASHION STUDIO

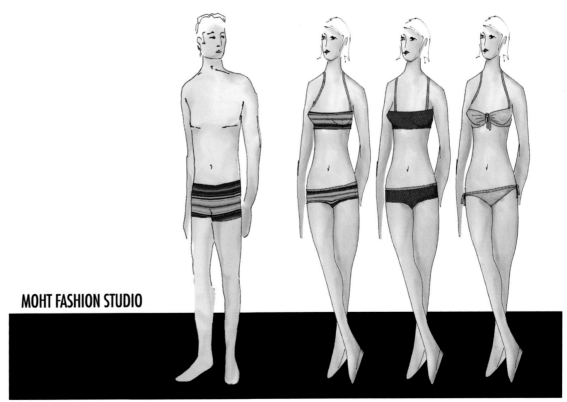

MOHT FASHION STUDIO

MOSHKO 38

Valencia, Spain, 1980;
Buenos Aires, Argentina, 1975;
Barcelona, Spain, 1978

"To be capable of expressing ideas in different types of objects."

INTERVIEW

How would you define your style?
Biting, ironic, daring, for the *connoisseurs.*

Which is the most difficult piece to design?
A piece that manages to express what somebody feels for a film, that is liked by as many people as possible, and that these people can feel identified with it.

Who or what is your main source of inspiration?
In the first place, we have always liked cult films, but also other forms of art like music, painting and illustration. We are open to receive influences from all that surrounds us and we do not just mean culture, but also the political, economical and social situation the world and the people around us live.

What area of your work do you enjoy the most?
The starting point is to establish the specific films and meditate on the images that come to our heads when we recall them. The whole process of wanting to express something from a movie, until you reach the final concept, is very rewarding. However, expressing ideas visually is not frequently easy; on the contrary, it is usually quite a challenge.

Who is your icon of style and good taste?
Without a doubt, Stanley Kubrick.

What are your plans for the future?
For the moment, we are only making t-shirts related with cult films. In the future, we would like to make pieces based on other art forms, and to be capable of expressing ideas in different types of objects.

professional CAREER

Moshko is a project headed by Santi "Sapone" Agustí, Sergio Saleh and Mich Micenmacher, and organized from Valencia, Buenos Aires and Barcelona. The three designers of this brand come from the world of production and communication, and have been working for television companies, design agencies and companies like the Disney Channel, Fox, MTV, Base Design and the Primavera Sound Music Festival for nearly a decade.

These three graphic designers have always been addicted to two things: good cinema and the idea of creating "t-shirts over things". However, it was difficult for them to find designs that spoke in the original language that films had traced for them.

This is the source of Moshko, a project that brings together cinema and design, and that came to light in December 2005. "The value of a t-shirt is in the picture that is stamped on it, which is never literal, but which always plays with a key scene of a film. The purpose is to create a smart piece that does not turn out to be cryptic. It must fly high enough not to die of boredom, and be useful enough so that it is not forgotten at the back of the closet", Moshko dixit.

Nowadays, Moshko is a reality that has points of sale throughout Spain. Their t-shirts have become "usual" at film and music festivals like the San Sebastian Film Festival or the Primavera Sound.

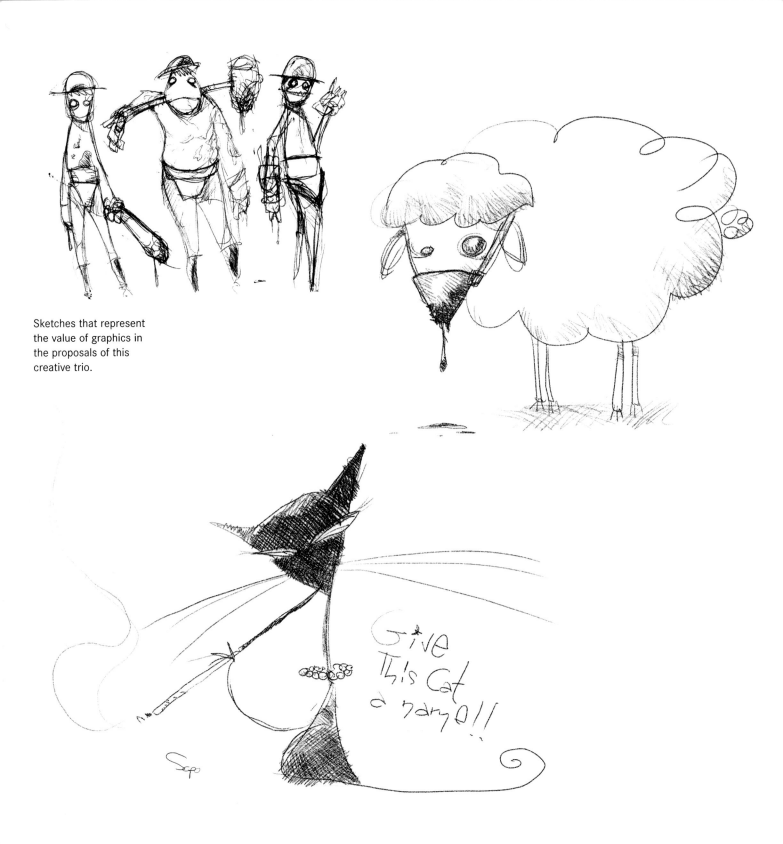

Sketches that represent
the value of graphics in
the proposals of this
creative trio.

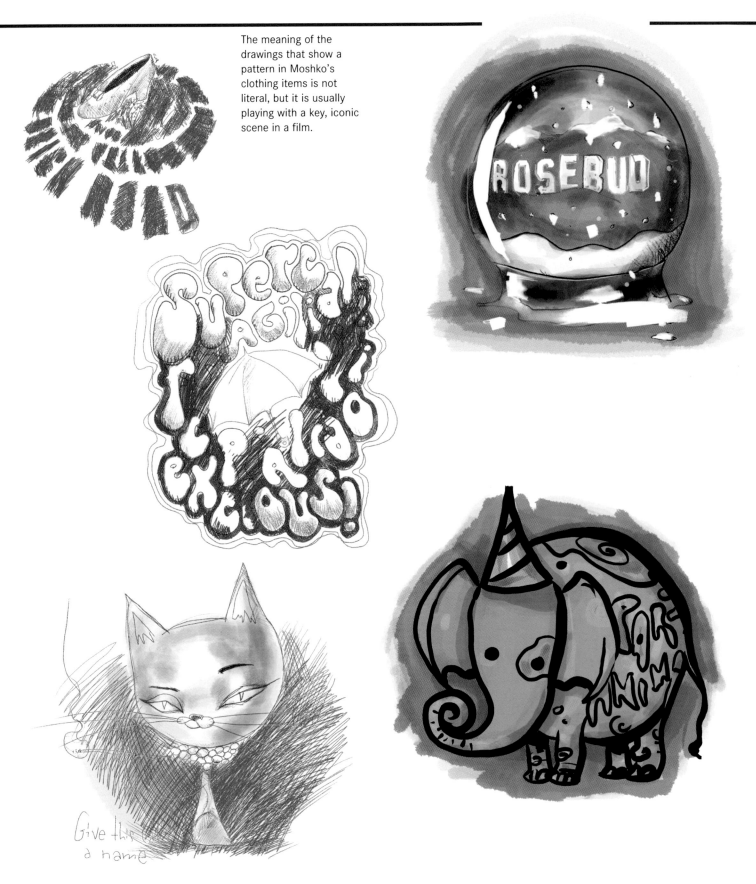

The meaning of the drawings that show a pattern in Moshko's clothing items is not literal, but it is usually playing with a key, iconic scene in a film.

neilBARRETT

Devonshire, United Kingdom, 1965

"Nothing is difficult to make if you work with the specialist craftsman in that field."

INTERVIEW

How would you define your style?
Understated, masculine and real.

Which is the most difficult piece to design?
Nothing is difficult to make as long as you are working with the specialist craftsman in that field.

Who or what is your main source of inspiration?
Anything and everything.

What area of your work do you enjoy the most?
The realization of the garments.

Who is your icon of style and good taste?
My grandfather.

What are your plans for the future?
To continue to enjoy the work that I do.

professional CAREER

Neil Barrett was born in Devonshire, United Kingdom, in 1965. His passion for design has its origin in his grandparents, both tailors, who transmitted to him their love for cutting and careful tailoring. After graduating at Central Saint Martins in 1986 and getting a master's degree from the Royal College of Art, he was appointed senior designer for Gucci in Florence.

The success he achieved for this brand opened the doors to another well-known firm, Prada, for which he created the first menswear collection. Four years later, Barrett designed a line with his own name which turned to be a success; his clothes were sold in hundreds of shops around the world. A year later came White, a brand of his own produced by Prada. The next step was an agreement with Puma to create a line of sports shoes and to redesign the Italian national soccer team uniform for the European Cup.

His collections have always been characterized by the measured use of details and the perfect cut. His menswear is very discreet and neutrally colored. Among his faithful customers there is Orlando Bloom, Kirsten Dunst, Jake Gyllenhaal, Chris Martin, Ewan McGregor, Brad Pitt, Mark Ruffalo and Naomi Watts.

Neil Barrett

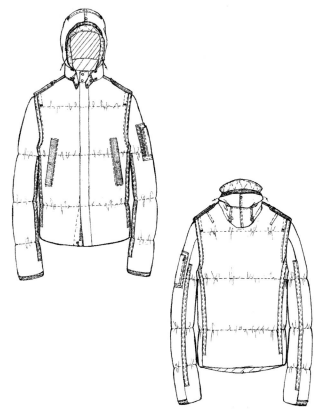

Via Savona 97
20144 Milan, Italy
T: +39 02 424 111 209
commercial@neilbarrett.com
www.neilbarrett.com

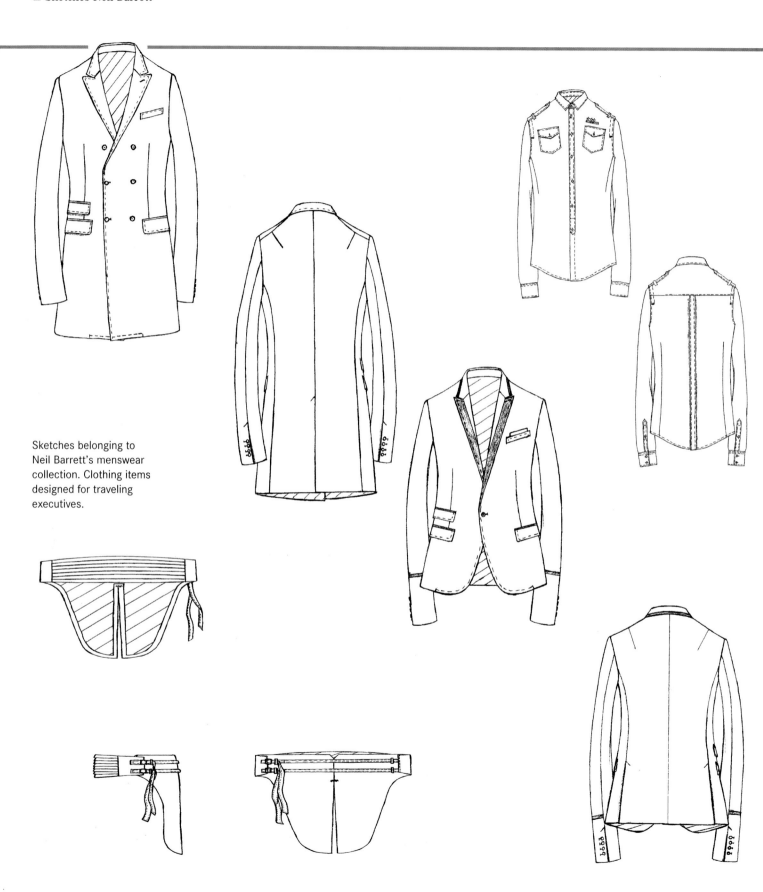

Sketches belonging to
Neil Barrett's menswear
collection. Clothing items
designed for traveling
executives.

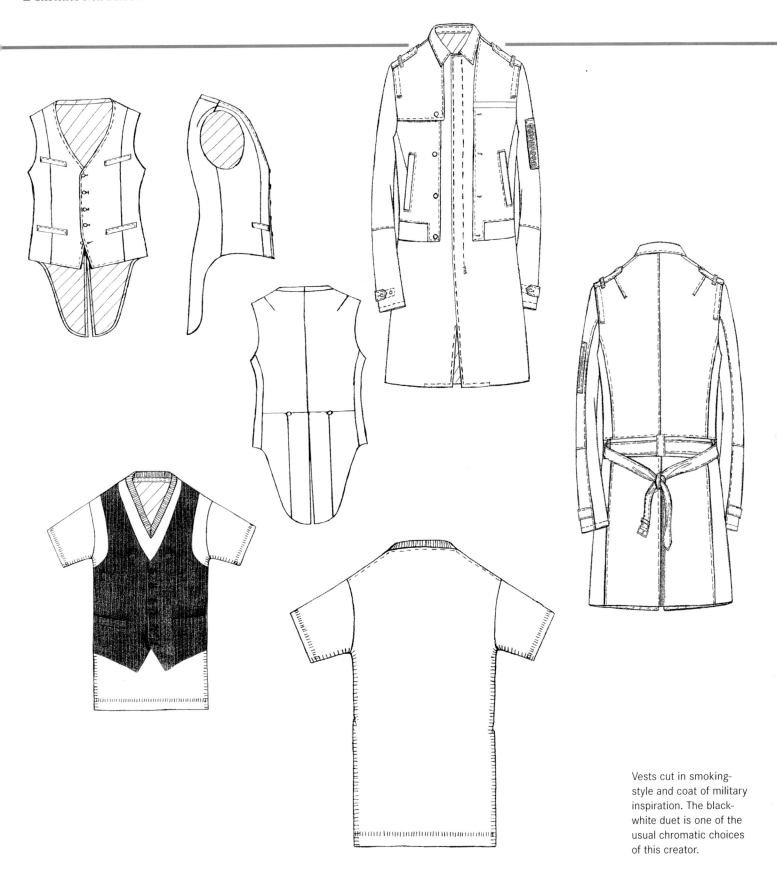

Vests cut in smoking-style and coat of military inspiration. The black-white duet is one of the usual chromatic choices of this creator.

PARNASSE 40

Barcelona, Spain, 1965 and 1971

"Style has more to do with attitude than with image."

INTERVIEW

How would you define your style?
We like to define it as fun elegance. Our silhouettes are always very feminine, mostly wearing shirt dresses and skirts over trousers. We use natural materials and colors that include neuter, nude, white, black and red. The volume is in the sleeves and the skirts. For the night, details include stones and trimming. It is a delicate femininity, with some degree of experimentation.

Which is the most difficult piece to design?
Perhaps coats, but we love to design them too!

Who is your main source of inspiration?
Our collections usually revolve around a topic which comes from the world of culture and art. "Alice in Wonderland", the myth of Pygmalion, Jacques Tati's films... In fact, our own brand name comes from the mythological hill where the muses and Apollo used to live, the Parnassus, the symbolic homeland of poets.

What area of your work do you enjoy the most?
We like the area of design: to think and develop a new project, starting from zero, every six months.

Who is your icon of style and good taste?
In our opinion, style has more to do with attitude than with image. We can be just as inspired by Audrey Hepburn as by Josephine Baker.

What are your plans for the future?
In a near future, we would like to extend the Parnasse style to other products like shoes, accessories or furniture.

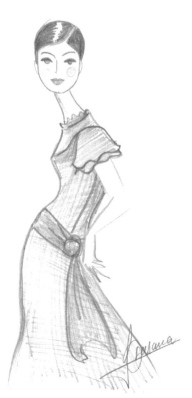

professional CAREER

Parnasse is a brand created in September 2002 by two designers from Barcelona, Susana Escolano and Dante Antón. Susana Escolano studied Fashion Design at the Centro de Diseño y Moda de Madrid, as well as Knitted Fabric Engineering at the Universidad Politécnica de Cataluña. Since 1994 she has been working for firms like Antonio Miró or Lebor Gabala. Dante Antón studied Anthropology at the Universidad de Barcelona and Communication Sciences at the Universidad Autonoma de Barcelona. He worked in various media from 1993 until 2003.

Parnasse was presented in Barcelona in September 2002, in the context of Pasarela Gaudí. In July 2003, they were invited by the organizers of the Japan's International Fashion Fair to participate in the Creator's Village, the space open for new creators. In September of that same year, they participated in the Circuit Platform, and in October 2004 they took part of Le Showroom de Hortensia de Hutten in Paris.

Parnasse always places its bet on an urban woman with esthetic interests, an innovative attitude and a sophisticated sense of humor. Their last collection is inspired by the spirit of the campus at Oxford University during the merry twenties: jazz, casual luxury, elegance and transgression. Their most common fabrics include knitted fabric, gauze or silk, all natural materials, intended to fit a very feminine silhouette with a lot of movement.

Dante Antón,
Susana Escolano

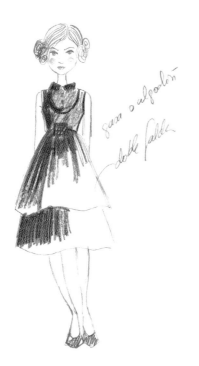

C/ Viladomat 88, 4º 2ª
08015 Barcelona, Spain
T: +34 93 423 94 83
info@parnasse.es
www.parnasse.es

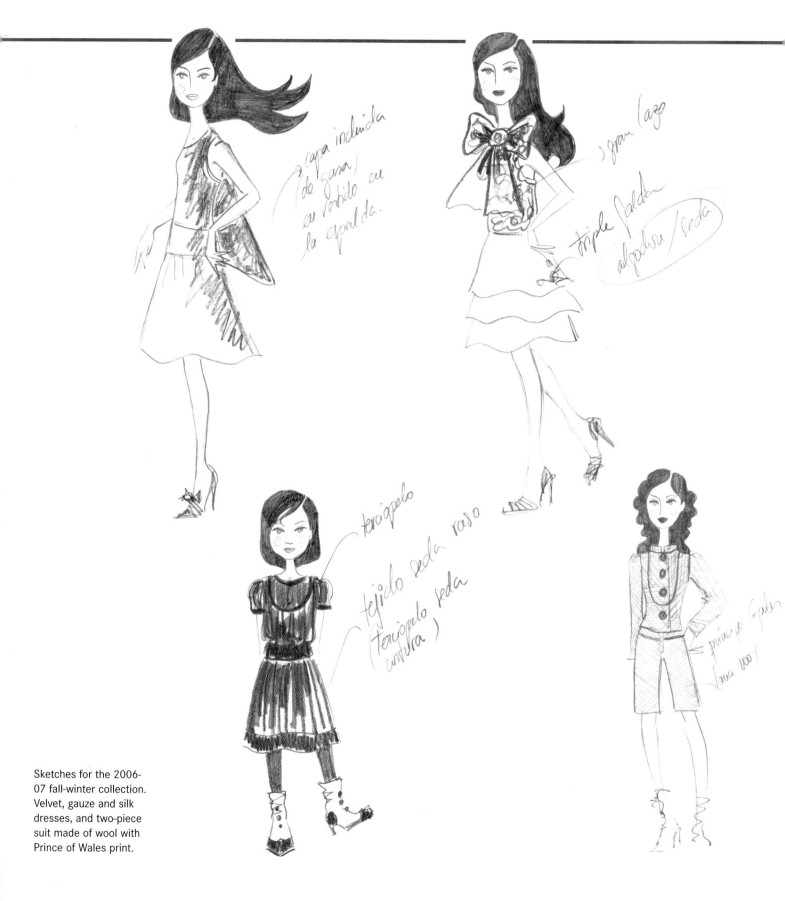

Sketches for the 2006-
07 fall-winter collection.
Velvet, gauze and silk
dresses, and two-piece
suit made of wool with
Prince of Wales print.

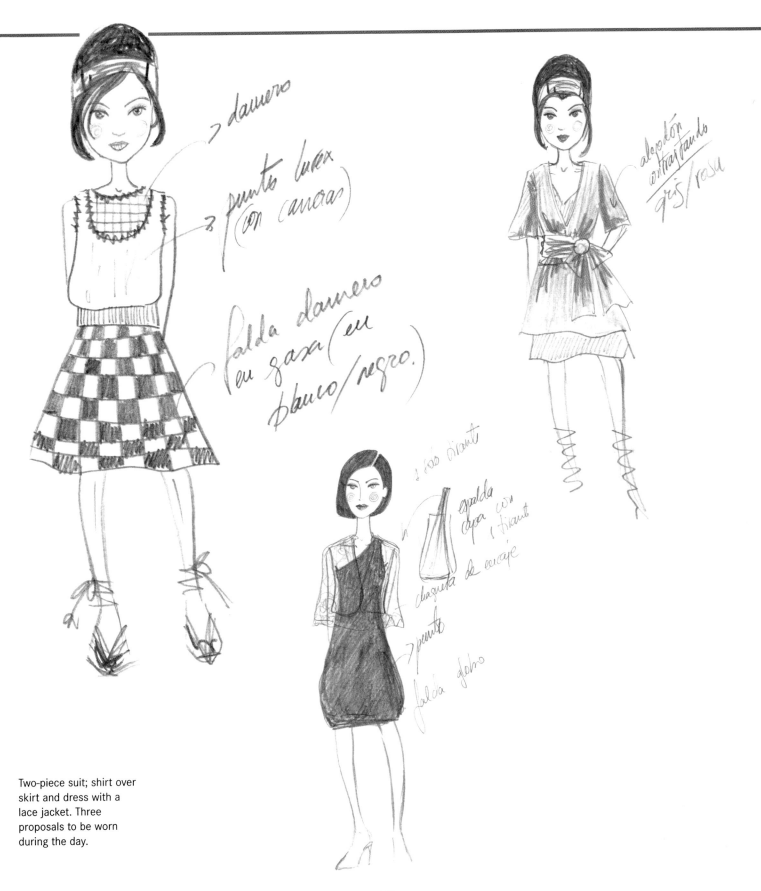

Two-piece suit; shirt over
skirt and dress with a
lace jacket. Three
proposals to be worn
during the day.

"I try to reinvent myself with my projects continuously."

INTERVIEW

How would you define your style?
With as few references as possible to any other known style; with as few transformations towards beauty as possible, as I try to interpret beauty in a very subtle way. Future is progress and change. We need to deconstruct fashion in its contents, laws and expectations.
I like to play with stereotypes and social codes that are expressed through clothing. That is why I do not limit my work to one particular style, and why the components I use for my collections vary so much.

Which is the most difficult piece to design?
The first ball dress for a teenager. It is hard to fulfill the expectations of a young girl.

Who or what is your main source of inspiration?
Personal, physical or psychological experiences. Contemporary phenomena, because I hate the nostalgic. I am challenged by the unknown.

What area of your work do you enjoy the most?
Traveling for a reason; and I love the exact moment in which I realize that I know what my next project is going to be about.

Who is your icon of style and good taste?
My icon of style does not necessarily have good taste.

What are your plans for the future?
To try to reinvent myself with my projects continuously, and not to be paralyzed by any sort of expectations. To practice more sports. To work more in Pelican Video, a multimedia video project that I am currently doing in collaboration with Michiel Helbig, a multimedia artist.

professional CAREER

Carolin Lerch

Carolin Lerch was born in Bregenz, Austria. She moved to Antwerp in 1995, where she graduated from the Fashion Department of the Royal Academy for Fine Arts four years later. Later on, she was invited to show her collection to the international press at the French Festival des Arts de la Mode, in the city of Hyères. She became an assistant to Paris-based designer Patrick van Ommeslaeghe, and then worked for Bernhard Willhelm for two years. She then enrolled in a mixed media course at the Royal Academy of Fine Arts in Gent, Belgium.

In autumn 2004, she founded Pelican Avenue, a fashion firm that represents her own collections, but that was also intended to be a platform for collaboration with artists from various disciplines. The firm aims to question the traditional codes of fashion, and proposes a different approach to it, avoiding conformity and stagnation. It wants to oppose the unstoppable rhythm of changing tendencies and the destructive attitudes of hypes.

The starting point of the collections and series of objects are personal reflections at several levels. The results are presented in different media like videos, photography or art installations. Presentations take place at conventional fashion events, with the purpose of reaching the appropriate circles. They also use the web, an anti-elitist meeting point that allows them to reach a wider public, free of prejudices.

Pelikaanstraat 104-108 b36
floor 8
B-2018 Antwerp, Belgium
T: +32 3 227 21 66
info@pelicanavenue.com
www.pelicanavenue.eu

Sketches with images
and resources for
inspiration that move
away from the traditional
fashion codes.

The starting point of the
Carolin Lerch collections
are personal reflections
on several levels. The
results are presented in
different media like
video, photography,
installations...

"I like funny, stupid-looking people."

Løgstør, Denmark, 1971

INTERVIEW

How would you define your style?
Genuine nerd.

Which is the most difficult piece to design?
Trousers are very difficult. The fit is extremely hard to get right and then you only need to go 2cms wrong to look like an idiot.

Who or what is your main source of inspiration?
It changes every season —we take a muse as a starting point for a collection, usually a woman of a certain character. Past muses have included Sissy Spacek, Cindy Sherman and Tonya Harding. But generally, I look a lot at photography and cinema, especially Diane Arbus, August Sander, Ingmar Bergman and a lot of American films like "Welcome to the Dollhouse" and "Female Trouble" —I like funny, stupid-looking people.

What area of your work do you enjoy the most?
I like research a lot, getting ideas from nowhere, and when you really start to know what the collection is going to be about. I do quite enjoy when it starts being real garments, but it's a stressful process.

Who is your icon of style and good taste?
Right now it's Tina Barney. I'm really into posh Americans, especially those Fifth Avenue ones that go to the Hamptons for the summer. I can't explain exactly why but they always manage to look good, even when they look like shit. It's a kind of careless smart look, there's nothing to it but it just suits them perfectly.

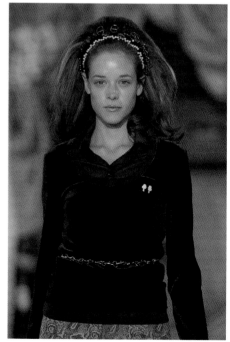

What are your plans for the future?
I have lots but I don't want to tell them yet.

professional CAREER

Peter Jensen

Of Danish origin, Peter Jensen, a graduate from Central Saint Martins, started his career as a designer for menswear items after a successful fashion show which took place during the Paris Fashion Week in 1999. His women's collection appeared right after this. And only two years later, his two collections were among those most valued by the specialized press.

In both cases, the tailor's trade is the basis that supports items of perfectly defined lines, built with prime quality materials and made with an almost artisan craft. This is the reason why there is a classical air to Jensen's proposals, although they are always sifted by humor and a certain irony, both manifest in the chromatics as well as in the combinations. His collections are always inspired on the figure of a relevant woman, of real or fictitious origin. Helena Rubinstein, Sissy Spacek or Fanny, from the Bergman film "Fanny and Alexander", have been some of their icons.

Aside from his own firm, Jensen has worked for other fashion companies like Topshop and Fred Perry. His clothes can be found at b Store in London; Opening Ceremony in New York; Creature of Comfort in Los Angeles; Gallerie de Vie in Hong Kong; UK Style in Moscow; Maud in Zurich; Woodwood in Copenhagen; Beneath in Stockholm and Dolls in Dublin.

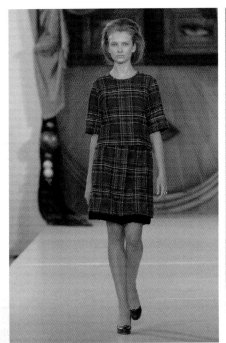
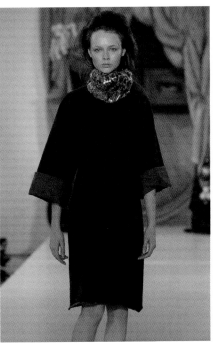

Studio 1
18 - 24 Shacklewell Lane
E8 2EZ London
United Kingdom
T: +44 207 249 6894
mail@peterjensenltd.com
www.peterjensen.co.uk

Jensen's clothes look deceptively straight-forward, and almost classic at times, but there is usually an ironic twist or humorous detail to his subtle, understated design.

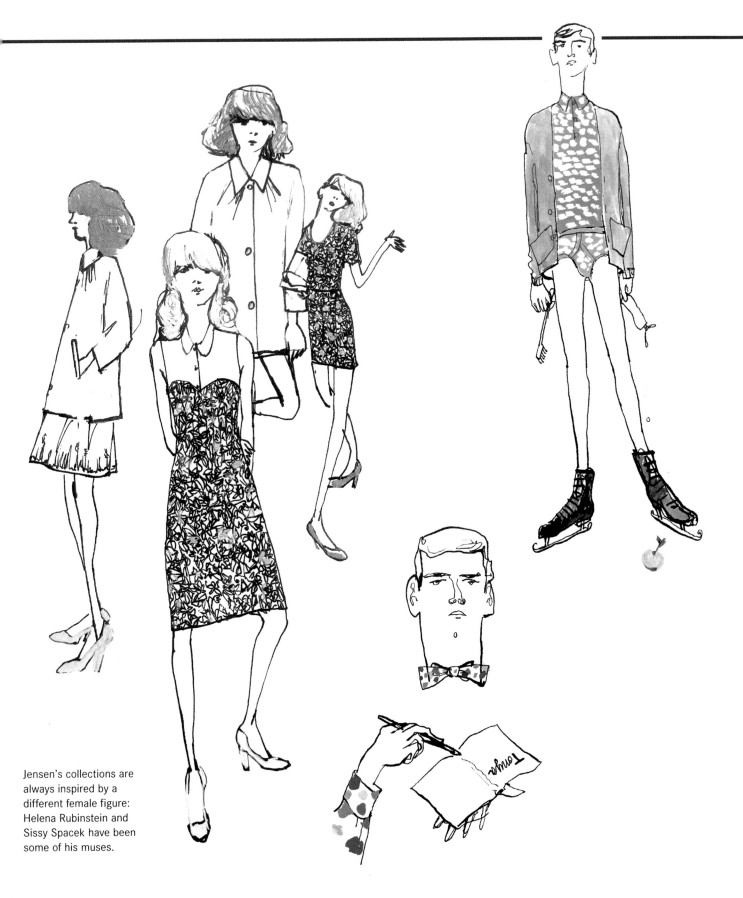

Jensen's collections are always inspired by a different female figure: Helena Rubinstein and Sissy Spacek have been some of his muses.

POSTWEILERHAUBER 43

Bretten, Germany, 1977;
Karlsruhe, Germany, 1973

"Thinking of each piece as something valuable."

INTERVIEW

How would you define your style?
Sober, concise, rational. Our shows are clean and contemporaneous in style.

What is the most difficult piece to design?
There are no pieces that are more difficult to make than others. There are pieces that take more time than others, but we are referring to ideas, to thinking each piece like something valuable, and in that sense, they are all equally complicated.

Who or what is your main source of inspiration?
We are inspired by the day to day. It depends on the topic we have chosen for our collection. These topics usually come from social, cultural or esthetic debates of the present moment. Things that are not treated and authentic, or, on the contrary, things that are very artificial or absurd, equally attract and repel us.

What area of your work do you enjoy the most?
Both tips of the process are special: the initial research and seeing the item placed on a hanger. When we dress our models for a fashion show or to take the pictures for the collection, we suddenly see the image as a whole. It is interesting to see the nearly unconscious changes that have been introduced between the idea and the final result.

Who is your icon of style and good taste?
Real icons are the people who have created their own universe and their own style.

What are your plans for the future?
To continue designing with illusion, to bring inspiration to other people's lives through our clothes.

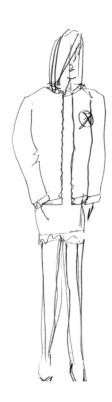

professional CAREER

Postweiler/Hauber is a fashion firm created by Eva Postweiler and Raphael Huber. Both of these German designers studied at the HFG Pforzheim in Germany, getting an honors degree in 2003. In August of that same year they founded their brand. All of their collections are a combination of men's and women's wear.

They presented their first collection entitled "Because the middle is inside" in Paris, in March 2004. This was followed by "Before, after and in between" and "Where the sky is so blue", both presented also in Paris. In April 2005 they were invited to participate in Pasarela Abierta in Murcia, Spain; they surprised the public with a collection dedicated to kites, their symmetry, patterns, brightness and colors. That same year they took part in the ZKM workshop in Karlsruhe.

Their collections normally use colors like bright white, silver or neon yellow; they also favor pinks and grays; and they use fabrics like viscose, chintz or plastic mixed with cotton. However, their 2006 spring-summer collection, "The night in your mind", surprised everyone by the use of a chromatic range which was not usual for the pair, including gold and turquoise blue, and materials like lycra or lurex; this collection was iconic for the creative duet, and a clear homage for Bowie glam and T. Rex. Their following collection, "Der Blaue Reiter", premiered in Paris and Berlin at the same time.

Postweiler/Hauber is sold in Japan, Munich, Amsterdam and Barcelona. Both designers have participated in individual exhibitions at the "Found for you" sample of the Museum Quarter in Vienna, organized by Wendy & Jim.

Raphael Hauber,
Eva Postweiler

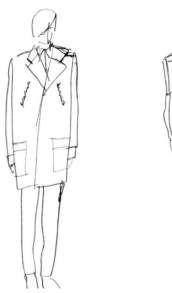

Franz-Holzmann-Strasse 9
69214 Eppelheim, Germany
T: +49 175 97 52 449
contact@postweilerhauber.com
www.postweilerhauber.com

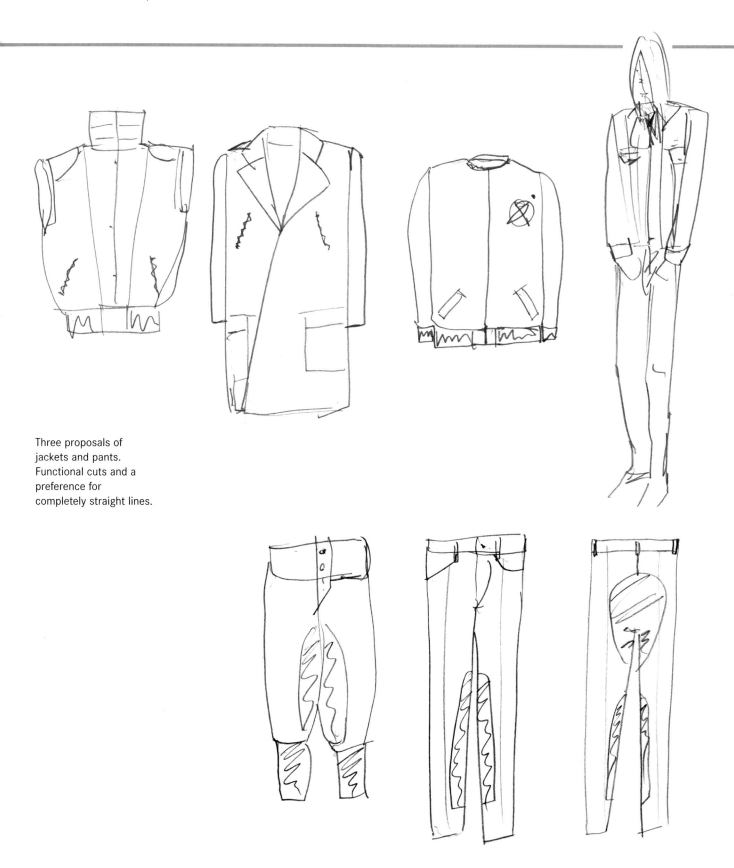

Three proposals of
jackets and pants.
Functional cuts and a
preference for
completely straight lines.

Different sketches for items of one menswear collection. Coats, jackets and pants. Each piece is baptized with a name and the predominating materials are viscose, chintz, cotton and mixes.

SPASTOR 44

Girona, Spain, 1975;
Barcelona, Spain 1975

"Our plans for the future: to continue enjoying our work."

INTERVIEW

How would you define your style?
We really like what Frédéric Martin-Bernard said: "Virile, sensual, fragile"... austere and elegant... a contemporary Spanish gentleman.

Which is the most difficult piece to design?
The one that does not convince you entirely.

Who or what is your main source of inspiration?
What happens to us, what we feel, what excites us, what scares us... myths... phobias... desires...

What area of your work do you enjoy the most?
Well, we can say the ones we enjoy less are facing the financial area and the Spanish industry. It is rough, tiresome and totally ungrateful.

Who is your icon of style and good taste?
Ian Curtis.

What are your plans for the future?
To continue enjoying our work.

professional CAREER

Spastor is a duo formed by Sergio Pastor Salcedo, born in Girona in 1975, and Ismael Alcaina Guerrero, born in Barcelona the same year. They started their joint adventure in 1995, and for the first two years they designed special small collections for ModaFAD in Barcelona. After that year, they showed their collections at Espacio Gaudí Moda in Barcelona and the Prêt-à-Porter and Workshop shows in Paris.

In 2000 and 2001, they participated in the Pasarela Cibeles in Madrid, receiving the L'Oréal award for the Best Young Collection. In 2002, Spastor made known its first mini-collection of shoes; it was done in collaboration with Kollflex.

In 2003 they presented their collections at the Pasarela Gaudí in Barcelona, just as they did in 2004. In February of that same year they came out with what would be their last women's collection "A means to an end", becoming since then one of the most important names of menswear design. Their clothing items have an avant-garde character, and have been called icons of new modernity by the specialized critics. Spastor has had the chance to present their collections outside Spain several times: aside from Prêt-à-Porter and Workshop in 1998 and 1999, they also presented them at Galerie Gilles Peyroulet & Cie in 2003 and the Espace Hexamo in 2004, all of them in Paris.

Sergio Pastor Salcedo

Ismael Alcaina Guerrero

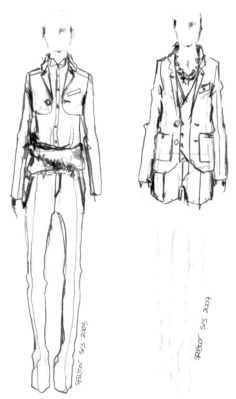

C/ Méndez Núñez 1, 2º 2ª
08003 Barcelona, Spain
T: +34 93 319 47 54
spastor@spastor.org
www.spastor.org

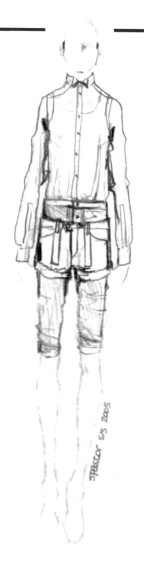

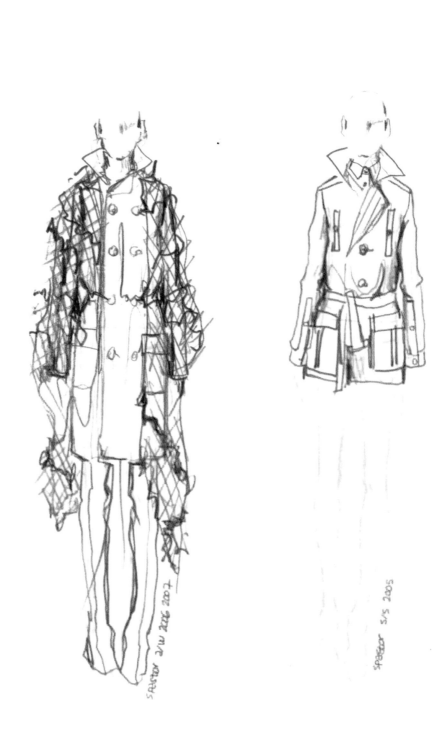

Sketches for the 2005
spring-summer and the
2006-07 fall-winter col-
lections. Two-piece suits
and men's raincoat with
double buttoning.

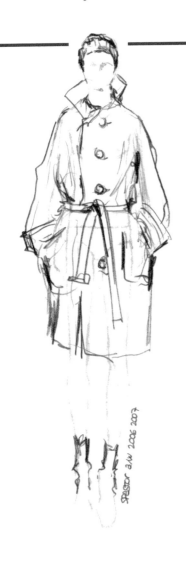

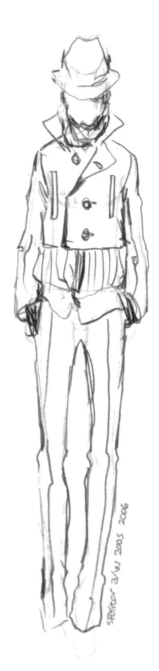

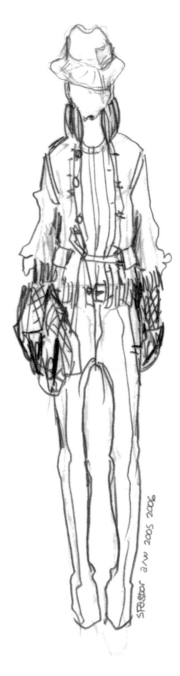

Sketches for the 2005
spring–summer and the
2006-07 fall-winter col-
lections. Raincoat with
simple buttoning and
men's two-piece suits.

"The piece talks to you."

INTERVIEW

How would you define your style?
For me, design is a way of expressing emotions, feelings, and for that I use the tools I know best: fabrics and patterns. We expect a routine act, as is getting dressed each morning, to become something exciting.

Which is the most difficult piece to design?
The most difficult piece to make is the one that is still only in your head. We make our own patterns, because we understand pattern design as one more tool for creation.

Who or what is your main source of inspiration?
Everything that provokes an emotion: music, cinema, graffiti, art. The spontaneity of contrasts, impossible mixtures, what is politically incorrect. And most of all, the street: that is the crib of non-conformity, of what is modern and new.

What area of your work do you enjoy the most?
Creating a collection is exciting from the beginning, when you start from zero and all directions are still possible. The idea of searching for something that is there and that you must find. Fabrics and colors that you choose are the first clear positioning. After this, pattern design, one of the parts I enjoy the most, and one of the most difficult too. Changes in ideas while you make the patterns. The piece talks to you and you need to know how to listen to it. After all the effort, to have the first samples and try them on, see them acquire a character of their own.

Who is your icon of style and good taste?
Lourdes Bergadà and Yohji Yamamoto.

What are your plans for the future?
The most important thing for me is to continue enjoying my work as I have done until now, and to make a collection that is each time better than the previous one. The rest, we will see. *Tout reste à faire.*

Barcelona, Spain, 1974

professional CAREER

From 1998 to 2000, young creator Syngman Cucala worked as an assistant for Lourdes Bergadà, a key name of Catalan design that has always been characterized by her independent vision of women's fashion. In the year 2000, Syngman finished his Fashion Arts and Technology studies, obtaining an honors degree at Southampton University. He then became an assistant to designer Josep Abril, until he launched his first personal collection in 2002. A year later, Cucala opened up to the international market.

"When I make my collections I have three favorite moments. First, is to do the initial statement of a new collection, to look for fabrics, to find its soul. It is always exciting to imagine that there is an empty wardrobe that needs to be filled. The second, is to investigate fabrics and patterns. You learn all the time, you make mistakes and form the solutions to these, sometimes an idea or a clothing item is born. These "imperfections" give spontaneity and strength to the collection. The third moment is when I see the collection. It is interesting to see where you started and where you end."

The use of blue and green tones is characteristic of Syngman, as are items such as blazers and cardigan jackets –made of first quality cotton or knitted fabric–, and wide shapes of studied and brave patterns, favoring an urban style, comfortable but elegant. Currently, Syngman shares his designer tasks with those of teaching at ESDI School of Design.

SYNGMAN CUCALA

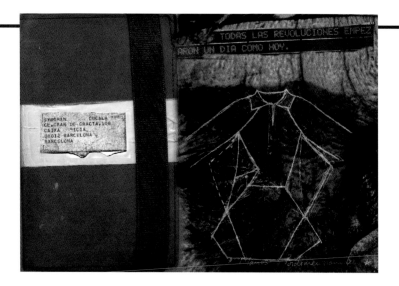

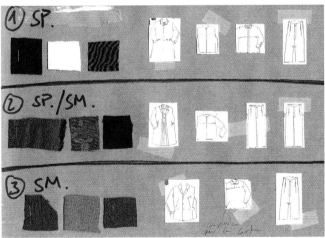

Notes, drafts and sketches that make up the universe preceding the creations of Syngman Cucala.

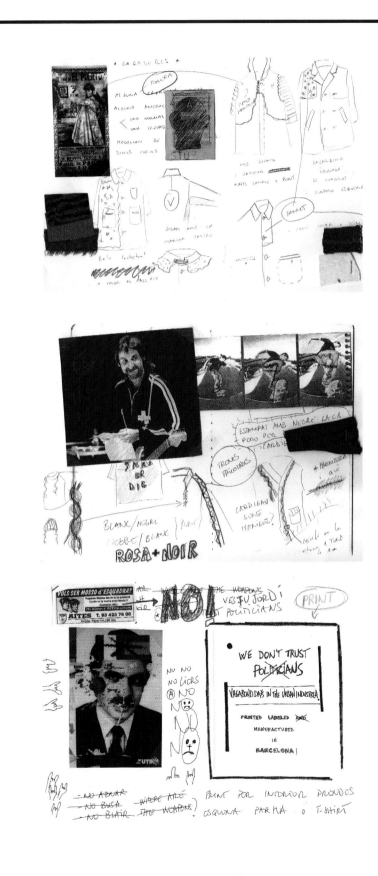

txellMIRAS 46

Sabadell (Barcelona),
Spain, 1976

"Good taste is very relative."

INTERVIEW

How would you define your style?
My style is a result of investigating and experimenting with patterns and shapes. I manipulate basic patterns, relocate them, fragment or widen them. I give a lot of importance to the concepts from which my collections emerge; I reflect upon the individual and reality. With no premeditation, I am traveling the way of the Japanese in the 80's and the Belgians in the 90's.

Which is the most difficult piece to design?
The more complicated a piece, the more complicated its design, whatever it is.

Who or what is your main source of inspiration?
My source of inspiration comes from outside fashion: I am interested in art, literature, cinema, music... Names like Duchamp, Boltansky, Beuys, Brossa, Gombrowicz, Tarkowsky, Faulkner, Bergman, Joseph Kosuth, Kafka or Dreyer are very important in my life and career. The results come after intense work.

What area of your work do you enjoy the most?
Designing pieces one by one, using hands, body and needle. I also like thinking up fashion shows where I can present a general concept with the appropriate lighting and music.

Who is your icon of style and good taste?
I do not have a specific icon. Good taste is very relative. More than beauty, I am interested in the sublime, as understood by Kant. Beauty pleases, the sublime moves, even hurts. I have always found this idea more interesting.

What are your plans for the future?
In the short to mid-term, I intend to continue working so the brand grows and reaches more people and shops. But I am only interested in fashion as a means, not as an end. I like painting, photography, creating objects like Dadaist ready-mades. I even wrote a script! So, in the long term, you never know.

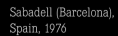

professional CAREER

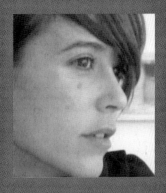

Txell Miras

Txell Miras was born in Sabadell, Spain, in 1976, and she has her own firm since 2003, when she also became part of the creative team of Neil Barrett in Milan. In 1999, she finished her studies of Fine Arts at the Universidad de Barcelona and exhibited her graphic work for the first time at the Galeria Bellas Artes in Sabadell. That same year she started her studies in fashion at Escuela Llotja in Barcelona, where she graduated with a special mention for her final project.

In 2001, she won the Insideouting contest, organized by the Domus Academy in Milan, obtaining a scholarship for a master's degree in Fashion Design at this Italian school. In September 2002, she was a finalist in the international Grand Prix contest in Tokyo. In July of the following year, she was considered to be the most promising young designer of Italian fashion by the Camera della Moda Italiana.

In September 2003, she was invited to participate in the group of young designers of Pasarela Gaudí. Her first collection was inspired by "Persona", the Ingmar Bergman film, and made apparent her taste for construction and deconstruction, for the use of sober colors and for the strong visual element in her fashion shows.

In April 2005, she participated in the Prague Fashion Week and in September she was awarded the Lancôme prize for Best Young Designer of Pasarela Gaudí. In January 2006, she participated in the recently created Pasarela Barcelona, in which she also took part the following year. Austrian magazine *Unit-F* chose her to represent Spain in the sample of Young European Designers in Vienna, in 2006.

Txell Miras's collections are currently sold at multi-brand stores in Spain, the United States, Germany, Belgium, Italy, Greece, Russia, Kuwait and Hong Kong. Her plans for the immediate future are focused on widening markets and continuing with her firm's international expansion.

C/ Dr. Torras i Bages 50
08223 Terrassa (Barcelona), Spain
T: +34 610 422 016
info@txellmiras.eu
www.txellmiras.eu

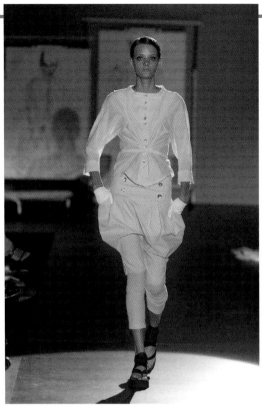

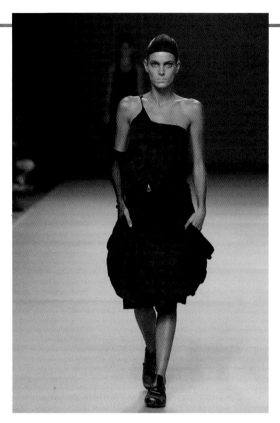

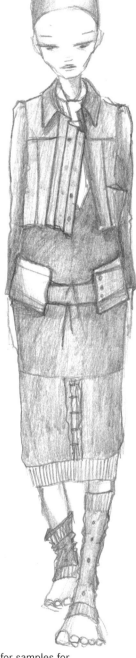

Sketches for samples for
the 2006-07 fall-winter
runway. Perfectly studied
patterns and use of
neutral colors.

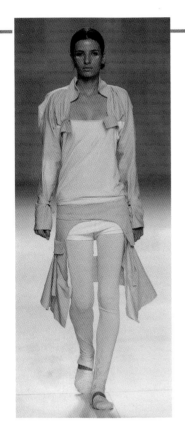

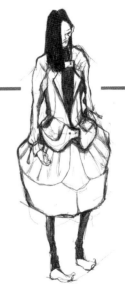

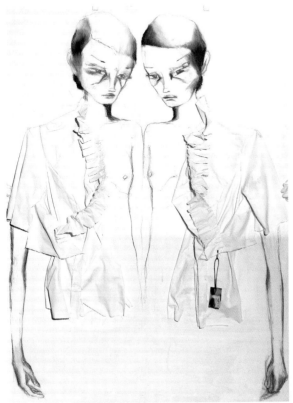

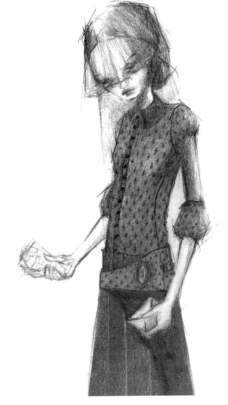